MUSIC IN STONE
GREAT SCULPTURE GARDENS OF THE WORLD

Text by Sidney Lawrence and George Foy
Introduction by Elisabeth B. MacDougall
Foreword by John Train
Photographs by Nicolas Sapieha

Project directed by Maria Teresa Train

Design by Lavinia Branca

Design Consultant: G.F. Cavaliere

Text edited by George Foy and Ptolemy Tompkins

A TRAIN / BRANCA BOOK

Published by Scala Books, New York

Distributed by Harper & Row, Publishers

ISBN 0-935748-61-X
Library of Congress Catalog Number 84-50549

Studio Art: Julius Brito
Printed in Yugoslavia by Gorenjski Tisk, Kranj
Typography by Photopregraph, Milan, Italy

FOREWORD
by John Train

Do not the greatest sculpture gardens stand at the pinnacle of the world's art in the seriousness of their intent and the power they exert upon the beholder?

I have in mind certain sacred places, such as Stonehenge or the Ryoanji Temple garden, where deep religious feeling combines with plastic beauty to create harmonious forms without particular use or representation, which thus really are "music in stone." The rose window of the Sainte Chapelle is in these terms "music" in glass, more than the Chapel itself, which can also be judged as architecture. Another example would be the Ardebil carpet, in the Victoria and Albert Museum, before which I try to spend a rapt half-hour whenever I'm in London, and which again doesn't mean or represent anything: music in textile. "De la musique avant toute chose," as Mallarmé said.

The Ryoanji garden, having no function or message except to work its magic upon the beholder, is truly music, and is rightly classed as one of the most glorious works of the human spirit.

Every day for centuries an endless river of reverent pilgrims have silently contemplated those 15 stones and that well-raked gravel. (Even the faded wall on the far side is ranked as one of the great national treasures of Japan.) The Ryoanji, and similar creations, exemplify a quality of the highest art: you are bewitched before you understand the process. The procession of lions on the holy island of Delos is for me another wonderful example of the unique quality of stone in the open air, particularly at dawn or sunset. It has an evocative power that charms the viewer, heightened by the problem of getting to the place at all — what the Symbolists called the joy of the "difficulté vaincue."

And correspondingly, when immense difficulties have been overcome in the creation of the work itself, the effort remains overwhelming centuries or even millennia later. That is why stones — particularly giant stones — are chosen over any other medium when the creator of a sacred monument hopes to create such an effect. Can any painting have the impact of Stonehenge or the pyramids? In part it is one's realization of the amazing dedication that their builders required to erect those huge stones in those sites, using techniques that we scarcely understand even today.

While it seems strange to call the pyramids a sculpture garden, they are, though on an immense scale. Indeed, from the air they have qualities in common with some of the gardens in this book.

So, as I say, can one doubt that they and the other sculpture groups I have cited are among the ultimate expressions of the human spirit in art?

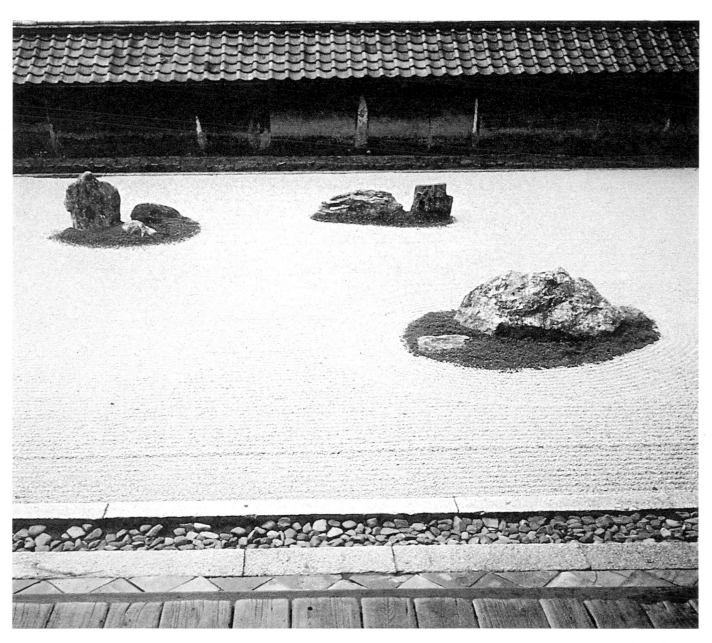

Black rock and white sand garden.
Ryoanji Temple Garden. Kyoto, Japan.

INTRODUCTION
by Elisabeth B. MacDougall

The impulse to place statues in an ornamental setting is as old as civilization itself. The contrast of the light colors of the statues against the darker green background of trees or other plants, the play of light and shade on the sculptures' surfaces, and the contrast between the unmoving statues and the changing, moving natural setting have had a universal appeal to all of mankind.

Religious and Commemorative Gardens

Traditionally, sculpture gardens have consisted of three types, religious, pleasure and museum. The first, and oldest, were not gardens in our modern sense of an outdoor area primarily used for recreation, relaxation or aesthetic pleasure, but areas set aside for some religious purpose. Statues were not placed there to be admired for their beauty or their value but to serve a religious function. Sometimes they were effigies to be worshipped, but more often they were votive offerings of thanks or propitiation to the deity or deities worshipped there. Such were the statues placed along the Sacred Way at Delphi, or the kouri and korai on the Acropolis in Athens. Possibly, even the lions that flanked the great processional way at the Temple of Amon at Karnak had a religious rather than decorative function.

Statues to be worshipped were also placed in outdoor settings, as the great images of Buddha at Bamayan and Borobadur attest. Sacred groves in Greece such as the one near the Academy in Athens, where Socrates and Plato walked with their students, had statues of woodland deities, such as nymphs, satyrs or Pan.

Statue gardens were also created to induce contemplation or meditation. The most widely known examples are the Zen gardens of Japan. They are found in numerous monasteries, often in the enclosed space behind the residences of the monks. The Stone Garden of the abbot of the monastery Ryoanji (see page 204), in Kyoto, is the most famous. The monastery and the garden date from the 15th century or earlier, but the present state is later. Fifteen stones of differing shapes and sizes are arranged in the small enclosed space of the garden on sand raked in wave-like patterns. No large plants grow in the garden, but a row of trees may be seen beyond the garden wall. The garden must be viewed from the open veranda of the house; only monks in observance of their religious duties are allowed to walk in the garden. The impact of the view from the veranda is overwhelming. Contemplation of the stones and the sand induces a feeling of tranquillity and timelessness. The viewer, divorced from the world and sensory experience, enters a trance state, an essential part of Zen religious practice.

Unlike the immobile contemplative state required by the Zen gardens, the Sacred Mounts in north Italy were designed to be traversed. The one at Varallo consists of 45 chapels and 600 statues portraying events in the life of Jesus. Starting with Adam and Eve and the Fall, and the Annunciation to Mary, other chapels have scenes from the childhood and youth of Jesus, the Passion and the Resurrection. The chapels are arranged on both sides of the steep winding path which leads up to the summit. At Varese, the Sacred Mount has 14 chapels representing the events in the life of Mary which make up the Mystery of the Rosary. In each, life-sized figures dressed in contemporary clothing are placed in realistic settings roofed and walled on three sides, but partially open to the front, much as the roadside shrines one sees on rural roads of Italy. As the visitor ascends the winding, and often steep path of these two Sacred Mountains, each group brings to mind the significance of the scenes. The prayers and meditation that ensue provide a religious experience like the telling of rosary or following the Stations of the Cross in a church.

Acts of worship, propitiation or thanksgiving were the inspiration for the types of gardens just described, but statues were placed in funeral monuments for a different purpose. Although the scale could vary from the small relief stelae used by the Greeks to the giant architectural complexes of Egyptian mortuary temples and the parklike acres of the 19th-century garden cemeteries, such sites were intended to commemorate the dead, and in some cultures to smooth the transition of the person memorialized to the afterworld.

Greek vases and Egyptian tomb paintings depict the small graves of their time; usually, there is a relief plaque or stone while nearby there are pots of flowers or trees, sometimes hung with votive offerings in memory of the dead. In Roman times, even more elaborate settings were made with tables and even small pavilions, where an annual commemorative banquet was held.

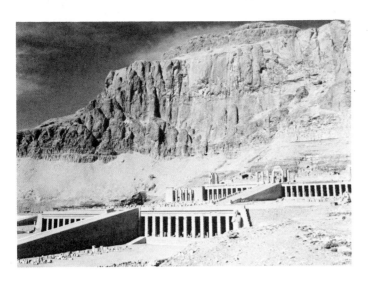

*Theban Necropolis: temple of
Hatshepsut at Der-el-Bahri. Luxor, Egypt.*

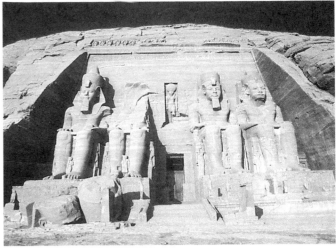

Abu Simbel, Egypt.

Vastly different in scale and intention, Mentuhotep's great mortuary temple at Der-el-Bahri, built in the 3rd millennium BC, consisted of a series of ascending terraces culminating in the colonnaded facade cut in the face of the cliff. The entrance courtyard was crossed by a monumental avenue lined with trees and statues of the pharaohs. Such monuments proclaim the power and wealth of the builder and were designed to make a presiding deity, in this case Hathor, look favorably on him and his successors. Even more impressive a reminder was created by Ramses II at Abu Simbel, where the face of the cliff was carved with many times life-size images of the pharaoh. No individual funeral monuments have surpassed the ancient Egyptian ones, but the 19th-century invention of the cemetery garden created a new form of commemorative display. Before their development, private burials were in churchyards, churches, or sometimes on private estates. None of these outdoor settings seemed appropriate for sculptural monuments, as the simple rows of tombstones of old New England cemeteries attest, but, when a family could purchase a lot or lots, as was possible in the garden cemeteries, sculptural display became the standard. The earliest of these cemeteries, Mount Auburn, in Cambridge, Massachusetts, was laid out like a public park and in the prevalent landscape or picturesque style, with winding paths and irregular plantings of trees and shrubs. Here individual monuments vie with each other in scale and sentiment, creating a veritable Garden of the Dead. Perhaps the founders recalled, from visits to Rome, the Via Appia bordered by ancient tombs and lined with pines and wanted to create a modern version. It is certain that the trees and shrubs were chosen by a committee of the recently founded Massachusetts Horticultural Society so that the cemetery could be an arboretum as well as a burial place.

There is no record of when statues were first used as decorations in a secular or non-religious setting, but it seems likely that the custom of placing statues of famous men in gymnasiums or palaestrae, the combined schools for youths and meeting place of adult Greeks, was a start. Commemorating famous philosophers as well as warriors and statesmen, the statues were intended to be an example for the young and adults alike. A similar motif survives today in parks created to memorialize national heroes, such as the park on the Gianicolo in Rome, where the major avenue is lined with busts of the leaders of the Risorgimento, the 19th-century revolution which unified Italy. A similar motif can explain the statues in other public parks, such as the Public Garden in Boston, although more often the accumulation was not planned, but occurred over a period of years.

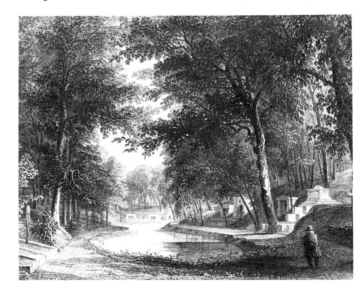

*Cambridge, Massachussetts, U.S.A.
View of Mount Auburn Cemetery.
Published in 1857.*

Pleasure and Museum Gardens

The decoration of pleasure gardens with statues was a late development in the history of ancient gardens. There is no evidence that the great royal gardens of Babylon, Persepolis or the Egyptian capitals had statues in them, and indeed, it is likely that the use of statues in gardens followed the appearance of genre, or secular statuary. Genre figures existed in ancient Egypt, but they were made to be placed in tombs, either representations of the person buried there, or made to accompany the dead on their journey to the afterworld and to continue to provide the services they had contributed in life.

Statues representing ordinary people, and with no evident religious function, first appear in Greece in Hellenistic times, in the late 3rd century. Some, such as the "Old Market Woman," or the "Drunken Old Man" seem too unpleasantly realistic to have served as garden decorations, but others like the "Boy Wrestling with a Goose," attributed to Boethius, or the so-called "Invitation to the Dance," had the light-hearted air one might expect in decorations for a pleasure garden. There is no documentation, but it seems likely that statues such as these were placed on the palace gardens of Hellenistic rulers such as the Seleucids of Syria, the Attalids in Pergamon, or the Ptolemies in Egypt.

There is no doubt, however, that statues were a prominent feature of Roman gardens, for there is literary as well as physical evidence for their presence. Letters by writers and important citizens like Cicero and Pliny the Younger describe statues in their villas, or ask friends to procure new ones. The chapters on stone in Pliny's Natural History describe many statues in private gardens in Rome. Even Martial, in a satirical epigram, records the presence of statues in public parks of Rome, such as the Porticus Livia. In addition, many garden statues have survived, ranging in size from the small genre figures found in many of the gardens in Pompeii to the great statue groups, like the "Laocoon," now in the Vatican Museum, or "Niobe and her Children," in the Uffizi in Florence, each found on the site of imperial gardens in Rome. Even paintings confirm the existence of statues as an integral feature of Roman gardens. Many of the wall paintings in Pompeii show statues placed on high bases, set against dense plantings of trees and shrubs, or herms (a pedestal topped by a bust) placed by fountains or against the low wicker fences used for the garden boundaries.

The statues that have been found in the gardens of Pompeii are usually small; there are Cupids, boys with animals, occasionally an image of one of the Roman deities. They do not seem to have had any religious significance, except for a few Lares, or household gods, so their role must have been that of decoration. After water became more available for private gardens with the construction of the aque-

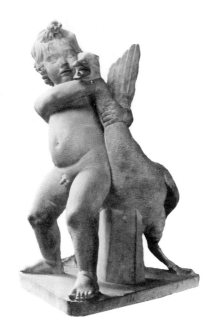

duct in the Augustan Era, garden fountains became common, and statues were placed next to little pools. Some were actually pierced so that water could spout from the mouths of the animals or figures. One especially impressive fountain from Pompeii was in the form of a tree; a serpent entwined in its branches was the waterspout.

The gardens in the city of Pompeii were small, and the size and number of their garden decorations restricted. The town houses were owned by a prosperous middle class whose taste was formed by examples of imported Hellenistic art. Certain statue types, of Greek invention, were repeated over and over again, much as today's garden statuary seems limited to a few popular types, gnomes, birds, frogs, and so forth.

A similar repetition of Hellenistic statue types has been found in the larger villas of the suburbs of Pom-

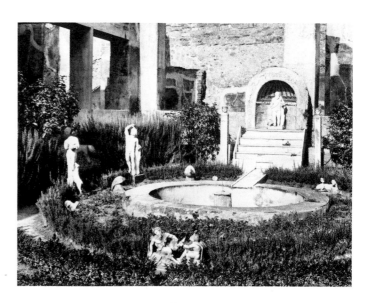

Marcus Lucretius' garden. Pompeii, Italy.

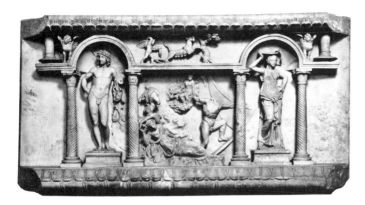

Boy wrestling with a goose,
*attributed to Boethius. Louvre
Museum, Paris.*

Ariadne abandoned by Theseus.
Vatican Museum.

peii and other nearby sites, such as Herculanaeum. These villas were often very large and contained many separate gardens, enclosed by porticoes near the house or with high walls farther away. The statues found at these sites have usually been copies of great masterpieces by Greek sculptors such as Phidias, Scopas or Praxiteles. They were life-sized, unlike the small scale statues of the town gardens, and frequently numbers of them were placed around the borders of a swimming pool or in the openings between columns in the peristyle courts. Although the statues found are usually of Roman deities, their role appears to have been purely decorative.

The placement of statues in Roman gardens is not certain, but the existence of so many duplicates of Greek works of art has led one archaeologist to suggest that they were placed symmetrically in pairs in the courtyards and around the pools. Some sarco-

phagi (Roman stone coffins) have decorations on their sides that may reflect the way statues were displayed in gardens. They show columned porticoes with figures of statues alternating with large reliefs between each column.

Such arrangements may have been common in town gardens in Rome and other cities of the empire, but the size and layout of the great country villas, especially the imperial ones, would not lend themselves to such a rigid scheme. In fact the design of these villas was not axial, symmetrical and geometric as the writers of the Renaissance and later believed, but informal and irregular, probably much like the landscape parks of the 18th century in England. Buildings were not confined within a single rectilinear exterior; instead many small structures with differing functions were arranged in the parklike surroundings. Pliny, describing his seaside villa, speaks of isolated dining pavilions, a separate study, a bedroom with its own courtyard, etc. A surviving example of this style is the Villa of Hadrian at Tivoli in Italy. There one can see audience halls and libraries, baths, guest quarters, a small isolated pavilion in the center of a pool that served as a place of retirement for the emperor, a canal-like pool with a great vaulted reception hall at its far end and many other buildings. They are distributed almost haphazardly in the rolling terrain. Statues have been found in many different parts of the villa; one set of human figures and animals were placed along the edges of the long pool. Another set of the nine Muses was excavated in the Renaissance; its precise original location is unknown.

Groups of statues were popular during the height of the Roman Empire and many of them are known today. Perhaps the most famous is the group of the Laocoon, representing the ancient myth of a man and his sons destroyed by serpents at Apollo's order

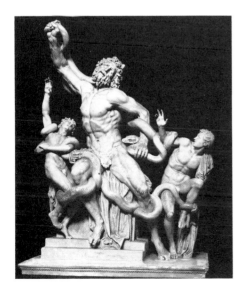

Laocoon *group. Vatican Museum.*

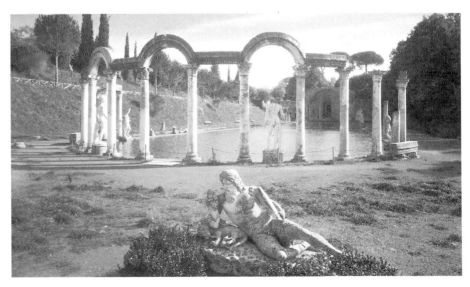

Canopus. Hadrian's Villa. Tivoli, Italy.

11

for his profanation of the temple. Yet another tale of punishment for defying the gods was represented by the Niobid group. The many statues in the best known surviving group represent Niobe and her children being destroyed by the wrath of Apollo and Diana. Yet another famous group, the so-called Farnese Bull, now in the National Museum in Naples, represents the story of the punishment of Dirce for her cruelty to Antiope, by Amphion the son of Zeus and Antiope. More than one set of the nine Muses has been found, and with the exception of the Laocoon group all were found on the sites of former imperial villas. The human or larger size of the figures and the number of individual statues in each group required a large scale setting. Unfortunately, these are not known, but it is possible that another group discovered in a seaside grotto at the site of a villa of the emperor Tiberius may give some idea of the way these ensembles were displayed.

The grotto at Sperlonga, on the Adriatic coast of Italy, was a large natural cavern, enlarged and made deeper by the creators of the setting. A pool was made in the center, and in this was placed a stone boat with figures of sailors and Ulysses, who, according to some interpretations, was shown tied to the boat to avoid the temptation of the siren Scylla as he sailed through the straits of Messina. In another recess of the grotto the scene of the blinding of Polyphemus, a tale also from the Odyssey, was represented in a group of many statues.

A question that one must ask about the sculpture groups concerns their significance. Were they intended to convey a moral, to admonish and instruct the visitor to the garden, did they just represent a story familiar from literature and therefore enjoyable to encounter in a three-dimensional form, or were they displayed as copies of original works of art?

Certainly many of the other statues that have been found in villa sites were collected and displayed for their value as works of art, especially in the town and villa gardens of the Roman empire. Other decorations, however, were adaptations of formerly religious types to a function appropriate to their nature. Thus, fountains were decorated with personifications of river gods, or water nymphs. Figures of Floras, Pomonas, and Priapus, the ithyphallic deity of fertility, found their place in garden plots, and terracotta reliefs, often pierced for fountain spouts, depicted mythical gardens such as the Garden of the Hesperides.

In the western world, this centuries-long tradition disappeared, and the physical traces of the gardens were obliterated with the invasion of the northern tribes and the shift of the capital of the empire to Constantinople from Rome. Not until a period of intense interest in antiquity, the period we call the Renaissance, was there a return of the desire for and

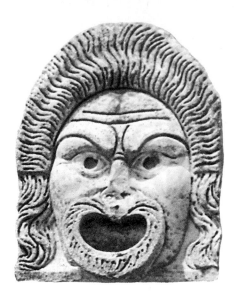

Roman theater mask from Ostia, Italy.

the ability to create great gardens with sculptural decorations. At first, the interest in the sculpture was for its value as evidence of the Roman past, and for its testimony to the wealth and culture of its owner. We find the humanists in Florence in the 15th century collecting sculpture to place in gardens by their studies, and wealthy merchants and patricians like Lorenzo de' Medici displaying their collection in a garden especially set aside for that purpose. Aristocrats, too, became collectors, as for instance Isabella d'Este, wife of the Duke of Mantua. Her avid pursuit of antiquities to decorate a suite of rooms and a terrace garden in the palace in Mantua is well-documented in her surviving correspondence. Rome became the center for the collection of antiquities and their display by the beginning of the 16th century. Its wealth of remains, which were brought to light almost every time a spade was put in the ground, offered boundless resources to the Roman aristocrats and members of the Papal court. In the first fifty years of the century several collections numbering hundreds of pieces were assembled. Later, dispersed by the fortunes of war or the profligacy of heirs, these collections became

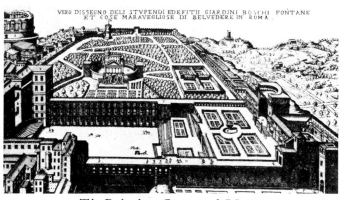

The Belvedere Courtyard. Vatican Palace. Drawing by Heemskerck.

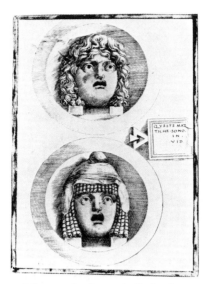

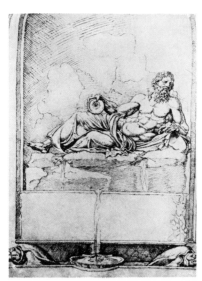

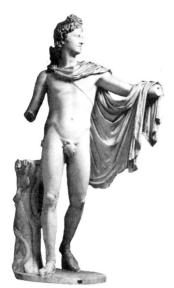

The masks from the Belvedere Courtyard. Vatican Palace.

River-God Fountain in Belvedere Courtyard. Drawing by Heemskerck.

Apollo Belvedere. *Vatican Museum.*

the foundation of most important museum holdings of antiquities.

Pope Julius II's desire to emulate the grandeur of ancient Rome, a desire which inspired him to start the construction of a new St. Peter's and the improvement of the Vatican palace, was also responsible for the first museum garden in Rome since antiquity. In a space between the wings linking the Vatican palace to an earlier hillside retreat, a courtyard opening on to the Vatican gardens was created to display the papal collection of ancient statues. Niches in the walls were made to hold statues, while the center of the courtyard had green plantings, fountains in the form of river gods, and orange trees. Julius II had begun to collect while still a cardinal, and brought with him to the Vatican what was to be one of the most famous of all the statues in the collection, the Apollo Belvedere. It was believed to be Greek and to represent the highest form of Greek art. Added to the collection as they were discovered were the Laocoon group and a statue of Venus. A reclining figure of a female, believed to represent Cleopatra, was placed in a niche, as were the others, but adapted as a fountain, with water running from her breasts, according to a description in a contemporary poem. Later, a second figure of a river god was placed in another of the niches and adapted as a fountain. In each case, the water was piped into the back of the niche, ran down the figure or issued from a vase (the customary attribute of a river god), and fell into a catch pool made of an ancient Roman sarcophagus. Ancient Tragedy and Comedy masks were placed at regular intervals around the cornice, together with an inscription taken from Virgil's Aeneid, "Procul, procul, o profani," (Stay out, stay out, Oh ye unworthy).

The sculpture court of the Belvedere started a tradition that survived for many years with its display of the statues in an ornamental and regularized setting. The intention was to revive the ways in which statues had been shown in antiquity; the emphasis was on their importance as works of art. Yet combinations of statues, such as the two fountains with their sarcophagi, were created, even though it was known that this was not true to ancient tradition, and statues were restored despite the damage such restorations did to the original work of art. This combination of attitudes is also evident in other sculpture gardens of the era. A part of the della Valle collection, notable for its size and importance, was placed in niches in a terrace garden in a style reminiscent of the Belvedere court, but with the addition of trellised vines between the niches and big plaques on a second level with inscriptions welcoming the visitor and explaining the value of looking at the works of art. The della Valle collection was later bought by Cardinal Francesco de' Medici for his villa on the Pincian hill in Rome. The garden facade of the palace was designed to hold the statues and reliefs arranged in a decorative and symmetrical pattern on all three levels of the facade. Statues and busts were placed in niches, while the reliefs were attached to the walls; the system is very reminiscent of the ancient sarcophagi described above as possibly representing Roman ways of displaying statues.

Not all gardens were as orderly in their arrangement and treatment of their collection as the Belvedere, the della Valle and the Villa Medici. A series of drawings made by the Dutch painter, van Heemskerck, in the 1530's show that an entirely different spirit often prevailed. Statues at the Villa Cesi, owned by a renowned collector, Cardinal Federico Cesi, are shown in Heemskerck's drawings, scattered haphazardly along the garden wall. Fragments of arms and legs are placed by complete statues on pedestals, and the whole has the appearance of a ware-

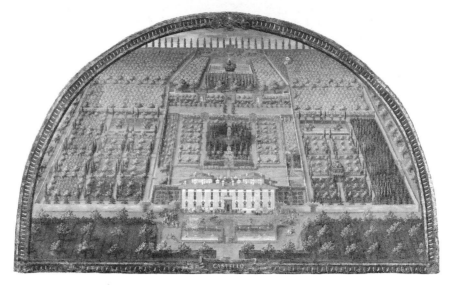

*A Lunette of Villa Medici at Castello,
Florence, by J. Utens.*

house of remnants awaiting restoration. This is also true of the Gallo garden, where one can see a sarcophagus, a fragment of a torso, a reclining nymph on a high base and Michelangelo's statue of Bacchus, scattered around in an apparently totally unordered way. For collectors such as these, the possession of the antiquities was sufficient; their value did not need to be enhanced by decorative display or restoration.

After the first decades of the 16th century a different attitude about the use of statues for decoration began to develop. The idea of the sculpture garden as a display of one's collection of antiquities was replaced; instead, the statues began to be used to create a narrative, an allegorical theme which usually carried a message about the power, wisdom or culture of the patron. The value of the statues as antiquities was superseded by their usefulness as symbols. This led, initially, to a quite different treatment of the statues themselves. They were no longer acceptable as fragments or incomplete figures. Instead they were restored or completed or changed. Many were adapted as fountain figures, by piercing holes for the passage of water; others were given arms, noses, feet, whatever was lacking, often by leading sculptors of the time.

The concept of the parable, that is a story containing a deeper significance, of course goes back to biblical times, and has existed as a tool for interpreting events in the New and Old Testaments since the Early Christian era. Late in the Middle Ages similar interpretative methods were used to give a Christian significance to surviving ancient literature. The stories in Ovid's "Metamorphoses" were interpreted with Christian moral explanations in a 14th-century work, "Ovide moralisée"; the stories of Hercules' Twelve Labors were similarly interpreted by a Florentine humanist at the end of the same century. In the 15th and early 16th century, the idea of using this kind of allegory began to be used in secular painting cycles in the palaces of the wealthy and the aristocrats.

The first known example of a similar approach to garden decorations occurred at the Villa Castello near Florence, in the program developed for Cosimo de' Medici, on his accession to the ducal throne in the 1530's. All the sculpture and fountains were an extended metaphor, starting with the personification at the top of the garden of the two mountains that delimited the duchy to the north, the rivers Arno and Mugnone which encircled the city of Florence, and going on to represent the lineage of the Medici and the cycle of the seasons. All were intended to convey the idea, already presented in official publications, that Cosimo's reign was ordained by God and that his rule would shower benefits on the citizens of Florence and Tuscany.

It was possible to convey these ideas because an allegorical system of symbols was readily comprehensible to the audience of courtiers and citizens it was intended for. This was based in part on the

*Villa Gallo, Rome. Drawing by
Heemskerck.*

14

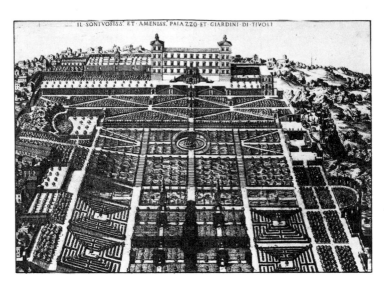

*Villa d'Este, palace and gardens in
original state. Engraving by Du Pérac.*

establishment in Roman times of conventionalized statue types frequently representing a pantheon of deities and the personifications of natural elements. These were known and recognized in the Renaissance and, in garden statuary, were used as a "lingua franca" readily understood by the cognoscenti. In addition to the recognizable physical types, certain associations had developed around the most common of them. Water, in the form of river gods or nymphs, could be usually understood to represent abundance, Hercules was the personification of moral strength and the conquest of vice, the Four Seasons represented the eternal cycle of time and hence the permanence of the regime or ruler celebrated.

This language of symbols appeared in Roman gardens soon after the decoration of Castello, and many of the gardens there had similar allegorical programs. Of the many, few have survived and the remaining examples of this type are outside the city. Of these, the Villa d'Este in Tivoli (see page 142) is perhaps best known, yet few of its visitors are aware that the various fountains and architectural features

*Villa Cesi, Rome. Drawing by
Heemskerck.*

were in fact a celebration of the virtues of the cardinal. His role as a patron of the arts is established by the presence of the Pegasus Fountain above the Oval Fountain, while the figures of the Tiburtine Sybil, and the personifications of the two rivers, the Aniene and the Erculaneo, describe his Tivoli domain. The Avenue of the Hundred Fountains had reliefs showing the deeds of Hercules, the mythical ancestor whom the d'Este claimed as founder of their family. Grottoes of Diana and Venus reminded the visitor of the moralizing tale of the choice of Hercules between the rocky path of virtue and the easy path of sin. The Dragon Fountain, while built to honor the visit of Pope Gregory XIII, whose heraldic symbol it was, also referred to the myth of the Garden of the Hesperides, guarded by a dragon, where Hercules had taken the three golden apples, symbolic of the virtues of a balanced temperament, generosity and asceticism.

The conventionalized statue types were used again and again, and their message was as clear to the viewer as an inscription or a written explanation would have been. The Villa Lante at Bagnaia (see page 162), for instance, clearly represented to the 16th-century visitor a contrast between pre-civilization, idealized as a Golden Age and represented in the park, and the growth of civilization, which was shown in the terraced garden. Pegasus and the Muses appear in the fountain at the entrance to the park, signifying the presence of a poetic narrative. The visitor followed the paths which wandered up the hill past fountains representing woodland animals, Bacchus and wine-making and ending with a head of Janus with two faces, one looking to the park and the past, one looking toward the formal garden and the future. From there one passed the waterfall, representing the flood which had destroyed the old order, and descended the hill, passing a fountain of

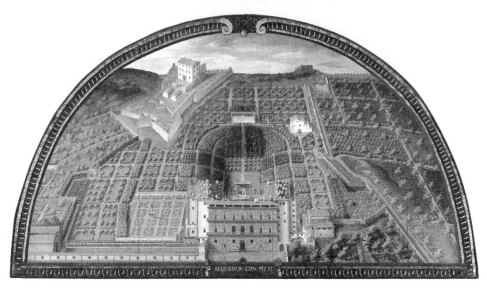

A Lunette of Pitti Palace, Florence, by J. Utens.

dolphins, formerly covered with a pavilion made to look like coral. This represented man's development of the manual skills. Beneath was a table, to show the civilized art of cooking and dining, a fountain in the form of a theatre, and finally the lowest fountain with armed figures in boats representing the martial arts.

In contrast, at nearby Bomarzo (see page 148) almost all the statues are unconventional; they are not derived from the repertoire of standard types but are inventions. Amongst them are elephants, orcas, a giant rending a smaller human in two, a giant mask. Their message or narrative would have been difficult for the 16th-century visitor to understand, and that difficulty persists today. Many interpretations have been offered of the significance of this enigmatic garden.

In other parts of Italy, the conventions established in Rome were adopted, but the statues used were modern, commissioned from local or imported artists; the wealth of ancient statues available in Rome did not exist elsewhere. Gardens such as the Boboli gardens (see page 164) behind the ducal palace in Florence were decorated with statues by the leading artists of the period, Ammannati, Tribolo and Parigi, but they used Roman prototypes, and their statues were of the familiar garden and pastoral deities. Ancient statues were also displayed at the Boboli gardens, but only as decorations. The more valued antiquities in Medici possession were in the Uffizi.

Just as Bomarzo departed from the conventional subject matter for garden decorations so did Pratolino, a villa built by Ferdinand de' Medici, in the 1580's. Although some familiar types appeared — there was a Mount Parnassus with the nine Muses, and a Bacchus fountain, for example — there were also a number of innovations. By one pool was a washerwoman and her son, who was defecating; in another part of the garden a fountain was presided over by a Nature god completely unlike the usual satyr or Pans. Most notable at the villa however was the giant personification of the Appennine mountains, shown crouching by a pool. His size was great enough for several rooms to have been built in his head; his eyes were windows. Even more unusual were the grottoes under the palace where several groups of statues were made to move by hydraulic pressure. In one, a group of animals played music on their instruments. In another, a servant came out of a recess in the wall, set a glass or beaker on a table in the grotto and returned to her resting place.

Such automata were popular and were to be found in other gardens too. At the Villa d'Este, in addition to the water organ, there was a fountain in which a bird flapped its wings and sang. The tradition for these goes back to antiquity; it was preserved in a treatise by an Alexandrian mathematician in which many devices automated by water pressure were described.

After Castello, none of the Florentine villas had iconographic programs of such unity or complexity, yet individual parts of the garden decorations alluded to familiar themes, such as poetry, the contrast of art and nature, the four parts of the world or the four seasons. These themes continued to be popular in Italy and in the countries where the Italian Renaissance garden style was imported. In one of the greatest and most famous gardens of the 17th century, Versailles (see page 168), almost all the familiar themes were repeated. The rivers of France, the Seine, the Loire, the Garonne and the Rhone, are personified as river gods, in the conventional reclining pose, at the Parterre d'Eau near the chateau. So also are the four parts of the earth, while the statues that lined the Grande Allée represented Flora,

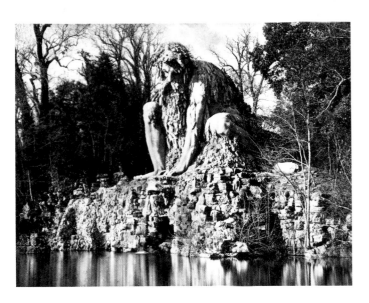

The Appennine, *Pratolino, near Florence.*

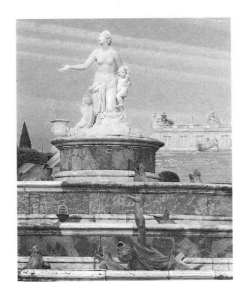

Fountain of Latona. Versailles, France.

Pomona and Ceres among others. The allées on either side of the central one had pools with fountains representing the four seasons: Flora for spring, Ceres for summer, Bacchus for autumn and Saturn for winter.

Yet sculpture was called upon to play a greater role in the great expanses of the gardens. On the main east-west axis that extended from the palace to the start of the Grand Canal the two major fountains are allegorical references to Louis XIV. At the far end of the Grande Allée the Chariot of Apollo the Sun King is shown emerging from the sea at the beginning of the day, while near the palace is the Fountain of Latona. She is shown with her two children Apollo and Diana watching while the denizens of Lycia in Turkey are transformed into frogs as punishment for refusing her aid.

The Latona Fountain is considered a reference to the Fronde rebellion early in Louis XIV's reign, and the punishment of the Lycians a warning of the fate that awaited his enemies. A similar theme of conquest and punishment appears in fountains on the North Parterre; the Neptune and Dragon Fountains refer to the defeat of Louis' enemies. The Enceladus Fountain, near the Basin of Apollo, which shows the defeat of the Giants by the Olympian Gods, is another such allegory on the triumphs of Louis.

Apollo the Sun King, of course, was a personification of the king; Louis was usually referred to by this title, and the theme was constantly referred to in decorations in the chateau, in court festivities and in the poetry of the period. So the appearance of the Chariot of the Sun driven by Apollo was an easily understood metaphor for the King's reign over his kingdom, a metaphor given intimations of universality by the indications of Apollo's passage through the sky, that is, over the gardens, the Fountain of the Four Seasons and the Four Quarters of the Earth.

In the 1670's a pavilion called the Grotto of Thetis completed the cycle of the day with groups of statues representing Apollo at rest in the caves under the sea where he returned at night. This, however, was dismantled when the chateau was enlarged in the 1680's and the group of Apollo and the nymphs tending him, as well as the two auxiliary groups of the horses that draw the Sun Chariot, are now in a picturesque outdoor setting designed by the painter Hubert Robert in the late 18th century.

Not all the sculpture decorations at Versailles allude to the monarch and his powers. Some of the most engaging as well as innovative decorations are the statues depicting LaFontaine's fables in the Bosquet of the Maze. The paths of the maze branched off at angles from each other, so that at each juncture there was a choice of two or more paths to take, and at each of these junctures a statue of one of the animals of the fables, with an inscription drawing a moral from the tale. Moralizing inscriptions were not unknown in gardens: for instance, one of approximately the same period near Turin is described as having 42 statues of the planets and the constellations. Each statue's base had an inscription which, their author tells us, was designed to teach the viewer astronomy and moral philosophy. At Versailles, the use of contemporary literature as a source and the ingeniousness of LaFontaine's inventions of animals and their activities gave an unusual elegance and charm to the ensemble.

Louis XIV's Versailles was viewed by his contemporaries as a paradigm, and it was imitated widely throughout Europe by rulers both petty and great. The innovations of design and decoration were adopted almost everywhere, but the significance of the fountains and sculpture groups was not often echoed. At Peterhof (see page 173), for instance, the great country estate built by Peter the Great on the

Temple of Apollo at Stourhead.
Wiltshire, England.

Gulf of Finland near his newly founded city St. Petersburg, the cascades, canals leading to the gulf, and the gilded statues are all derived from Versailles. Grandeur and extravagance, however, seem to be their only significance; there is no discernible allegory.

The same is true of most of the gardens on the Continent in the century following the construction of Versailles. The same themes, the same statue types reappear, but they no longer are intended to tell a disguised story. New subjects appeared when a vogue for outdoor theatres developed in the 18th century. Their backdrops and wings were made of hedges, and the stages were often ornamented with a permanent cast of actors drawn from the Commedia dell'Arte plays or contemporary drama. Harlequins and Pulcinellas peered out from the wings, shepherds and shepherdesses pirouetted on the stage.

This taste for the dramatic influenced even the old traditional statue types — they seem more like aristocrats performing one of the popular pantomime ballets than serious representations of the ancient gods. At Veitshöchsheim, the statues are translations into stone of courtly "tableaux vivants."

The tradition for the use of statues in English gardens is different from the Continent and less influenced by the conventions established in Italy at the start of the Renaissance. At the beginning of the 16th century, at the same time that gardens decorated with ancient statues or their copies began to be so popular in Italy, the gardens created for Henry VIII at Hampton Court, Richmond and Nonsuch were embellished with wooden statues of the heraldic symbols in the royal coats of arms. At Hampton Court a payment is recorded in the 1530's for two statues of dragons, two greyhounds, one lion, one horse and one antelope. Later statues of hinds and harts were added. These figures, painted in lively colors, were placed on tall poles; similar statues were placed in front of the tents erected for jousts or at the meeting between François I of France and Henry VIII called, for the luxury of the appointments brought by the monarchs, the Field of the Cloth of Gold. Drawings of these Tudor gardens, none of which have survived in their original state, show that the poles were placed at the corners of the low rectangular planting beds in which the gardens were divided. In one of them, the poles were connected by railings painted in the Tudor colors, green and white. Since the animals chosen for coats of arms and used in the gardens were symbols of virtues and the legitimacy of Tudor rule, the decorations were a form of propaganda celebrating the virtues and right to rule of Henry VIII. The function of these decorations was no different than those in the gardens of the Italian nobility; only the symbolic language was different.

With the reign of Queen Elizabeth, a more Italianate influence became dominant, and heraldic decorations fell out a favor. Although symbolic expressions honoring the queen were popular, they were usually expressed both in reality and in poetry by flowers. Yet one feature from the Continent, grottoes with automata, became popular, and several designed by the German Isaac de Caus were built at Wilton and other seats of the Elizabethan nobility. Statues did not play an important role in the gardens of the period, nor in most 17th-century gardens. An exception is Lord Burlington's villa at Chiswick. This was laid out in a very Italianate form, just as the pavilion was an evocation of Palladian design. In the gardens were many features which Burlington or his architect Inigo Jones must have admired in Italy. An exedra-shaped screen with niches for statues was originally planned, but not built, as the terminus for

*Temple of British Worthies. Stowe,
England.*

the main path, while the other radiating paths all finished with statues.

In the 18th century the great landscape garden revolution in England swept away the formal gardens of the preceding centuries, and sculpture gardens were replaced by parks dotted with pavilions, temples and grottoes in a classical style. Statues were still used, but rarely in the open landscape. Where one finds them, as in the grotto at Stourhead (see page 174), they are modern copies of Roman statue types. Stourhead's grotto held a figure of a sleeping nymph copied after the one in the Belvedere statue court, and a Neptune copied after Bernini's baroque transformation of the ancient type. So too, the statues at Rousham (see page 178) are copied after famous ancient pieces, such as the Hellenistic group of the Dying Gladiator.

The statues and temples scattered apparently at random in the informally designed parks evoked, whether consciously or not, the atmosphere of the gardens of ancient Rome. The nostalgia for a golden age seems to pervade the vistas of these gardens; an ideal of classical perfection inspired patron and artist alike.

Yet even these utopian landscapes were not totally divorced from the realities of present day life. At Stowe, where the early formal gardens were gradually replaced, starting in the 1730's, by informal plantings and naturalistic designs, and new areas given classical names such as the Elysian Fields or the Grecian Valley garden, structures and statues were used as an expression of political protest. A classical temple was named the Temple of Ancient Virtue, while a ruinous one was built and called the Temple of Modern Virtue. Across the stream from the temples — a stream called the Styx after the one Romans believed marked the entrance to the Underworld — was a structure called the Temple of British Worthies. Two curving walls flanked a central niche which held the bust of the Black Prince; the side niches had busts of notable Englishmen ranging from King Alfred to Francis Drake and from Inigo Jones to Sir Walter Raleigh. The whole was a protest against the policies of the Prime Minister, Sir Robert Walpole, and the monarch, King George II. In Hawkwell Field, the Gothic Temple and its attending statues of Saxon deities were evocations of England's noble past and a reminder that it was these invaders who had brought with them the principles of constitutional government.

Statue gardens and their symbolism disappeared at the end of the 18th century, replaced first by romantic gardens that evoked one's emotions and then by gardens in which plants were collected and treasured as statues had been in earlier centuries. Sculpture collecting continued, but it is not until the 20th century that museum gardens for the display of works of art came into fashion. Today, they are found in many countries, exhibiting collections of masterpieces, as in the garden of the Museum of Modern Art. Sometimes they feature the works of one artist, as is the case with Carl Milles' work in Stockholm or Henry Moore's in Much Hadham, England. In some ways, we have come full circle; sculpture gardens today must be much like those from the earliest times, simply outdoor settings for beautiful works of art.

Chapter One
OPEN-AIR COLLECTIONS

The Hand of God *by Carl Milles at Millesgården.*

STORM KING ART CENTER

The **Storm King Art Center** is the only garden of its kind in the United States. Its two hundred acres of dramatically rolling meadows and dense woods provide an environment for sculpture that no other site in America approaches.

Named after an imposing peak hard by the valley it occupies near Mountainville, New York, Storm King focuses on giant contemporary works. It has more of these than such gardens as Louisiana, in Denmark, or the Kröller-Müller, in Holland, its closest European counterparts.

Storm King's design has an especially American quality to it. While European gardens tend to feature closed spaces, the dominant background at Storm King is the open fields. As one leaves behind the hedges, patios and smaller sculptures surrounding the museum building, the land opens up into huge landscapes and broad undulating meadows.

Here the pieces have a freedom not afforded in urban settings or the more "civilized" gardens, and they respond with a new power, bright colors setting off the green of pines, polished surfaces reflecting the expanses of sky.

In one such open area, Tal Streeter's "Endless Column" zig-zags its way sixty-seven feet into the air, cutting into both sky and landscape. In the background, "The Arch," by Alexander Calder, rises in ominous black planes, suggesting great mass. Its slender neck protrudes over fifty feet in the air, dwarfing the trees in the background. This giant stabile is the last large-scale piece completed by Alexander Calder before his death in 1976. Nearby on another substantial field, the heavy and charged "Iliad" by Alexander Liberman broods in front of a group of pines. In the distance, powerful I-beam constructions by Mark Di Suvero seem ready to lumber across the landscape.

Pieces by other artists also reflect a world more tailored to giants than men. Robert Grosvenor's black 204 feet long "Untitled" in cor-ten steel plays counterpoint to an entire mountain ridge, bringing balance to the landscape by reversing its pastel curves with a single inverted span of dark brown. "Fayette, for Charles and Medgar Evers" is a black double-rhomboid twist by Charles Ginnever. Framing two spaces, larger and small, it recedes from the ridge on which it stands to the parallel line of the horizon. Japanese-American artist Isamu Noguchi's "Momo Taro" reigns near the house, on a slightly higher hill than Liberman's "Adam."

Storm King
Endless Column *by Tal Streeter —*
steel.
In the background: The Arch *by Alexander Calder — steel plate.*

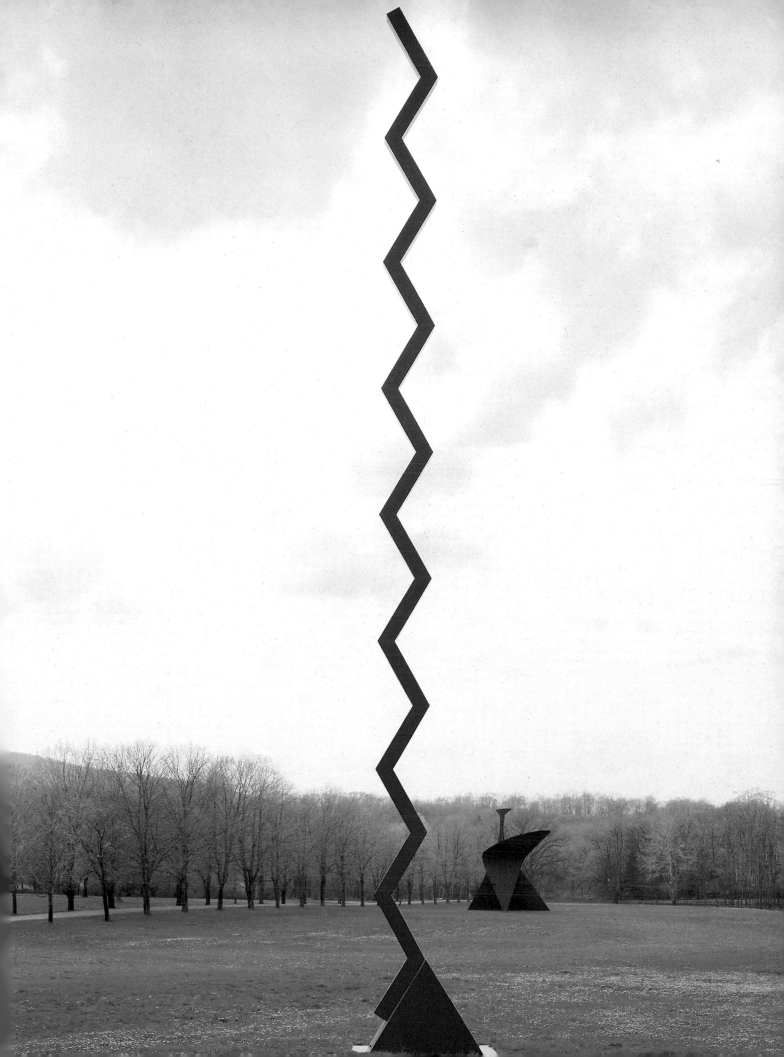

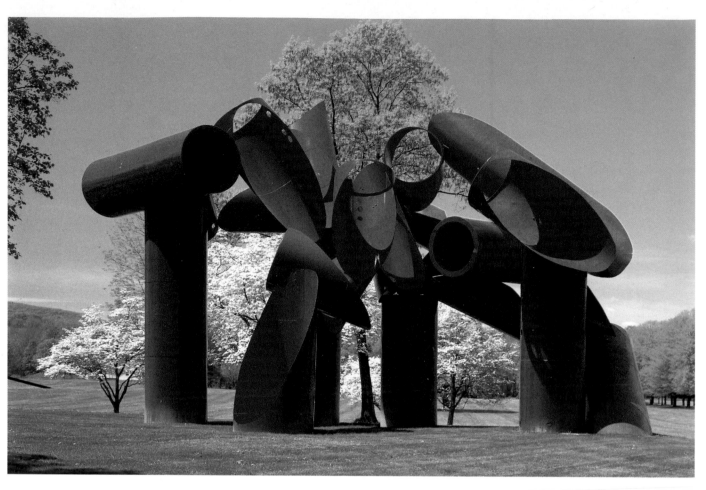

Storm King
Iliad *by Alexander Liberman —*
steel.

"Momo Taro" was commissioned in 1977 and carved in Japan. Its nine white granite components illustrate a Japanese folk tale. They rest on a specially shaped site like ruins of some ancient temple celebrating the creation of the Appalachian chain.

More modestly scaled pieces also play effectively with the scenery: Grace Knowlton's "Spheres" roll off a hill; Sol Lewitt's "Five Modular Units" mimic the conifers behind them; David Stoltz's "Day Game" of dark, linear steel squirms through the grass.

Other works by Di Suvero, George Rickey, Barbara Hepworth, Henry Moore and Grosvenor are displayed on grounds tailored by Greenwich, Connecticut, landscape architect Bill Rutherford. Rutherford is intimately involved with the site, having worked with the trustees and artists of Storm King for twenty-five years.

But the man who transformed what were once fields into one of the world's foremost sculpture gardens was originally a local boy. Ralph Ogden grew up in and around Mountainville, heir to a company called Star Expansion Industries. When his neighbor and friend Vermont Hatch died in 1958, Ogden and New York attorney Walter Orr saw that Hatch's land probably would be sold and sub-divided, spoiling its beauty forever. Ogden bought the estate and turned its Norman-style house into a "country museum," as he later described it, to serve as an adjunct to city collections. He set up an independent, non-profit corporation to run Storm King. Launching the museum's program with an exhibition of Winslow Homer paintings, the new corporation's board of trustees worked to create a respectable art collection with Fritz Wotruba's "Walking Man," their first big-name acquisition. The board of trustees developed the idea of using the whole estate to display new pieces. Washington art critic Benjamin Forgey recalls, "Ogden had seen the Kröller-Müller outdoor sculpture museum in Holland, and he

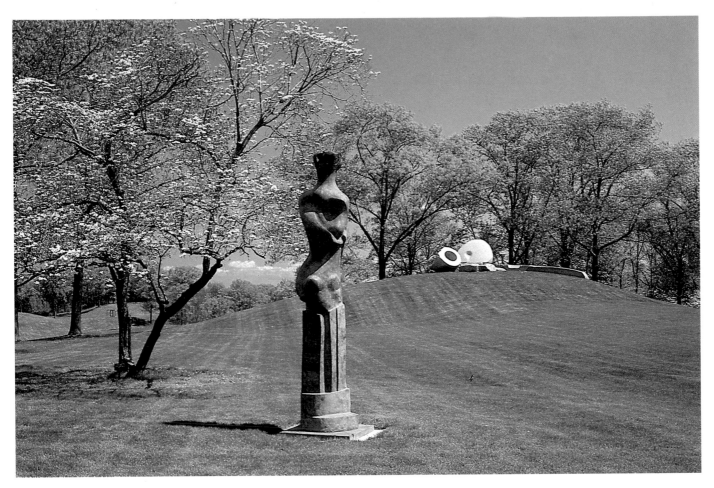

conceived of his new property along similar although more spacious lines."

A decisive event occurred in 1967, when Ogden travelled to David Smith's "sculpture farm" in Bolton Landing, New York, on Lake George. There, a procession of Smith's humanoid steel and iron pieces — "Voltrons" and "Tanktotems" — were displayed in an environment similar to Storm King's. "I'd been looking for something to sort of make the art center," Ogden later recalled, "and when I saw the effect of Bolton Landing, I thought then, a bit like a square businessman, this is an amazing opportunity."

Storm King acquired thirteen of Smith's sculptures, placing eight of these at the art center in a clearing next to the house. Their arrangement replicated the original display. The Smiths established Storm King's reputation. Works by popular, as well as lesser known artists joined the Smiths, many of them by-products of a growing demand for "public sculpture."

Under the guidance of the board of trustees, chaired by Ogden's friend and long-time business associate Peter Stern, Storm King has continued its progression from the country museum of 1960 to what is perhaps the most definitive collection of large contemporary sculptures in the United States.

Storm King
Figure *by Henry Moore — stone.*
In the background: Momo Taro *by Isamu Noguchi — granite.*

Following page: Storm King
A general view:
Foreground: Suspended *by Menashe Kadishman — steel.*
Above left: Four Poles and Light *by Gilbert Hawkins — aluminium.*
Beyond: Adam *by Alexander Liberman — steel.*
Background right: Four Corners *by Forest W. Myers — stainless steel, Cor-ten steel.*

25

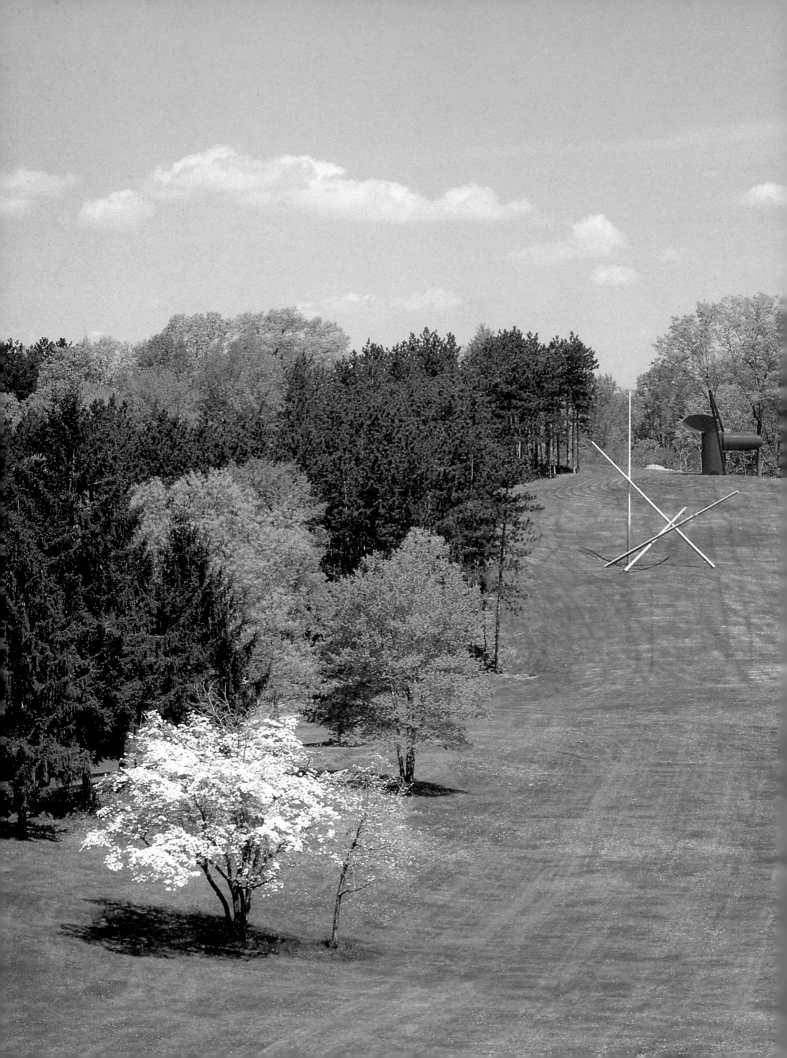

PEPSICO SCULPTURE GARDEN

The **PepsiCo Sculpture Gardens,** situated in the world headquarters of the PepsiCo Corporation, are an impressive example of how art can transform a business environment.

From the entrance PepsiCo looks all glass and steel, like any other modern office complex. But the flagpoles and geometric window bands conceal what is one of the largest corporate collections of sculpture in North America. At PepsiCo this means a broad selection of modern works, as well as striking architecture and landscaping.

At the entrance of the interconnected buildings, a flowered walk of European-style cobblestones leads to a lushly planted inner courtyard. This area is laid out on two levels, in the shape of a cross. The surrounding offices rise for three stories, cantilevered over each other to form a kind of reverse ziggurat. A fountain with a bronze dolphin, a nymph and myriad spouts, bubbles at the courtyard's entrance. The work of British sculptor David Wynne, this piece dominates the area. Around it are sunken gardens with different motifs. One is Japanese, another is designed "specifically as a background for sculpture." The sculpture in question consists of subtly placed bronzes by Henry Laurens, Jacques Lipchitz and Seymour Lipton, providing a foretaste of the things to come.

This is the "intimate" section of PepsiCo. On the other side of the complex lies a vast lawn. Monumental sculptures occupy the entire area like a fantastic army. A fountain is the centerpiece here as well: from a pond edged with weeping willows a water jet shoots 75 feet into the air. Other large works are stationed around the pond. Arnaldo Pomodoro's "Triad," the largest sculpture at PepsiCo, consists of a group of three 50-foot fissured columns, each of a different material. In addition to this complex piece, another Pomodoro, the kinetic "Big Disk," perches nearby. Next to the lake stands "Double Oval," a punched-hole abstraction by Henry Moore, one of the artist's larger works. On the garden's border, "Capricorn," Max Ernst's largest freestanding sculpture, combines abstract themes with a self-portrait that includes his wife, the painter Dorothea Tanning.

The earliest sculpture in PepsiCo's eclectic collection is represented by Auguste Rodin's life-size "Eve," originally commissioned for the "Gates of Hell" series by the Paris Museum of Decorative Arts in the last century. The banished "Eve," her head bowed and arms crossed,

PepsiCo
Triad by Arnaldo Pomodoro —
bronze and Cor-ten steel.

28

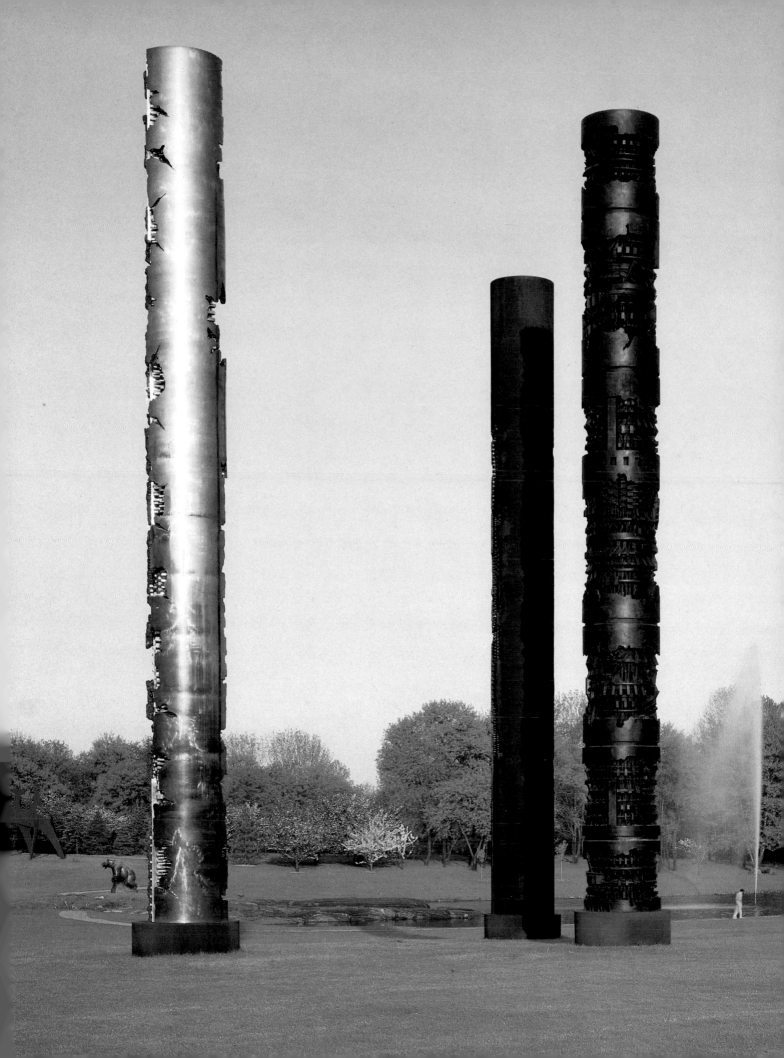

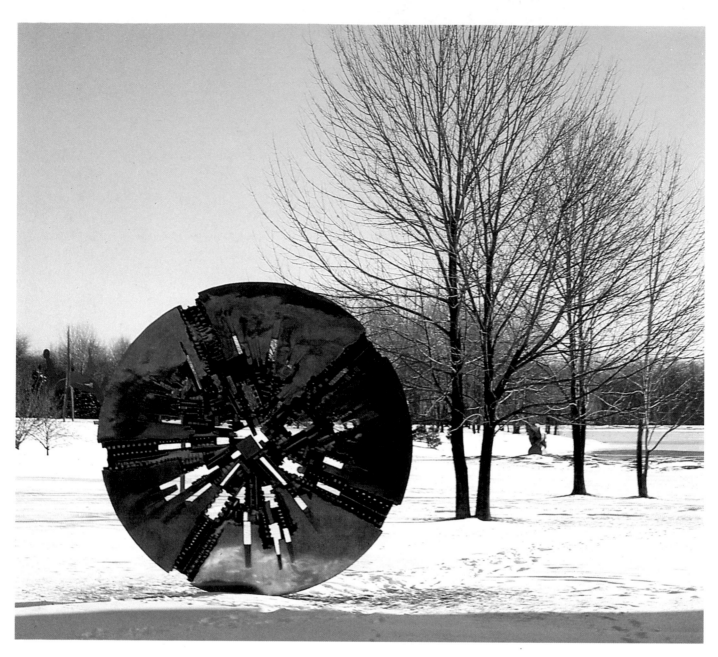

PepsiCo
Big Disk *by Arnaldo Pomodoro —
polished bronze.*

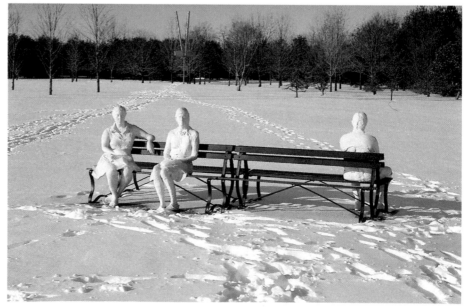

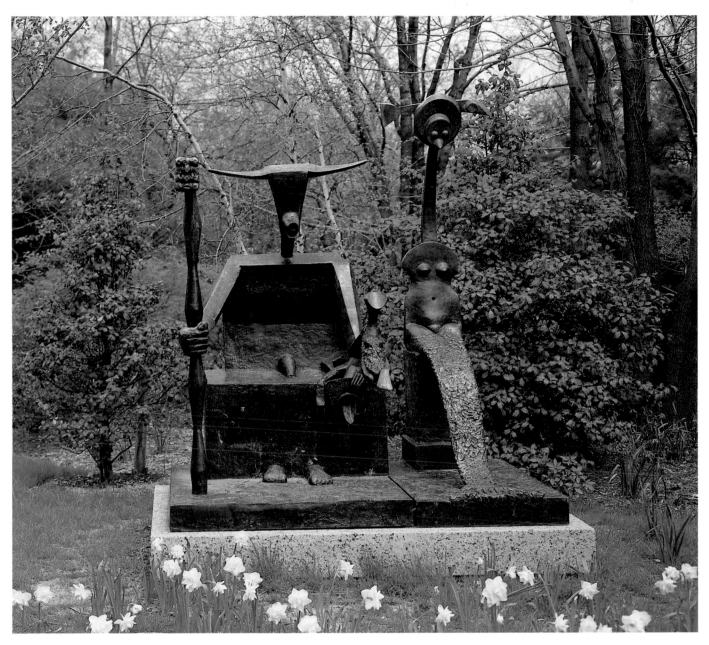

PepsiCo
Three People on Four Benches *by
George Segal — bronze with white
patina.*

PepsiCo
Capricorn *by Max Ernst — bronze.*

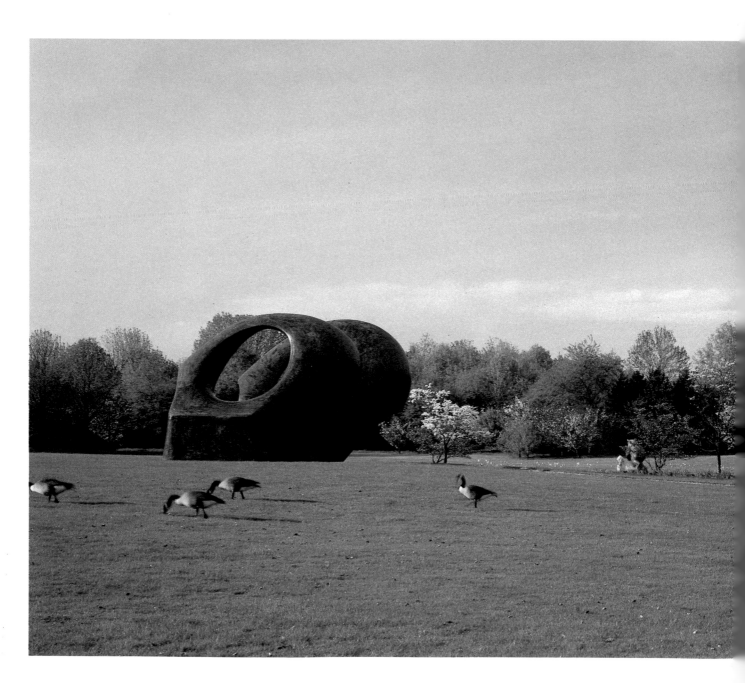

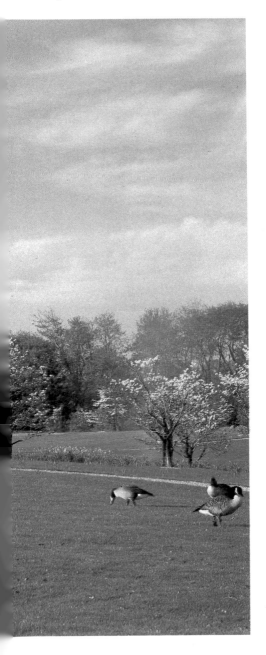

PepsiCo
A general view: Double Oval *by*
Henry Moore — bronze.

presents a stronger contrast to the garden's green background than many of the abstract pieces. Also on the lawn is "Hats Off," a flaming red Calder stabile, as well as works by Izamu Noguchi, Louise Nevelson and others. The latest acquisition at PepsiCo is George Segal's "Three People on Four Benches," chalk white figures that epitomize the feeling of lounging in a park.

It was in 1970 that PepsiCo Corporation made the move from city to suburbs, building on 122 acres of the former Blind Brook Polo Club. The spot was chosen by Donald Kendall, PepsiCo's chairman of the board and chief executive officer. A visionary executive who masterminded Pepsi-Cola's merger with Frito-Lay as well as subsequent acquisitions, Kendall was responsible for the merging of art and business on these grounds.

According to collection cataloguer Donna Stein, Kendall envisioned "an environment that would integrate three art forms — architecture, landscape architecture and modern sculpture."

Kendall commissioned the architect Edward Durell Stone to design the building, and his son E.D. Stone, Jr. to landscape the sculpture grounds. He began selecting sculpture as well. "Why leave it up to some committee to chose art when it's a fun thing to do yourself?" he once told an interviewer. For Kendall, sculptures "have a very personal and exciting meaning ...a range from stability to adventure, the things I believe in." As the collection has grown to include over 30 pieces, Kendall has become increasingly interested in showing it to the public.

"It was the wealthy who supported the arts in the past, but only few could enjoy it," he commented recently. "We buy with a broader base of people in mind." PepsiCo currently attracts about 10,000 visitors annually. Kendall would like more.

In 1981, Kendall engaged the renowned British garden designer Russell Page to review and improve the plantings in the gardens. So far, Page has introduced hundreds of plantings and "plant groves," as Kendall calls them, to complement the sculptures and add richness to the landscape. He has developed a "sculpture walk" of gravel that winds through the garden, and put in an elaborate system of waterworks, with water-lilies and goldfish, and backed by a colorful bank of flowers. "I'm enjoying it very much," Page, now in his seventies, said recently. "I use the trees as sculptures and the sculptures as flowers, and then I take it from there. It's a cross-current kind of thing."

BROOKGREEN GARDENS

The most famous sculptures in the United States are not the Calders, Moores, Noguchis and other modernist works which have sprung up recently in public places across the country. Rather, they are figurative monuments that link the viewer more directly to his social subconscious — even if, as is often the case, their historical significance overshadows their real artistic merit.

These monuments include Gusp Borglum's giant presidential portraits at Mt. Rushmore, Daniel Chester French's paternal Lincoln at the memorial in Washington and Paul Manship's gilded art-déco Prometheus above the skating rink at New York's Rockefeller Center.

Brookgreen Gardens, located in South Carolina, is devoted exclusively to this figurative genre. Its lush grounds, including a large wildlife sanctuary, hold examples of figurative sculpture from the late 19th and early 20th centuries, with a strong emphasis on the Beaux-Arts to Art-Déco period. Most of the major artists of that time are represented, from French to Manship to A. Sterling, Calder and Frederick Remington.

There are also works by less familiar sculptors such as James Earle Fraser, creator of the Indian head on the U.S. five-cent piece, and Adolph Alexander Weinman, who made the ornaments for New York's old Pennsylvania Station.

The old plantation grounds are alive with magnolia and dogwood, flowerbeds and lily ponds; an energetic collection of art populates this environment. Men and children, animals and creatures of myth conspire under the ancient oaks and Spanish moss to create an air of timeless unreality that suits the antebellum surroundings.

At the center of a circular pool, a lithe Diana by Anna Hyatt Huntington is typical of many of Brookgreen's works. The sculpture shows the goddess caught in mid-motion, flanked by one of her hunting dogs. A pair of bronze panthers by Wheeler Williams slinks with green lacquered eyes through a splay of palmetto fronds behind the hunting goddess. An oak-lined promenade leads to the garden's center, with its crisscrossing walkways and formal ponds. To the right in the dogwood garden, a pair of romanticized "Riders of the Dawn" by Weinman jump muscular steeds over a stylized sun. The theme of man-with-animal is a recurring one: examples include Nathaniel Choate's symmetrical "Alligator Bender" and Beatrice Fenton's "Seaweed Fountain," in which a child gambols on top of a swimming sea turtle.

Elsewhere, a Pegasus soars heavenward, Icarus crashes to earth with melted wings and assorted creatures — sharks, gazelles, hawks — pose with or without humans. These and 400-odd similar works have the overall effect of turning Brookgreen into the kind of fantasy land intended by its founders, Archer and Anna Huntington, who together

Brookgreen
Diana of the Chase *by Anna Hyatt Huntington — bronze.*

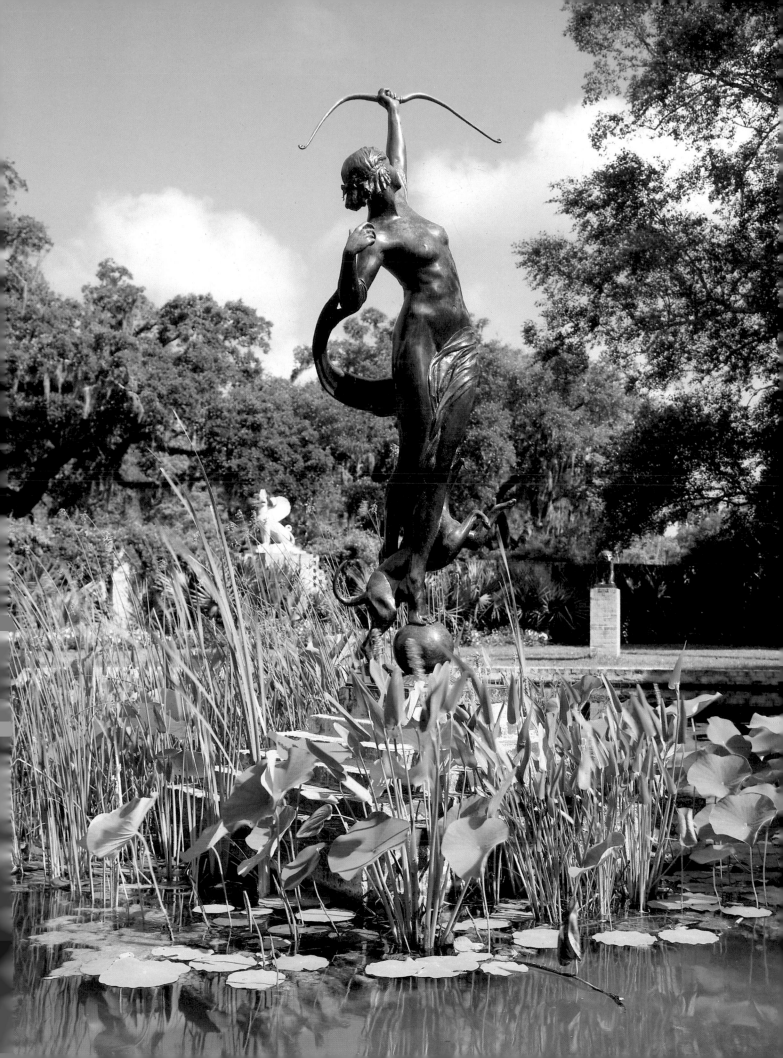

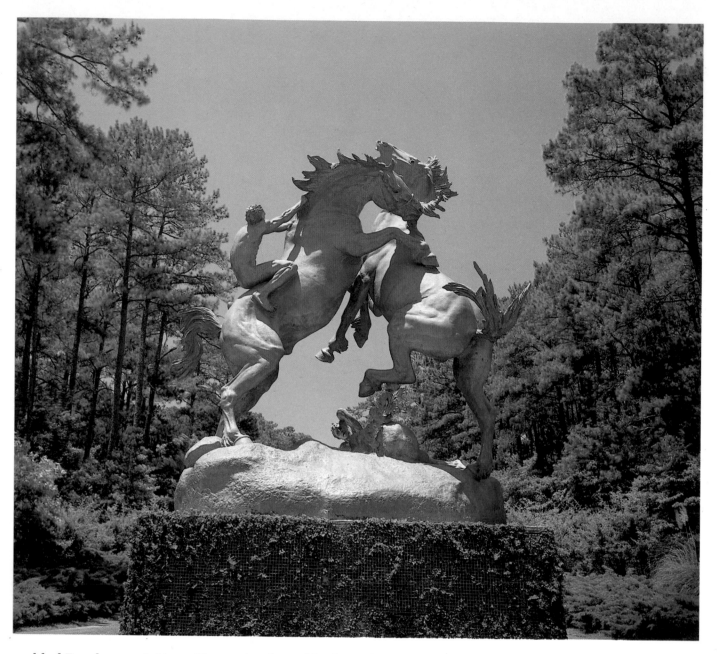

Brookgreen
Fighting Stallions *by Anna Hyatt*
Huntington — cast in aluminium.

molded Brookgreen into a self-contained world where the naturalistic art they both loved could be displayed in appropriate settings.

It was Anna who originated the idea of developing a garden, around the former site of the plantation house, to serve as an outdoor exhibition space for her own work and that of her contemporaries, many of whom were unemployed because of the Depression and in need of commissions and sales. Anna's fondness for high-spirited subjects still permeates the gardens. Her own works are a case in point: "Youth Taming the Wild," her first work for Brookgreen, is a study of opposing forces; "Fighting Stallions" stands at Brookgreen's entrance, challenging the horizon with its energy.

From the 1930's through the mid-1950's, when Archer died, Brookgreen served as the Huntington's winter retreat.

The garden grounds were originally part of a plantation, the center of one of four properties obtained by king's grant in the 1730's and first operated as indigo plantations. Inhabitants of these plantations include Washington Allston, a well-known early 19th-century landscapist, and the daughter of Whig politician Aaron Burr, who married Joseph Allston, later governor of South Carolina.

Brookgreen
The Thinker *by Henry Clews Jr. —*
aluminium statue on bronze base.

In a gesture toward the property's past, Anna and Archer Huntington kept the basic T-shaped orientation of the original grounds. They converted them according to Anna's plan into a system of pathways in the shape of a giant butterfly. The butterfly's "tail" was the live oak promenade, its "torso" a reflecting pool conforming to the rectangular foundations of the former plantation house. Its "wings" were Anna's free-form pathways. The old kitchen building was retained and six millstones were placed along the pathways. A serpentine, open-brick-work wall surrounded the area, creating niches for sculptures in the process. A gallery of small sculptures was built and additional pools and gardens added.

The old plantation grew to include a wildlife park with an alligator swamp, otter pond, an enormous net aviary supported by ninety-foot masts where visitors, strolling along a boardwalk through cypresses, can observe ducks, ibis, egrets, and herons. Today, together with its 400-plus sculptures, the garden boasts some 2000 species of plants. Their colors and fragrance reinforce the atmosphere of natural fantasy which is the hallmark of Brookgreen.

CALIFORNIA SCENARIO

With his **California Scenario,** the sculptor Isamu Noguchi has created a "total sculpture experience." Believing that art should not be placed in disconnected settings, Noguchi creates environments that draw the viewer in, making him a participant rather than a spectator. Fundamental to the sculptor's work is stone: for him the whole world is made of stone. "It is nothing new," he says, "it is as old as the hills. It's our fundament... Stone has the quality of durability. It does not pollute, it merely goes back to the earth naturally."

As the centerpiece of the South Coast Plaza Town Center, an office and retail center in Costa Mesa, California, the Scenario occupies an unlikely place for such ambitious work. Contrary to most sculptures placed in urban centers, it is not a marginal decoration, but a self-contained and intricately realized work of art which may be entered and explored.

Bordered by the reflective glass grids of two office towers and the white concrete wall of a parking structure, the garden is an ensemble of sculptural and natural elements built around specific elements which constitute California's environment. Like a Japanese rock garden whose individual rocks and planting work as metaphors for an entire landscape, the Scenario's various shapes and organic arrangements evoke different aspects of California's geography and terrain.

"The Desert Land," a circular mound planted with cactuses, agaves, aloes and other desert flora, suggests California's desert terrain. In the background "The Forest Walk" outlines a horseshoe-shaped path of Sierra white granite rising more than six feet from the sandstone field of the garden where wild flowers and native grass grow. A twenty-six foot triangle, "Water Use," gives off a cascade of water which winds through the plaza in a rock-strewn shaped waterway. The stream vanishes under a giant pyramid, a graphic allusion to California's reliance on irrigation. Other components have similar specific significance. "Land Use" is a simple form of Sierra white granite elevated on an eight-foot high knoll of honeysuckle-covered earth, alluding to California's tradition of thriving land development. "Energy Fountain," a stainless steel pipe spouting water over a cone of broken-face Rockville granite, captures the vitality of the society and the dynamism Noguchi relates to his native state. A thirty-foot tall triangular form of

California Scenario
The Spirit of the Lima Bean *by Isamu Noguchi — granite.*

California Scenario
Water Source *by Isamu Noguchi —*
sandstone.

sandstone, "Water Source," symbolizes a majestic mountain with cascading waterfalls; this element creates joyous sounds of life-giving, flowing water.

In addition to the six components, Noguchi sculpted a unique work for the garden. "The Spirit of the Lima Bean" gets its name from the fields on which the South Coast Plaza complex is situated. Henry Segerstrom, who commissioned "California Scenario," first approached Noguchi to create the garden and worked with the artist throughout its design and development, had originally produced lima beans with his family on the property before converting it to commercial use in the 1960's. The composition was originally named "Source of Origin," but Noguchi retitled it to fit the thematic emphasis of the garden, and to

honor his friend Segerstrom's half-century of agricultural land use. Fifteen bronze-colored, decomposed granite rocks were found and precisely cut and fitted in Takamatsu, Japan; then they were reassembled by Noguchi and two master stone cutters on the site. The piece was first to be placed in the garden, creating a theme of appreciation for the state's geography that the other components would follow. Together, they embody Noguchi's statement of 1949 that "the function of sculpture... is more than merely the decoration of architecture or the treasure of museums." This widely and extremely productive sculptor has again proved his point in numerous subsequent projects — Chase Manhattan Plaza in New York, the UNESCO gardens in Paris, and the Beinecke Library program at Yale, among others.

California Scenario
Energy Fountain *by Isamu Noguchi*
— granite, stainless steel.

BILLY ROSE ART GARDEN

Seen from afar, the four crescent walls of native Jerusalem stone which support the terraces of the **Billy Rose Art Garden** seem to rise as natural features of the land itself. The bulging arcs of the garden, built into the complex of the Israel Museum, combine architecture with landscape to form an environment for sculpture that is a sculpture in itself. "Even without the pieces," Rose once said, "the garden would be interesting."

The harsh sunlight, sparse greenery and design of the garden give a stark yet effective backdrop to the predominantly late 19th-century and early 20th-century pieces on display. Beyond the curved rock walls of the entrance, Maillol's "Chained Liberty," Henry Moore's "Vertebrae," and Menashe Kadishman's yellow "Suspense" characterize the garden's pleasing severity against a rolling blanket of white gravel. A wedge-shaped mound rises behind the statues. Topped by Isamu Noguchi's "Water Source Sculpture," this is the highest of the terraces, affording a view of the hills to the west as well as the rest of the garden. In addition to the terraces, the garden contains an area of "cells" for sculpture and two enclosed pavilions for indoor works. Skirting the terrace borders, or installed against the curved rock walls, are Lipchitz's "Mother and Child," Rodin's "Adam," and other masterworks by artists such as Alexander Archipenko, Émile-Antoine Bourdelle, Anthony Caro, Lynn Chadwick, Marino Marini, Elie Nadelman, Picasso, Germaine Richier, David Smith, Jean Tinguely, Victor Vasarely. In addition a large section of one terrace has been set aside for works by Israeli sculptors. Like the occasional olive, cypress or pine around them, these works are entirely exposed, appearing naked in contrast to those situated in the lush gardens of northern Europe or the eastern United States.

The Israel Museum also has a collection of original plasters donated by the British sculptor Jacob Epstein, and 140 bronze sketches by Lipchitz. These, together with works by Marisol, Arp, Nevelson, Giacometti, Marcel Duchamp are housed in the pavilions. The Israeli artist Yaacov Agam has devised an "Op" outdoor piece for the Museum's entrance and Robert Indiana's well known "Love" sculpture became the Hebrew "Ahava," a gift to the people of Israel from an American couple.

This mixture of Western and Eastern influences reflects not only the historical importance of the Holy Land as a cultural cross-roads, but the heritage of Japanese-American Isamu Noguchi, designer of the garden. Noguchi achieved worldwide recognition through his blendings of organic oriental forms with abstract western geometry, and the balance of cultures at the Billy Rose Sculpture Garden reflects this sensitivity.

Billy Rose Art Garden
Upright Motif No. 7 *by Henry Moore — bronze.*

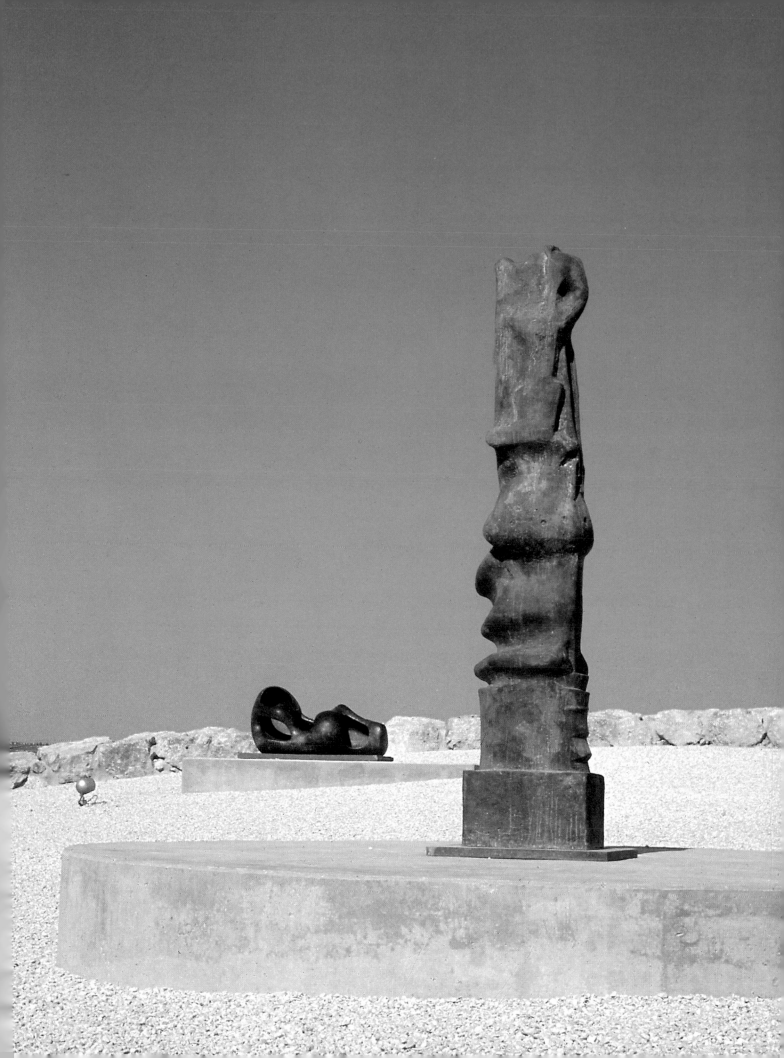

The garden's unlikely sounding name comes from its founder, a dynamo of New York's theater world and author of such classic melodies as "Me and My Shadow" and "Paper Moon." He ran the Ziegfeld theater for a period, and introduced some of Broadway's most celebrated productions, including "Who's Afraid of Virginia Woolf?"

In later years, Rose's energies became increasingly devoted to Jewish causes. At the same time Rose began building a private art collection which, by 1960, was of museum quality. At this time Nahum Goldmann, head of the Jewish Agency in New York, suggested he donate it to the National Museum in Jerusalem.

Rose accepted. He not only donated his collection of over one hundred pieces, but plunged into fund-raising and planning for the exhibition of his donations. Completion of the garden was to take nearly five years. In 1965, the first shipment of sculptures arrived from Manhattan, only days before the garden's dedication. Unfazed by the delay, Rose personally supervised the unpacking and installation of the pieces.

Rose died two years later, in 1967. Further donations of work followed and the garden continued to grow. Today its terraces of Jerusalem stone are a major part of Israel Museum's attraction.

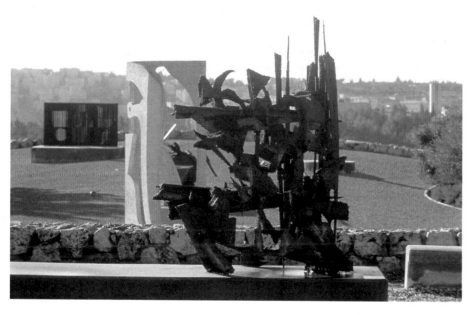

Billy Rose Art Garden
Foreground: Sculpture by David
Palombo — iron.
Center: Profile by Pablo Picasso —
cast concrete.
Background: Screen by Victor
Vasarely — painted iron.

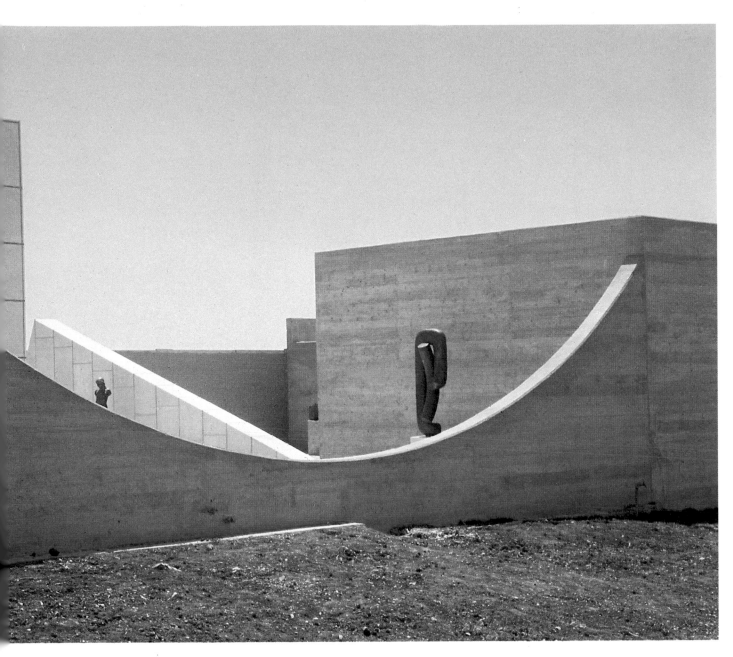

Billy Rose Art Garden
Wall Khmer *by Isamu Noguchi —*
bronze.

THE HAKONE OPEN-AIR MUSEUM

THE UTSUKUSHI-GA-HARA OPEN-AIR MUSEUM

Japan's most renowned sculpture garden, **The Hakone Open-Air Museum,** exemplifies the blending of East and West in that country today.

Its predominantly Western collection includes Jean Arp, Constantin Brancusi, Jean Dubuffet, Aristide Maillol and others, and is set in thoroughly Japanese landscape in the foothills of Mount Fujiyama. Works by young Japanese sculptors at the Hakone echo the expressive bronze figures and kinetic art pieces made by Americans and Europeans. Its five acres use design principles considered fairly standard in the West. Nevertheless, echoes of a traditional Japanese garden remain in the elegant footpaths, carp-filled pools, and a traditional public teahouse with curved roof, bamboo fencing and parasols.

Equally Oriental is the respect for the natural environment. Museum president Nobutaka Shikanai writes that the Hakone sculptures "both splendidly harmonize with the beauty of nature and contend against its roughness." The nearly 300 pieces on display do not shrink against the vast space of the surrounding landscape, nor do they rob it of significance by focusing all attention on themselves.

About two hours outside Tokyo by train, the museum lies in the center of the Hakone region, one of Japan's most popular tourist resorts. Hakone has always been famous for its hot springs and its fresh air. Since it opened in 1969, the museum has joined the list of the area's chief attractions. As many as 1,000,000 people visit the museum annually.

The vistas at Hakone are wide and Carl Milles' "Man and Pegasus," standing thirty-odd feet high on one of the artist's characteristic pedestals at the museum's entrance, seems specifically made to soar against its mountain background. The same imposing peaks spread behind four oversize bronze allegorical figures: "Power," "Victory," "Liberty," "Eloquence," by Émile-Antoine Bourdelle, that stand along the edge of a spacious stone terrace. Bourdelle is well known in Japan, having had numerous exhibitions there in the 1920's. His influence on westward-looking Japanese sculptors has been considerable.

To the right of these lie Moore's "Reclining Figure: Arched Leg" and the dual fins of a pierced Barbara Hepworth sculpture. The glittering steel pipes of a giant motorized letter "Z" send erratic reflections through

Hakone Open-Air Museum
Wind's Impression *by Masayuki Nagare — white granite.*
Background right: Sixteen Turning Sticks *by Takamichi Ito — stainless steel, iron, motor, paint.*
Background left: Man and Pegasus *by Carl Milles — bronze.*

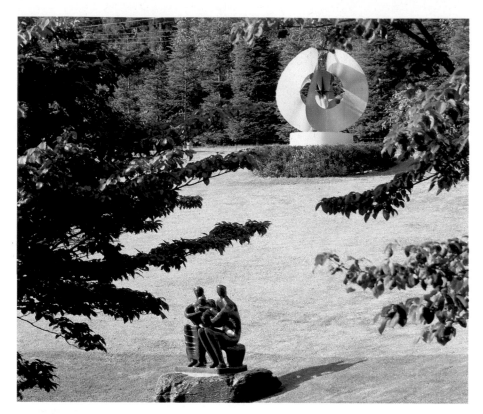

Hakone Open-Air Museum
Foreground: Family Group *by Henry Moore — bronze.*
Background: Spheric Theme *by Naum Gabo — stainless steel.*

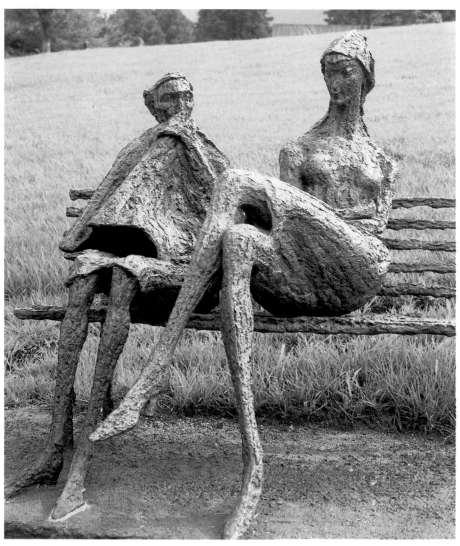

Hakone Open-Air Museum
Park in Rome *by Toshio Yodoi — bronze.*

48

tranquil surroundings beyond. Entitled "Sixteen Turning Sticks," this popular piece by Takamichi Ito occupies a good vantage point for observing other areas of the museum.

Below the terrace with the Bourdelles is a children's play area with a giant jungle gym, in primary colors, reminiscent of Sol Lewitt's grids. Visible on a distant slope, a 10-by-30-foot mosaic of a cow is the work of 5,000 schoolchildren, who collaborated to produce it in 1972. On the far side of the Ito an elevated walkway leads to the "Greco Garden," where a wide lawn features a crowd of sensuous female figures by the Italian sculptor Emilio Greco. Footpaths snake through a thicket of trees, across lawns and clearings, from statue to statue.

The variety is impressive. Hakone groups works by well known abstract sculptors like George Rickey, Max Bill and Isamu Noguchi, as well as those of Japanese figurativists, less well known in the West, such as Sogan Saito, Taimu Tatehata, and Ryoji Goto. Conceptual carvings sit alongside the figurative pieces. Motorized "kinetic" works swing or pump. Some sculptures burrow into the earth: poured concrete retaining walls trap mosaics and wall pieces. In addition there is a star-shaped maze and French artist Gabriel Loire's "Symphonic Sculpture," a cylindrical, stained-glass tower, over forty-feet tall, with a spiral staircase and rooftop observation deck. Three interior exhibition halls hold more sculpture, including such masterworks as Brancusi's "The Kiss."

Hakone's scope and variety are even more impressive considering its youth. A by product of the Japanese "miracle" of the 1960's, the museum grew and attained fame through the efforts of its founder Nobutaka Shikanai. President of both the museum and the Fuji-Sankei Group, Japan's largest communications conglomerate, Shikanai makes all selections for the permanent collection, oversees sculpture installations, organizes loan exhibitions and administers program policies.

Shikanai, who was born in 1911, became involved in cultural matters while working his way to the top of Japan's broadcasting and printing industries. Convinced of the need to "promote contemporary sculpture as an environmental art and thus introduce a vital new force into the art and culture of Japan," he spearheaded a drive to create the kind of garden then springing up in the West. Hakone was the result. Shikanai started the project by asking Japanese sculptor Bukichi Inoue to design a complex of buildings, terraces, plazas and pathways, which were then built under Shikanai's close supervision. Shikanai has overseen each development since.

On the occasion of the museum's tenth anniversary in 1979, the industrialist set up two international sculpture competitions, one abstract and one figurative. The competitions were named, respectively, for Henry Moore and Kotaro Tokamura, a pioneer of modern figurative sculpture in Japan and disciple of Rodin.

The Hakone location proved that tourism and culture could mutually benefit each other, and partly as a response to its success Shikanai and Fuji-Sankei accepted a request by Goro Yoshimura, governor of far-off Nagano Prefecture, to launch a sister museum to coincide with the opening of the "Venus" motorway. Set in an alpine landscape in the center of Japan's northern Honshu Island, the **Utsukushi-Ga-Hara Open-Air Museum** is surrounded by jagged snow-capped mountains, proving the ability of contemporary sculpture to assert itself in dramatic spaces.

In fact the lack of trees, the steep slopes give a sense of liberty to such pieces as Bernhard Luginbuhl's abstract "Gun for sparrow (Osaka Punch)," a three-legged orange steel construction installed along the edge of a ravine. Another abstraction, Group Kitano's "In Quest of

Utsukushi-Ga-Hara Open-Air
Museum
Bouquet *by Shin Hongo — bronze.*

Phase Space by Iron and Wire" is a bridge, built of two girders, that visitors can cross. The spare landscape holds many figurative works, mostly by Japanese artists: Yuki Shintani's six-columned monument "Amore," for example, outlines dancing figures against the horizon. The complex itself is composed of three buildings: a low-lying children's museum, an Edwardian-looking restaurant structure, and a crenellated brown "Castle of Venus." The latter is actually a museum of sculptural reproductions of the Venus de Milo, Apollo Belvedere, Bernini's "David" and other European masterpieces previously inaccessible in northern Japan.

Utsukushi's collection, some of it acquired through the Hakone's biennial series of international exhibitions, combines with its awe-inspiring environment to create a garden as powerful as its southern counterpart. Governor Yoshimura looked forward to this success when he wrote at its opening in 1981, "...We sincerely hope that the assembled works of sculpture will blend seamlessly with the natural splendors we are so proud of, and that the works will be loved by many people visiting here and will long continue to give them inspiration and enjoyment."

Utsukushi-Ga-Hara Open-Air Museum
Soaring *by Kentaro Kimura — white granite.*

FATTORIA DI CELLE

Situated in Pistoia, Tuscany, the **Fattoria di Celle** is a unique experiment in the possibilities of sculpture gardens.

Since 1982, Celle's management has invited artists to explore its terrain, in order to conceive pieces that would mesh with Celle's environment. With few exceptions, every work in Celle was created specifically for its particular location, producing a dialogue between landscape and art seldom attempted, in Italy or elsewhere.

Fattoria di Celle is the brainchild of Giuliano Gori, an industrialist from nearby Prato. Gori began collecting art as a young man, and built up a solid collection of contemporary paintings and sculptures.

An international art and museum conference held in Prato in 1976 reinforced Gori's desire to create a site in Italy available for specially commissioned work, along the lines of "Art-Park" in the United States or "Documenta," the recurring art exhibition at Kassel, West Germany. Manfred Schneckenburger, Documenta's 1977 organizer also urged Gori to remedy the situation.

The natural setting of the Prato area seemed ideal for such a purpose. Twenty artists were invited to build projects there and fifteen accepted. Their work was completed by June 1982.

Robert Morris's "Labyrinth" is typical of the scope and ambition of Celle's works. This triangular piece is stark and minimal. It can be entered and followed to its center. Like medieval churches in Tuscany, it is surfaced with green and white marble striping.

Live oak branches and bright light mingle overhead. A pathway leads directly from "Labyrinth" to an open field sprouting curved metal strips and steel contraptions, the largest of which is an elegant hollow globe symbolizing an astrolabe. This is Alice Aycock's "Nets of Solomon," a tribute to pre-Renaissance scientific inventions. Aycock's gentle metallic arcs offer a contrast in shape to the slope of the field on which they sit. Dennis Oppenheim's "Construction of the Mind" is next in the progression. This sculpture resembles a large metallic spider-web set among the trees.

Past an elegant Victorian tea-house, there is a thicket of laurels. Behind the trees lurks a concrete slab by the Milanese sculptor Mauro Staccioli. His hulking triangular form, standing eight meters tall, appears ready to lunge forward to block the pathway. It is described by Amnon Barzel in the guide to Celle as an "intervention of the 'rational' into the 'natural'."

The walkway leads uphill to a cultivated area split by Dani Karavan's "Linea 1.2.3.," a "line" made of white concrete. The line scars a steep slope from wood to field, then turns through a bamboo grove, and into the murky waters of a pond.

Fattoria di Celle
Linea 1. 2. 3. *by Dani Karavan —*
white concrete.

Fattoria di Celle
Nets of Solomon *by Alice Aycock*
— *steel.*

Fattoria di Celle
La Mort d'Éphialtes *by Anne and*
Patrick Poirier — marble and bronze.

Fattoria di Celle
Theme II and Variations *by Fausto*
Melotti — stainless steel and copper.

56

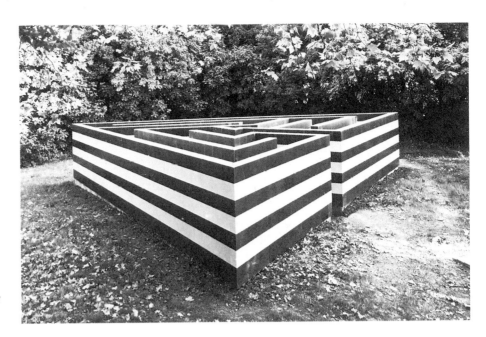

Fattoria di Celle
Labyrinth *by Robert Morris — green and white marble.*

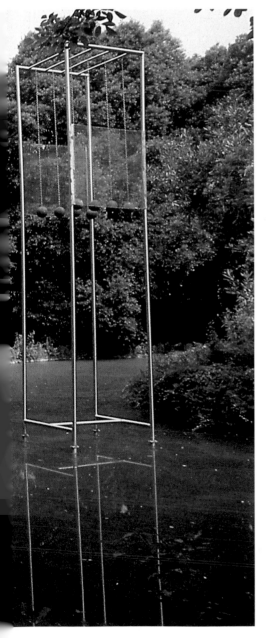

Uphill from the Karavan is a Tuscan version of Stonehenge by the United States sculptor Richard Serra. Eight rough stone blocks stand in a sloping field and redefine their site (in the sculptor's words) by revealing the "logic" of the grade.

A recreation of an Italian farmhouse stands at the top of the hill, setting off the Serra in striking fashion. The house was designed by the 19th-century landscape artist Giovanni Gambini who gave the original estate its final form in 1845. The pathway then returns to the same pond Karavan's "line" dips into. The visitor catches a glimpse of an overgrown island holding another of Gambini's English-inspired follies. This is a copy of a Greek temple-pavilion, barely visible behind the foliage.

At the base of a nearby waterfall is Anne and Patrick Poirier's "La Mort d'Éphialtes," showing the defeat of this character from Greek mythology at the hands of the gods Zeus and Apollo. The story is rendered by a group of colossal fragments sculpted in marble — an eyebrow and eye segment, a bit of chiseled hair, some unidentified anatomical or drapery outlines — as if a 40-foot statue had been blown to bits. The violence is intensified by a bronze arrow sitting dead center in the eye; zig-zag lightning bolts pierce nearby rocks. This depiction is particularly relevant to the area, given the Italian Renaissance's obsession with classical themes.

In a neighboring gully, the U.S. artist George Trakas has constructed a series of steps, pathways and ramps which conform to the natural shape of the land. Similar in feeling is Fausto Melotti's "Theme II and Variations," a composition that evokes wind-chimes and swings. The steel and copper sculpture is erected over another pond. This is the only large-scale work not commissioned specifically for Celle.

A tour of Celle ends on a lawn dotted with more conventional contemporary sculpture: a horse and rider by Marino Marini, a stone abstraction by Giò Pomodoro, and a handful of other pieces.

Finally there is the magnificent villa itself. Villa Celle was built by Cardinal Fabrone, a 17th-century diplomat and religious leader. It has sixty rooms, a chapel, and a view of Vinci, hometown of one of the Renaissance's most original thinkers. All the rooms eventually are to be filled with works of art, and more sites will be chosen for outdoor sculptures within the 68 acres of hunting preserve, vineyards, and olive groves surrounding the building.

THE GARDEN OF THE GODS

STRAVINSKY FOUNTAIN

Niki de Saint Phalle's "bosomy, broad-bottomed giantesses" first appeared in Paris and New York galleries in the 1960's. These "goddesses sprung full-grown from the depths of psychoanalysis," as critic Pierre Descargues described them, have consistently intrigued and entertained the public. Stretching and pirouetting, Saint Phalle's candy-colored "Nanas" fuse pop brashness with children's art to achieve an effect of playful surrealism.

Over the years, "Nanas" and other flamboyant creatures have earned the French-American sculptor a fair amount of notoriety. In 1966, for example, Saint Phalle exhibited the enormous reclining "She," a collaboration with Jean Tinguely, in the galleries of Stockholm's Moderna Museet. Its accessible womb, as well as other interior mechanisms such as a bottle-destroying machine, scandalized the public.

In 1980, the artist began her own sculpture garden, **Garden of the Gods,** in the Tuscan countryside, with the idea of fulfilling an old dream to create a 20th-century "Sacro Bosco." Visits to Bomarzo itself as well as to Antonio Gaudi's mosaic-lined park in Barcelona and the Chaval folk garden in southern France influenced the sculptor's choice of theme, which centers around the 22 characters of the Tarot. Each of these — from Fool to Empress, High Priestess to Magician — will be presented in the completed garden. Sprayed with color and decorated with ceramics and wildflowers, trees and shrubbery, the characters will form a giant half-moon representing life's journey, beginning with the Fool and ending with the Magician. The garden will thus spirit the visitor through a myriad of human characterizations, evoking, in Saint Phalle's words, a "mystical and philosophical feeling."

Although perhaps not technically a "garden," another outdoor collection of Saint Phalle's has already been completed at the Beaubourg (Centre d'Art et de Culture Georges Pompidou) in Paris. Flanked, on one side, by the museum and its radically exposed architecture, by the 13th-century Sainte-Marie church on the other, the **Stravinsky Fountain** opened in March of 1983.

Another Tinguely collaboration, this hectic square of water is populated by an array of spidery machinery interspersed with Saint Phalle's colorful creatures. The fountain honors influential Russian-born com-

Garden of the Gods
Unfinished Tarot figure *by Niki de Saint Phalle.*

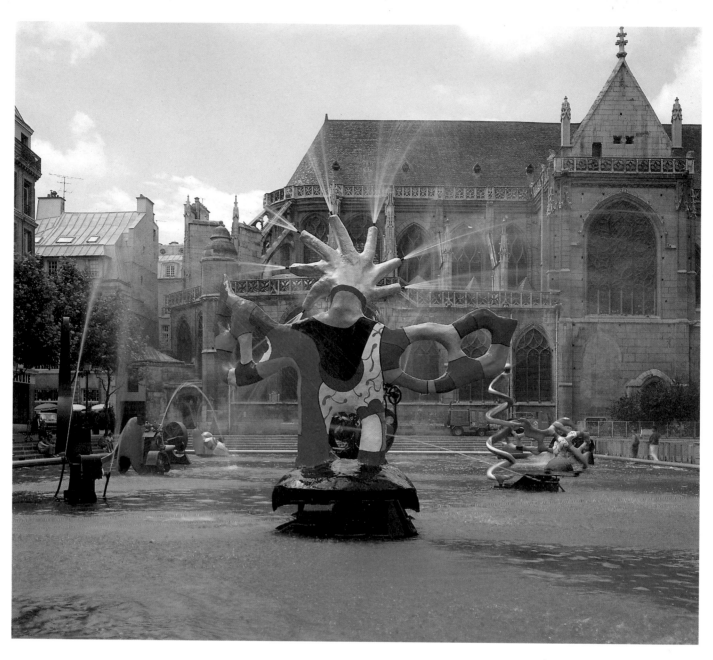

Stravinsky Fountain
Sculptures by Niki de Saint Phalle and
Jean Tinguely.

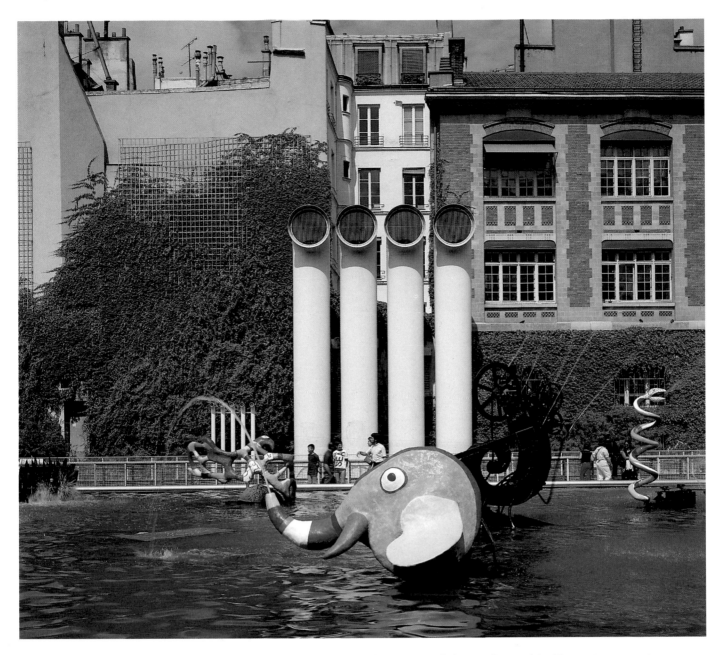

Stravinsky Fountain
Sculptures by Niki de Saint Phalle.

poser Igor Stravinsky and is built, appropriately enough, on top of the Centre's subterranean department of music. It came about as a result of an initiative by conductor Pierre Boulez, who approached Tinguely and Saint Phalle and asked them to undertake the project — an appropriate choice, considering Stravinsky's reputation for colorful, dynamic music.

Treble and clef symbols twirling and nodding to one another emphasize the fountain's musical theme. Beyond them, assorted personages and forms rise and gyrate above the water, the largest and highest being a birdlike creature shooting sprays in all directions. This is an allusion to Stravinsky's folkloric ballet, "Firebird," inspired by the phoenix myth. An elephant figure, sitting upright, is the artist's reference to "Circus Polka," while a Derby hat, spinning uncontrollably on the surface, is related to "The Rake's Progress."

Other pieces include a twirling snake, a mermaid-like figure, a skull, spitting lips, and a set of mechanical arms that shoot wayward jets of water over the fountain and onto the plaza and viewers. Each of these elements refers directly or indirectly, to Stravinsky's work, from opera's like "Oedipus Rex" to the legendary "Sacre du Printemps."

MIDDELHEIM OPEN-AIR MUSEUM OF SCULPTURE

Founded in 1950, the **Middelheim Open-Air Museum of Sculpture** is the oldest garden for 20th-century sculpture in Europe, predating the enlargement of the Kröller-Müller garden by ten years.

Located in the Belgian port city of Antwerp, Middelheim's 15 acres display a broad selection of works from Rodin's era to the present. The mix is deliberately eclectic, embracing the famous and the obscure, scrambling styles, materials and nationalities with unabashed enthusiasm.

The estate was mentioned for the first time at the beginning of the 14th century. It had different proprietors until it was bought by the city of Antwerp in 1910. The magnificent castle in the style of Louis XVI, built in the second half of the 18th century, as well as the layout of the park, were the work of Paris architect Guimard, famous for designing the "Quartier du Parc" at Brussels. The entrance lies on a residential street flanked with opulent 20th-century architecture. Past the iron gates, on the right are the museum buildings with François Pompon's well known "Polar Bear" dominating the space. On the left the formal park begins; here, among lawns and groves, are sited some of the world's best known sculptures. Moore's "King and Queen," symbolic of archaic and primitive royalty, ushers the visitor into the sculpture garden. Placed on the lawn opening up beyond these figures are among others Rodin's sensuous "Age of Bronze," Maillol's floating female figure "The River," inspired by nymphs from the fountain at Versailles, and his seated nude "The Mediterranean," Pablo Gargallo's cubist bronze figure "Prophet," Rick Wouter's pensive "Domestic Cares," Marcello Mascherini's romantic "Faune" inspired by Débussy and Giacomo Manzù's stark figure "The Cardinal." Bordered by an impeccable rose arbor, the lawn curves into the distance with a background of further sculptures sinking into perspective. Paths lead into pine woods where various pieces, somber and joyful, lie scattered in the shade.

Famous figures, such as Raymond Duchamp-Villon's spiralling "Horse" and Eugène Dodeigne's stone piece "Three Figures," blend favorably with less known works. A cast of Carl Milles' "Pegasus" dominates one half of the back of the park, a sculpture pavilion, containing more fragile sculptures and other works of art, the other. A small Calder stabile holds court among an assemblage of smaller pieces. Next to the pavilion, a pond surrounds a colorful ceramic fountain with four Art-Déco roosters by Olivier Strebelle. A high-tech tubular structure by Ingman Hellgren rises behind glistening forms activated by the North Sea wind. Jesus Raphael Soto's 60's Op piece, "Double Progression Green and White," ascends in a series of hypnotic metal poles at the edge of the clearing.

A group of older figurative sculptures line the way back to the entrance

Middelheim
The Red Indian *by Arvo Siikamäki — aluminium.*

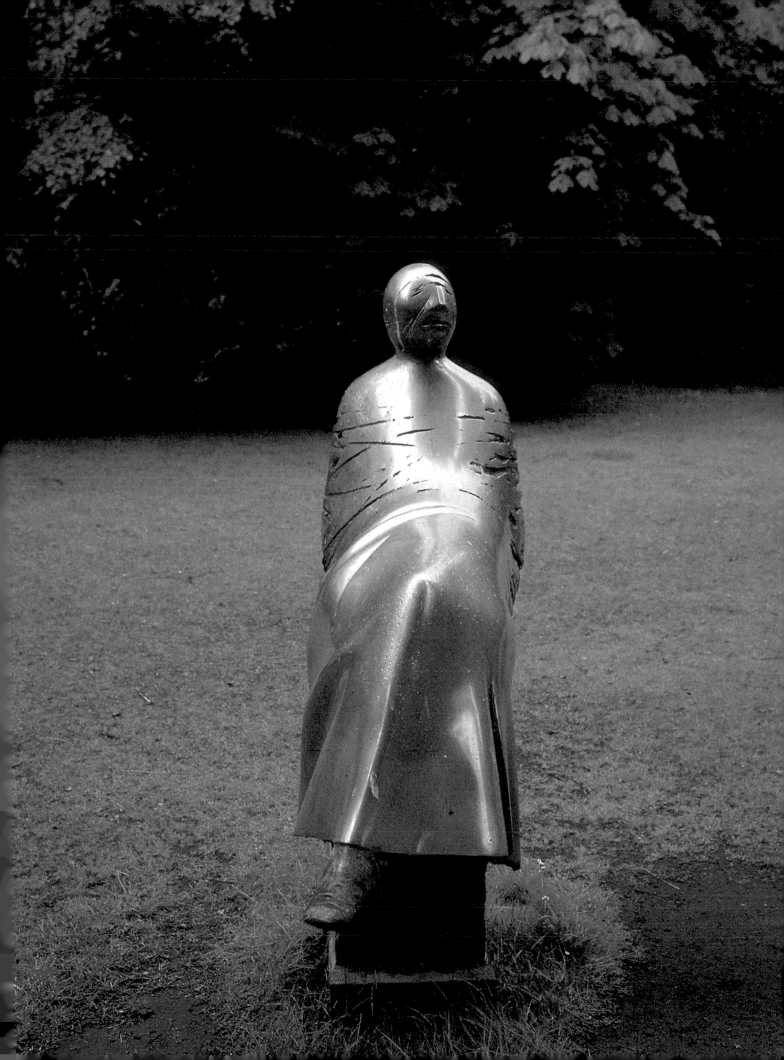

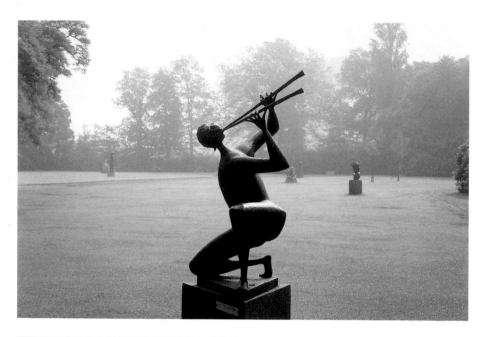

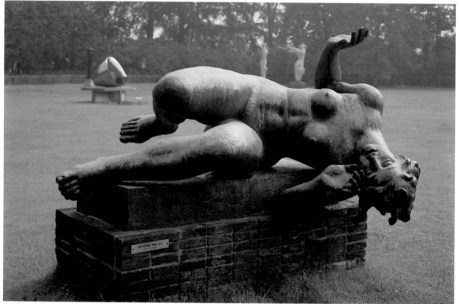

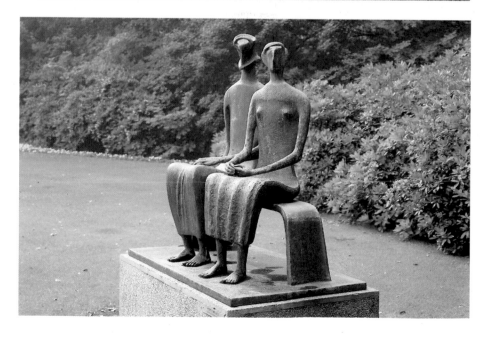

Middelheim
Above: Faun *by Marcello Mascherini*
— bronze.
Center: The River *by Aristide*
Maillol — bronze.
Below: King and Queen *by Henry*
Moore — bronze.

Middelheim
Vertical-Lyric-White *by Slavo Tibec*
— aluminium.

Following page: Middelheim
A general view:
At left: White Marble *by Morice*
Lipsi — marble.
Center: Sun Disk / Moon Shadow
V *by Louise Nevelson — black*
painted aluminium.
At right: Domestic Cares *by Rick*
Wouters — bronze.

along a winding axis dominated by the bamboo, oak, willow and catalpa trees that crowd against the path and narrow canals, patrolled by ducks.

Sloping down from the wooded areas, another lawn provides a view towards the manor house. This lawn also features many diverse pieces, including a pair of gossiping pregnant women by Charles Leplae, a pale abstract flame by Yasuo Mizui, a black aluminium composition by Louise Nevelson and Alberto Viani's white marble "Woman's Torso." Most of the sculptures shown were acquired by the city of Antwerp, lent by the Royal Museum of Fine Arts and the Royal Academy at Antwerp or donated.

It was sculptor Ossip Zadkine who in 1950 urged Antwerp's burgomaster Lode Craeybeckx to use the manor and the grounds for an outdoor museum of sculpture similar to those recently set up in London's Battersea Park and Sonsbeek-Arnhem, in the Netherlands. The first Middelheim biennial exhibition occurred that year and the event has continued to the present during the summer months. A sampling of the exhibition pieces generally stays behind, further enhancing the garden's unique eclecticism.

Each biennial has a regional focus; there was an "Anglo-Saxon" biennial in 1959, five Eastern Bloc nations plus Japan were featured in 1967, and Scandinavia headed the list in 1979. The 1971 exhibition included the work of sculptors from the United States along with four other countries. In 1983 the museum offered a ten-year retrospective exhibition.

While the biennials attract the crowds, the permanent collection draws a steady stream of visitors who come to experience what an Italian critic called "a living museum... where sculpture is always bound to the life of modern people."

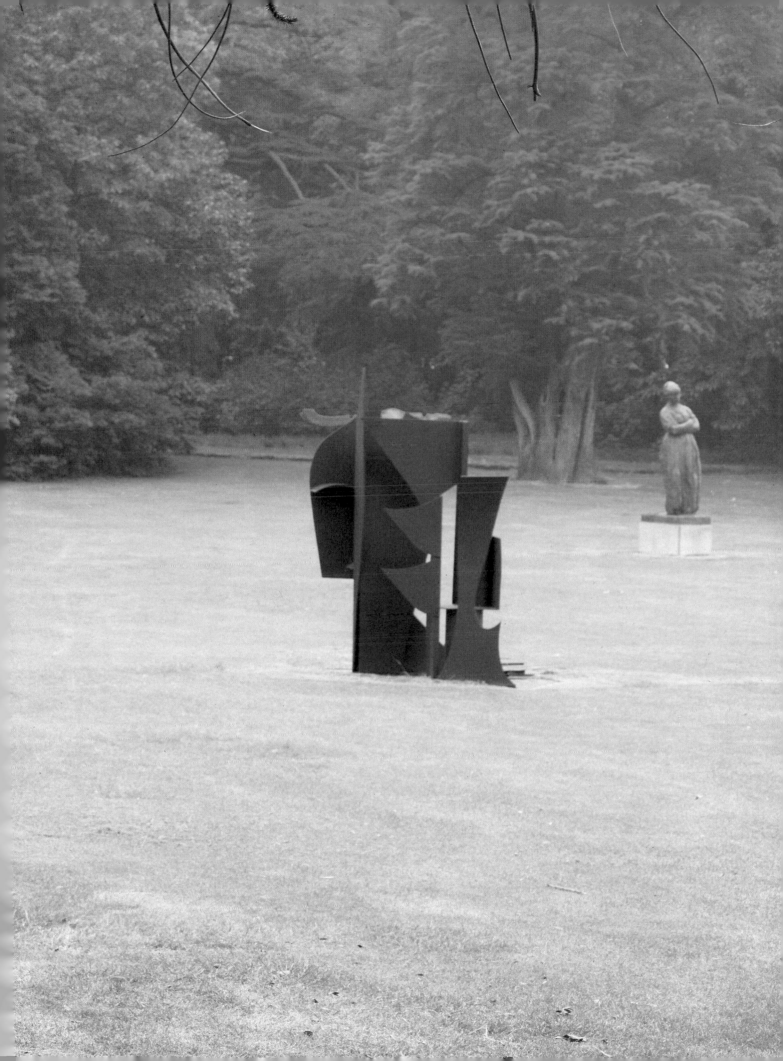

SUTTON PLACE

When British landscape architect and author Sir Geoffrey Jellicoe was asked to redesign the grounds of **Sutton Place** in 1980, he faced a considerable challenge. Built between 1521 and 1530 for Sir Richard Weston, a close associate of King Henry VIII, this Tudor building had been known for hundreds of years as one of England's loveliest country houses.

In this century it became a focus of attention as the residence of legendary oil magnate J. Paul Getty, who lived at Sutton Place from 1959 till his death in 1976. One of the wealthiest men of modern times, Getty amassed most of his ecletic art collection at this English residence. After he died, this was transferred to the lavish, neo-Roman museum bearing his name on the Southern California coast.

In 1980 the English estate was sold by the Getty Oil Company and another American, Stanley Seeger, leased Sutton Place with the aim of using it to house his own art collection and to provide a focus for the performing and visual arts. Architect Sir Hugh Casson transformed the house into a "living" museum combining old and new. Sutton Place currently shelters a wide range of works of art, from Pre-Columbian pottery to paintings by Francis Bacon, Jean Dubuffet, Picasso, David Hockney and others. Sir Geoffrey Jellicoe, for his part, reshaped the gardens in accordance with Seeger's particular vision.

"I realized," said Jellicoe, "that... (Seeger) would be trying to create a garden which expresses the modern mind, sympathetic to the ethos of the place, which comprehends the past, the present and the future... This is what I am trying to do in my later years, to create something in the environment which is deeper than what the eye can see, to detect what I might call the invisible world which is abstract art." Jellicoe followed these principles to reshape the old garden in what is said to be one of the largest undertakings of this type since the renovation of Chatsworth.

To balance the original "kitchen garden," Sir Geoffrey built another walled garden with meandering pathways and a rich array of flowers, thus preserving the symmetry of the grounds. The new walled garden is divided into two sections approached by stepping stones over a lily moat. The "Paradise Garden" was built to embody the "concept of heaven brought to earth... purely to attract you with the sound of waters and arbors and bird life." Beyond is a "secret moss garden," overgrown and planted with wild flowers. Another equally evocative site centers on a cascade and grotto. The rock and water complex was carefully planned and falls over several levels, eventually flowing down through the "Wild Garden" to the River Wey. Visitors can "land at the bottom and walk up through the cascades," according to the designer. "A very dramatic arrival."

Sutton Place
The Wall *by Ben Nicholson — white marble.*

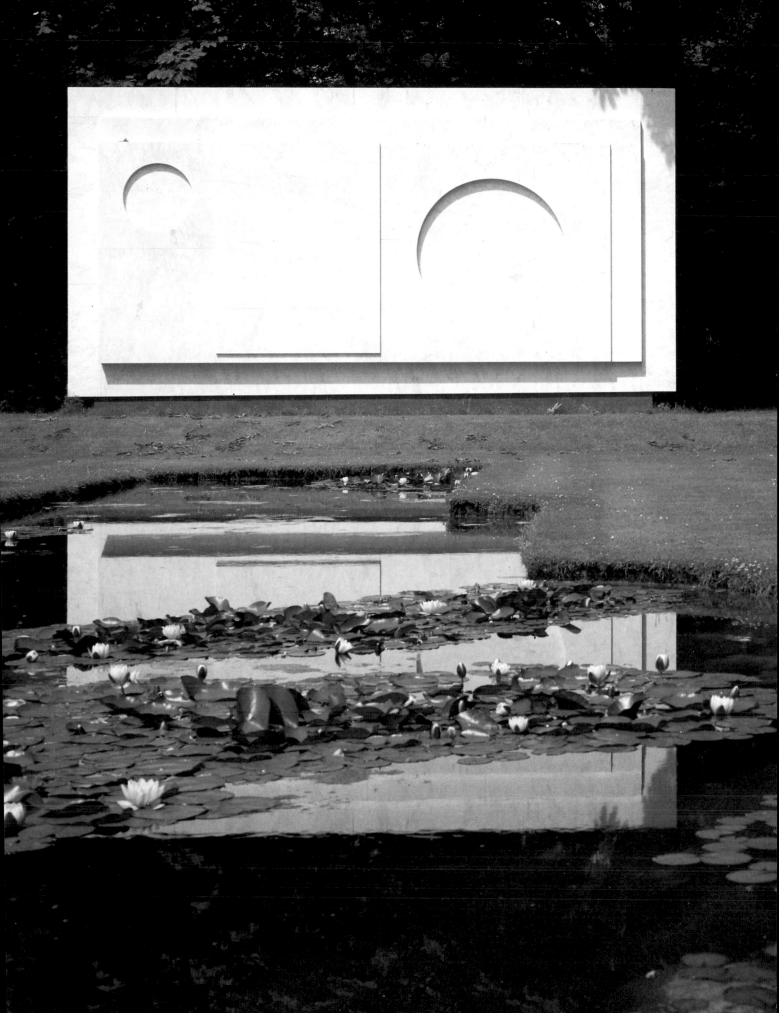

Sutton Place
Project for the cascade, grotto and avenue of fountains by Sir Geoffrey Jellicoe.

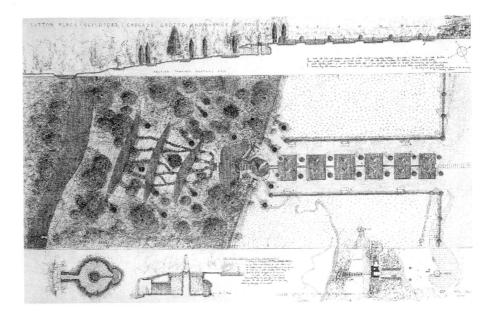

Sutton Place
Five Roman Urns in the "Surreal Garden."

Specific works of art occasionally served as a source of inspiration for Jellicoe's landscaping. The secret moss garden, which he describes as "very mysterious, like an inner sanctum of the mind," is based on a fantasy painting (depicting fairies) by Atkinson Grimshaw which hangs in the mansion itself.

Miró's flowing, organic abstractions inspired the kidney-shaped raft and stepping stones in the "Miró Pool," although Sir Geoffrey later said "that after thinking it over for some time, it's changed into a Miró/Hockney/Magritte picture — a sort of combination of all three." Magritte's "odd juxtaposition of things in space" also strikes echoes in the "Surreal Garden." Here a row of five oversized urns exaggerated by a false perspective leads the eye to an enigmatic, "very experimental" window in a brick wall.

The Surreal Garden points to a pictorial junction in the Sutton Place grounds. The convergence is marked by the "Nicholson Wall," a huge, abstract, relief sculpture of bone-white Carrara marble cut into overlapping rectangles and circles, each balanced against the other. Standing at the end of a clipped corridor of lawn, behind a sculpted reflecting pool, the wall is the work of Ben Nicholson who, together with Henry Moore, is one of the most respected masters of British modern art. "Here," says Jellicoe, "you reach something which is sublime — all the worries have gone, you are seeing something which lifts you — really gives faith."

Nicholson and Jellicoe are long-time friends and associates. They searched for a place to put something like the wall for nearly twenty years.

"He'd had one built," recalled Sir Geoffrey, referring to Nicholson's 13-by-49-foot relief wall at the "Documenta III" exhibition at Kassel. "He loved it and this is what he wanted repeated. I can't tell you the famous places in England where I very nearly got it across, but always we fell down — there wasn't enough money and I'd given up."

The Sutton Place project, however, provided the perfect opportunity, and Seeger encouraged the largest scale possible.

The reworking of Sutton Place is not yet completed, but if all goes according to plan, Jellicoe's landscaping scheme may well earn similar praise. It is a sculptural environment that comes very close to fulfilling Jellicoe's search for the invisible, timeless ethos that lies behind all abstract art.

MUCH HADHAM

Through the study of form in nature, Henry Moore has created a style of sculpture that synthesizes the abstract with the organic in a unique way. Moore does not seek to copy nature, nor to put the forms of nature beneath those of art.

Instead, he strives for a marriage of the two. In a book by Stephen Spender on Henry Moore the sculptor was quoted as saying: "Think of bronze in rain, and of trees, themselves sculpture which sheds leaves and reveals the base skeletons of trunk and branches. But never so geometric as to compete with sculpture, only providing contrast to it."

For Moore, sculpture is very much "an art of the open air," and his work is therefore well represented in the world's sculpture gardens. His residence in **Much Hadham,** Hertfordshire, England, has become a sculpture garden in itself — the sort of environment one would expect from an artist who has spent his life creating abstract organic forms to contrast with natural ones.

Formerly a 16th-century estate called "Hoglands," Much Hadham consists of a manor house, enlarged and renovated over the years, and a handful of outbuildings scattered over the grounds. Near the residence itself is a tightly manicured stretch of lawn holding ten large sculptures. Moore often passes through this garden on his way to an imposing structure resembling a hangar that functions as one of his studios. Willows, elms, and tightly cropped hedges define a garden that is a microcosm of Moore's favorite themes. A "Draped Seated Woman" in bronze reclines, set apart from shrubs and other sculptures. She is the area's dominant piece. Beyond rises "Knife-Edge: Two Pieces," a similar shape and composition but only half the size of Moore's "Mirror Knife Edge" in front of Washington's National Gallery. The broken pebble forms of this work stand out against a background of soft vegetation, with no rival architecture to encumber them.

The same is true of Moore's "The Wall: Background for Sculpture," a mass of mountain, rock and bone forms which is underlined by flat turf all around. "Upright Motive No. 9" is a totem piece illustrating Moore's belief that "there is no background to sculpture better than sky because you are contrasting solid form with its opposite — space. The sculpture then has no competition, no distraction." Examples of Moore's reclining figure and warrior themes share the area as well. They are placed with Moore's concern for contrast in mind. Finally, at the wood's edge, two massive abstractions rear up in white fiberglass; the rough-hewn "Arch," and the "Large Two Forms."

Much Hadham
The Wall: Background for sculpture No.2 ,
by Henry Moore — bronze.

Much Hadham
Double Edged Knife *by Henry Moore.*

"Large Standing Figure Knife Edge," a contemporary version of the classical "Winged Victory of Samothrace," guards the spot where the woods thin to become sheep meadows. Here crouches the "Sheep Piece," the most famous sculpture at Much Hadham. The animals rub against the monumental bronze and have polished the metal so that it shines. Moore created the sculpture as a "gift" to the sheep he has watched and sketched from his window for years.

In the late 1950's Moore visited the estate of sculpture collector Sir William Keswick in Dumfriesshire, Scotland. There for the first time he saw a number of his own works (including the famous "King and Queen") placed outdoors, holding vantage points along a sweeping valley landscape. Keswick's example gave Moore the idea, and Much Hadham provided him with the opportunity. He and his wife Irena have lived there since 1940, when they were forced out of London by

German bombing raids (some of Moore's better known drawings include sketches of figures huddled in bomb shelters dating from that period).

Moore originally hailed from a dingy industrial town in Yorkshire, and had spent much of his subsequent time fleeing cities. The move to Much Hadham therefore fulfilled an old desire. The soil itself offered him new inspiration: Much Hadham had been originally a livestock farm; its grounds held decades-worth of animal bones, giving the sculptor a new repertory of forms to add to his rock and pebble abstractions. "All (sculptures) are placed perfectly," wrote Moore of Keswick's estate. "Seeing them has convinced me that sculpture — at any rate, my sculpture — is best seen in this way and not in a museum." Much Hadham has become Moore's testimony to these sentiments.

Much Hadham
Sheep Piece *by Henry Moore — bronze.*

Following page: Much Hadham
A single bronze piece from Three Piece Sculpture: Vertebrae, *1968-69.*
Draped Reclining Figure, *bronze, 1952-53.*

MILLESGÅRDEN

Located in Stockholm, **Millesgården** is the definitive show-place for the work of Swedish sculptor Carl Milles (1875-1955). What was originally his private studio is now a public park, spilling down toward Värtan Bay and holding over 160 of Milles' sculptures, most of them bronzes.

Milles' sensuous figures stand amid fountains or perched precariously atop twenty-foot pedestals, as if in flight. His work is quirky, satirical. It combines a love of his subjects with a keen sense of humor, which occasionally got Milles into trouble with patrons.

Mythological characters are subjected to unconventional and occasionally embarrassing treatment: Jonah bounces confusedly atop a plume of spray from a frog-faced whale, faces of Greek heroes appear bug-eyed and comical, angels float in the air sporting ice skates. In addition, the unabashed nudity of many of the pieces caused problems at the time of their creation. American critics at one time denounced a sea nymph of Milles' as being no better than pornography.

Mediterranean and Nordic influences blend at Millesgården; Scandinavian birches and pines back up classical nudes and Italianate cascades. This is no accident, for Milles, like many Scandinavians, was enamored of Italy. He convalesced there briefly as a young man and the attraction was strong enough to make him return to teach, work and reacquaint himself with his great idol, the baroque master Gian Lorenzo Bernini. After 1951, Milles spent winters in Rome.

Milles first left Sweden in 1897 at the age of twenty-two, reportedly to become a gym instructor in Chile. He ended up instead in Paris, where he worked in a coffinmaker's shop and sold souvenirs, before deciding on a career in sculpture. Auguste Rodin accepted him as assistant and Milles worked under the master until 1904. It was during this time that he met Olga Granner, a young Austrian artist who became his wife. Milles next moved to Munich. He returned to Sweden in 1906, and built a studio at Lidingö which served as his base until 1929, when he left for the United States. During this time he created nearly fifty portraits of well-known Swedes, as well as the "Seagod," "Susanna Fountain," the "Sunsinger," a big "Industrial Fountain" for the technical university in Stockholm, "Folkunga Fountain" for Linköping, "Gustav Vasa" (in carved wood) for the Nordic Museum in Stockholm and a lot of smaller sculptures.

Milles spent the next two decades in America teaching at Cranbrook Academy, near Detroit, and produced some of his best known works on

Millesgården
Angel Musicians *by Carl Milles, on the lower terrace — bronze.*

Millesgården
Right: The upper terrace with the
Loggia in the background.
Left: Folke Fillbyter *by Carl Milles*
— bronze.

American soil: the "Orpheus Fountain" for the plaza of Stockholm's Concert Hall, and "A Meeting of the Waters" in St. Louis, among others. He also built several sculptures and fountains for the academy's campus, whose architect was fellow Scandinavian Eliel Saarinen. His largest work, "The Fountain of Faith" in Falls Church, Virginia, shows 28 figures reuniting after death.

By the time of his own death Milles was well-known and widely imitated, especially in the United States and Scandinavia. He died in 1955 at the age of 80, after spending four summers at Millesgården and the winters in Rome working on such projects as "Aganippe's Fountain" for the Metropolitan Museum in New York.

"Great art has to be youthful," Milles told Time magazine shortly before his death, "...and I am still a boy." His own art, he added, was the stuff of "dreams" and he could easily execute "2,000 more" if he were not so old.

Millesgården did not become a public museum until 1936, when the artist, deciding it was unlikely he would return to live permanently in his homeland, donated it to the Swedish people. By then he and his architect brother Evert Milles had installed a reflecting pool for his "Susanna" basin fountain and erected two chapels in a small rectangular garden they called "Little Austria," in honor of Milles' wife. He also brought in such curious local artifacts as columns from Stockholm's demolished opera-house and its old dramatic theatre.

In 1948 Milles gave his extensive collection of ancient Greek and Roman sculptures to the government. The main house, with its Italian-style loggia and frescoes, was converted into a museum for the classical sculptures as well as Milles' smaller works. Replicas of his American pieces, such as the "Indian Head" monument in St. Paul, Minnesota, the "Jonah and the Whale" fountain at Cranbrook, and the "Pegasus"

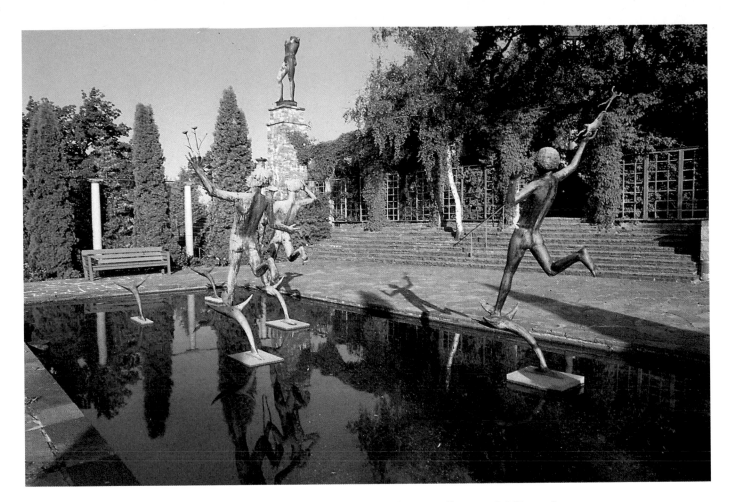

sculpture in Des Moines, Iowa, were added to Millesgården's collection. An area called "Olga's Terrace" was constructed to accommodate segments of the water sculpture "Aganippe."

A spectacular studio of red sandstone was built along an extensive terrace skirting the water's edge in honor of Milles' return from the United States in 1951. The studio overlooks a three-flight cascade of huge granite steps whose spacious surface exhibits Milles' monumental "Poseidon," and a forest of striking "Angel Musicians" set on columns, which contrast with the jumble of refineries visible across Stockholm's harbor.

The terrace also holds the emphatic "God's Hand" (1954), an image that has become the symbol of Millesgården. On the eastern wall of the terrace is inscribed a flowery poem by Milles, reading in part:

> "Commemorating the fever of creation
> the joy of beautifying life with art
> for joy, fate and you, people,
> we pray you humbly to preserve it well
> so that amid changing fortunes
> what artists dreamt shall long live in this world."

VIGELAND SCULPTURE PARK

The **Vigeland Sculpture Park** in Oslo, Norway, occupies a parcel of land nearly a half mile in length within the city's Frogner Park. Honoring the work of Gustav Adolf Vigeland (1869-1943), Norway's most popular 20th-century artist, the park was in fact designed by the sculptor along with many of its sculpture groups. The figures, carved in granite or cast in bronze, illustrate the development of man.

Trained as a wood-carver, Vigeland studied at Rodin's studio in Paris, as well as in Germany and Italy, but returned to live and work in his native land in 1902.

Vigeland's expressive, thematic figures soon became very popular in Oslo. Enthusiasts queued by the thousands for his rare studio "open houses" and eventually donated the funds to ensure Vigeland's ultimate magnum opus, the sculpture park, which opened in 1924. "I was a sculptor before I was born," Vigeland once said. "I was driven and lashed onward by powerful forces outside myself." These forces surfaced in the energy of Vigeland's art. The park's earliest piece is a magnificent fountain that depicts muscular bronze giants holding a pool-sized basin of water. Around the fountain stands a ring of 20 bronze sculptures of trees and humans engaged in mysterious interactions. Sixty relief sculptures edging the base of this structure illustrate similar themes and an enormous labyrinth mosaic spreads over the floor of the immediate surrounding. The fountain may be the park's chronological keystone piece, but it is by no means its largest.

Vigeland's "Monolith," a 56-foot-high stone column, holds 121 carved nudes whose expressions and body poses range from joy to anticipation to despair. Surrounding "Granite Groups" show brooding men, old women, mothers and children embracing emotionally, youths looking upward in wonder.

The park's dramatic and symbolic qualities intensify as one explores its other three elements: granite bridge edged by turbulent bronzes: figures and groups in poses a running woman holding up her child, an infant in an upside-down womb position, a struggling man entrapped by a giant metal ring. Forged iron portals, another element with human outlines: maidens, aging women and muscle-bound men, in trios that appear to talk among themselves. The elevated "Ring Group," at the far end of the park, is a colossal stone sculpture of seven swirling, interlocking nudes — four adults and two children — forming a perfectly silhouetted circle. "Let Europe come and see my works when they have been erected here," Vigeland once said.

Vigeland Sculpture Park Frogner Park.

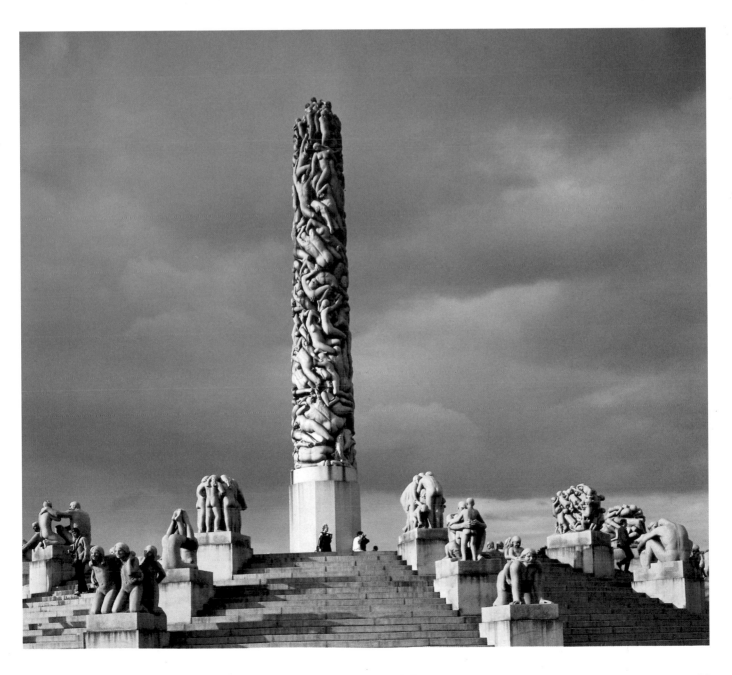

DŽAMONJA SCULPTURE PARK

The small village of Vrsar lies about forty miles southwest of Trieste along the Adriatic coast in the peninsular region of Istria. Dušan Džamonja, Yugoslavia's most prominent sculptor and monument-maker writes of the area: "When I look toward the shore with its coves and islets, or the other way, where the rich red earth stands out against the green of cypresses and rolling hills, I am not sure which vista gives greater pleasure to the eye. These scenes are continually changing with the weather and seasons, but they never disappoint, never betray the love I feel for every inch of this region in which I have sought to find peace."

Džamonja is speaking of the plot of land on which he built his residence and the **Džamonja Sculpture Park.** While travelling in the 1960's through this historically rich region (Istria was a resort for Roman patricians as early as 500 B.C.), the sculptor came across the ruins of an old homestead. Taken with the beauty of the site, he decided to build a house and a studio to provide a retreat from activities in Zagreb.

Džamonja continued to produce patriotic memorials and monuments elsewhere in Yugoslavia at a rate that was to make him a household word in his country. At the same time he began placing sculptures throughout the open grounds of his new property. The property filled up with pieces as Džamonja's reputation grew. When the park "went public" in 1980, most of the main house was converted to gallery space for smaller sculptures. Džamonja himself, now just over 50, still maintains a residence and workshop on the grounds.

The main house and its terraced gardens are oriented toward an inlet of the Adriatic, edged by the village of Vrsar and a mountain with a monastery on top. Sculptures are arranged closely around the house: "Suite II," an early work in aluminium, seems to levitate effortlessly over a pool on the terrace. On the house's other side, the more recent "Sculpture 75-D," a seven-foot piece built entirely of wooden slats, forms the shape of a "planet" with "haloes" surrounding it. Next door, wooden blocks outline a second wooden sphere, pierced by strong patterns of iron spikes.

In the surrounding fields, other works are more loosely arranged. "Sculpture 75-C," a broken, rusted sphere, creates an interplay of curved columns against the green background. Nearby are other orbs in different mediums: "Sculpture Alp-II," for example, is in aluminium and polyester.

Sculpture 76 P *by Dusan Dzamonja — polyester.*

Sculpture LXX-MX *by Dusan Dzamonja — marble.*

These pieces, both violent and serene, are typical of Džamonja's work in their use of hard, primary materials. Art historian Giulio Carlo Argan has said that Džamonja looks upon art as a form of hard labor, as tiring as the most arduous work in the field or factory. In contrast to the dynamic quality of much of his work, the materials used are heavy and static in their original form. "The toil of the craftsman," comments Argan, speaking of Džamonja, "must remain clearly legible in the work of the sculptor."

Džamonja's mastery of these materials is that of a master craftsman in the medieval sense of the term, and much in keeping with his garden's human environment of farms, peasants and fishermen. Like Brancusi, who worked during his last years in his native Romania, Džamonja has blended respect for local tradition and handicrafts with a wholly modern sensibility. His understated work abstracts form and volume while at the same time blending with the Adriatic surroundings.

The stark clarity of the molded polyester "Sculpture P-5" is a case in point. A ground-hugging composition of broken spheres, it recalls, as Argan points out, a monumental caterpillar crawling along the grassy

field. (Others have compared it to the sail-shaped Sydney Opera House.)

Another white work, "Sculpture LXX-MX," uses an idea of vertical space, typified by Stonehenge, that can be entered and exited like a plaza or building. Carved in veined marble, open at the center, linear rather than circular, it quietly dominates a field of full and half globes. This last piece provides a link to the public aspect of Džamonja's work. Through these monuments Džamonja has become known as a translator of the Yugoslav spirit. "The recurrent theme (in Džamonja's words)," writes Argan, "has always been related to a global concept... embracing historical events. Džamonja seeks above all an identification with the man in the street who can recognize his own life experiences, his own memories and beliefs."

Sculpture P-5 *by Dusan Dzamonja* — *polyester*

Chapter Two
MUSEUM GARDENS

The garden of the Maeght Foundation.

MUSEUM OF MODERN ART

Though it has gone through several radical changes since its inception in 1939, the sculpture garden of the **Museum of Modern Art,** remains "the heart of the museum," in the words of the museum's former curator of architecture Elizabeth B. Kassler. If this is so it is not due simply to the garden's superb sculptures, for the garden has traditionally served as a meeting place for New Yorkers, and a center for artistic events and experiments. These have ranged from full-fledged architectural structures, such as R. Buckminster Fuller's 1941 twin-domed Dymaxion Deployment Unit, to one of Jean Tinguely's self-destroying machines, to jazz performances. Founded in 1929 "for the purpose of helping people understand, enjoy, and use the visual arts of our time," the Museum of Modern Art has grown to become the largest and most distinguished museum of 20th-century art in the world. Its recent expansion project has doubled its exhibition space, and though the garden itself has remained relatively unchanged, an elaborate glass "garden hall" puts renewed emphasis on it. Visitors are immediately made aware of the garden as they enter the Museum; its plantings and sculptures are at once visible through multi-layered windows.

The original garden had a somewhat spontaneous beginning when in 1939 the museum opened its new building on the site of the townhouse at 11 West 53rd Street which it had occupied since 1932. The museum's trustees were aware of the need for an outdoor exhibition space to complement the new international-style building by architects Edward D. Stone and Philip L. Goodwin. But no real garden had been planned because the space available was only 75 feet long. At the last minute however, John McAndrew, then curator of architecture, and museum director Alfred H. Barr, Jr. were notified that John D. Rockefeller, Jr. would contribute a strip of land adjacent to the museum, enlarging the garden to an area approximately 400 by 100 feet. In a matter of days, McAndrew and Barr had to transform, as Kassler put it, "a huge rubbly tract into a favorable sculpture setting." McAndrew later recalled, "Alfred and I stayed up all night, and I made a model of the whole garden with steel-wool trees while Alfred placed sculptures where they could be seen best — that is, so that you would not have to come in and see everything at once but had to turn corners." Working quickly, the two men developed a series of free-standing screens which defined spaces for individual sculptures.

Despite minor difficulties, the garden was nevertheless completed on time. With the exception of 1942, when plane trees and a restaurant were added, it remained roughly unchanged until 1953. In that year an entirely redesigned garden opened: the Abby Aldrich Rockefeller

The Museum of Modern Art Sculpture Garden
At left: Whale II *by Alexander Calder — standing stabile, painted sheet steel, supported by a log of wood.*
Center: Broken Obelisk *by Barnett Newman — Cor-ten steel.*
At right: Family Group *by Henry Moore — bronze.*
Against wall: Backs I, II, III, IV *by Henri Matisse — bronze.*

Sculpture Gardens, dedicated to the memory of one of the museum's original three founders. Architect Philip Johnson, a long-time associate of the museum, created a serene, modernist, Miesian design, transforming the modest, wooden-fenced area into a strongly geometric piazza with islands. Speaking of his "roofless room," the architect said: "What I did, was to make a processional, using canals to block circulation and block vision, too, and bridges to establish the route. Always the sense of turning to see something. The garden became a place to wander, but not a rigidly defined path." Working with landscape architect James Fanning and the museum's director René d'Harnoncourt, Johnson surfaced the plot with unpolished marble slabs, erected a 14-foot wall along 54th Street, further enclosing the garden, and integrated new and lusher plantings. A channel-like reflecting pool spanned by bridges was installed, and a dining terrace.

In 1964 the garden changed again, accompanying an expansion of the museum itself. The alterations were less radical this time, with additional plantings, an upper level over a new wing at the east end of the garden, the installations of a plate glass wall paralleling 54th Street, which further increased the architectural focus on the garden. Though

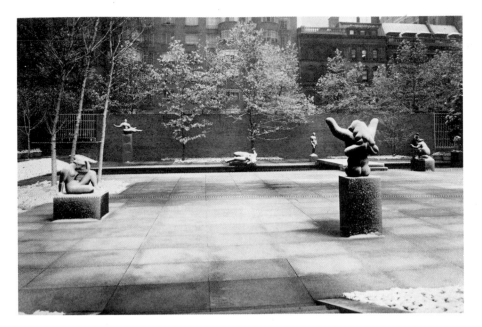

*The Museum of Modern Art
Abby Aldrich Rockefeller Sculpture
Garden, designed by Philip Johnson,
Winter 1953.*
Foreground: The Mediterranean *by
Aristide Maillol and* Mother and
Child, II *by Jacques Lipchitz.*
Background: Floating Figure *by
Gaston Lachaise,* The River *by
Aristide Maillol,* Standing Woman
by Wilhelm Lehmbruck, The
Washerwoman *by Pierre-Auguste
Renoir, and* Torso *by Bernard Reder.*

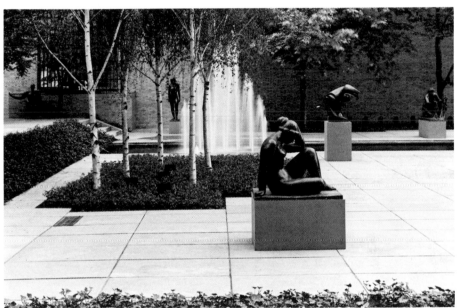

*The Museum of Modern Art
Abby Aldrich Rockefeller Sculpture
Garden, designed by Philip Johnson,
Summer 1964.*
Foreground: The Mediterranean *by
Aristide Maillol.*
Background: Floating Figure *by
Gaston Lachaise,* Assia *by Charles
Despiau,* The Horse *by Raymond
Duchamp-Villon, and* The
Washerwoman *by Pierre-Auguste
Renoir.*

this gradual modernization was regretted by some, the changes were in general applauded. Of the 1953 garden, a "Time" editorial said, "Chaos has given way to order, a tangled monotony is replaced by disciplined variety."

The 1984 expansion of the museum has brought minimal alteration to the Abby Aldrich Rockefeller Garden itself but dramatic change with respect to its surrounding structure. Now, a soaring glass Garden Hall, added to the original 1939 building, overlooks the garden with its familiar greenery and sculptures by artists such as Rodin, Lachaise, Picasso and David Smith. Facing the garden on the east side are two new restaurants; to the west are group reception areas. But the new Garden Hall is the element that allows visitors to view the sculptures as well as the garden itself from a new perspective as they are carried up or down by escalators or as they contemplate the whole from one of the balconies within the hall. The effect on the newly planted garden, with its reflecting pools fully restored, of glass on three sides is to bring the garden into the museum, giving the impression of the garden as an oasis in the middle of the museum itself, not merely as it has always been — an oasis in one of the busiest cities in the world.

WHITNEY MUSEUM SCULPTURE COURT AT PHILIP MORRIS

Excluding the elegant backyard of the Museum of Modern Art and the Metropolitan Museum's glassed-in areas on Central Park, the closest approximation to a modern sculpture garden in New York City is the **Whitney Museum Sculpture Court at Philip Morris.** This branch of the Whitney Museum of American Art lies indoors, but its design is such that the ten monumental works on display have all the room and light they need.

The arcade and sheltered recesses of the building's facades on Park Avenue and 42nd Street invite the public to enter the oasis of calm that the sculpture court provides. The 42-foot-high court on the ground floor of the Philip Morris company's 26-story headquarters is quiet and spacious, clean and sparse. The walls and floor are all of limestone, and the angles on the staircase and large windows are perfectly squared off, geometric and uninvolved.

This all works to benefit the pieces on view, which are "fairly active," in the words of branch curator Lisa Phillips. "They are organic for the most part, and they play off the architecture... Many of the pieces are literally kinetic or imply movement (and) they involve the viewer that way."

The two key words here are "movement" and "involve": movement because the pieces, dynamic in themselves, are also rotated in and out of the sculpture court at regular intervals, so that the collection can change and grow at the aggregate level; "involve" because the artworks, half of which came from the Whitney's permanent collection, are meant to touch viewers who don't commonly frequent art exhibitions. "Most of all people who pass by here," sculptor Louise Bourgeois has observed, "are busy business people, the kind who never set foot in a museum. Maybe this way they'll get to see some art."

A large, wild piece located on one side of the floor, Claes Oldenburg's "Ice Bag - Scale C," catches the eye immediately. At once whimsical and serious, this blow-up caricature of a mechanized household implement injects humor into the court's lofty reaches. On an adjacent "island," elevated and planted with trees, stands Robert Graham's "Stephanie and Spy." It is an impressively realistic, dark bronze ensemble of female nudes that offers a restful, balancing contrast to its neighbor. George Segal's "Dancers," cast expressly for this space, give the court a focus on the other side of the island. A buoyant composition of female nudes dancing in a circle, the piece is deliberately reminiscent of Henri Matisse's painted dancers of seventy-five years ago. The figures are exactly lifesize: Segal made all his sculptures from molds of real people. Seen against a mirror and a bed of greenery, these patinated bronze figures embody the "active" composition curator Phillips had envisioned for the court, as well as a strong sense of humanity. In keep-

Whitney Museum at Philip Morris
Dancers *by George Segal — bronze with white patina.*
Background: Gran Cairo *by Frank Stella — synthetic polymer.*

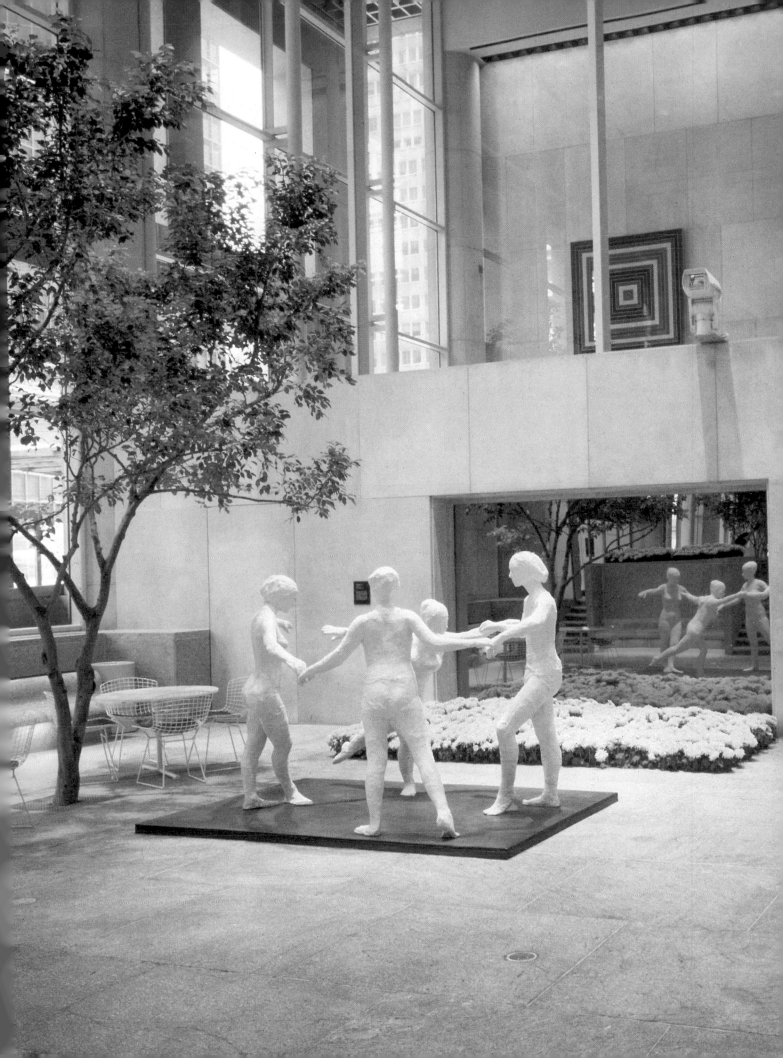

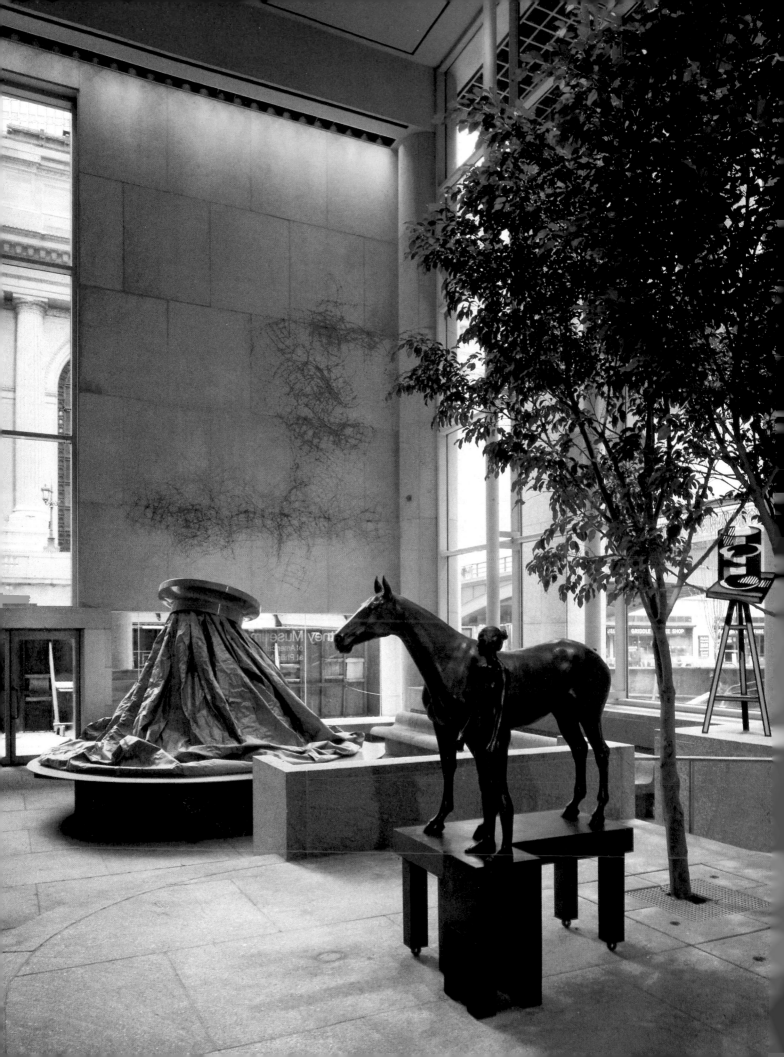

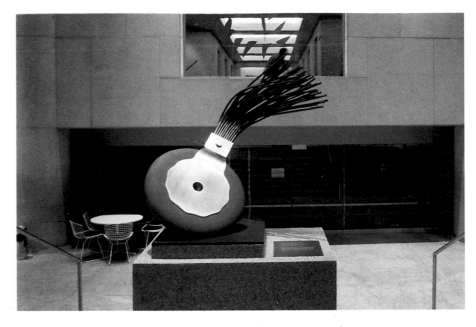

*Whitney Museum at Philip Morris
Foreground:* Stephanie and Spy *by
Robert Graham — bronze.
Center:* Ice Bag — Scale C *by Claes
Oldenburg — fiberglass laquer, nylon,
steel and motor.
Background:* True Jungle *by Alan
Saret — painted galvanized wire.*

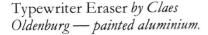

Typewriter Eraser *by Claes
Oldenburg — painted aluminium.*

ing with museum policy, however, the Segal has recently been rotated in favour of a de Kooning.

Against the wall, next to a background of mirrors and plants, stands John Chamberlain's "City Lux." This chaotic blend of crushed automobiles seems to bring the metropolis outside to its logical conclusion. A bright red Calder mobile glides above. On the opposite wall is a galvanized-wire relief, Alan Saret's "True Jungle: Canopy Forest." "True Jungle" has some of the frenetic gesturing qualities of a Jackson Pollock, only in three dimensions. Also on hand are Lichtenstein's "Gold Fish Bowl," and works by Nevelson, Louise Bourgeois, and Bryan Hunt.

Together with its other component, a 2,000 square foot gallery space for paintings and graphics, the Whitney/Philip Morris Sculpture Court thus provides the midtown area with an impressive selection of art. In an area primarily reserved for offices, fast-food counters and shopping boutiques, it also gives people who work in the area a place to relax. The Philip Morris company has had a 25-year record of patronage of visual arts, supporting the first Pop and Op art exhibition to travel the country in the 60's, as well as the Metropolitan's Vatican show of 1982. Affiliated with the Whitney since 1967, the company has since provided funds for several of the museum's biggest shows.

It was Ulrich Franzen, architect of the headquarters building, who first came up with the idea of a branch museum. Having been affiliated with the Whitney on other projects, Franzen was aware of the museum's need for a new sculpture space to display some of its larger works.

In addition, Franzen was familiar with a local zoning ordinance that allowed a building additional floors if it featured "covered pedestrian amenities" to divert crowds off the street. The new branch would therefore benefit both parties, giving Philip Morris extra space, and providing the Whitney with more exhibition footage in an area of the city where land is at a premium.

Another benefit for Philip Morris has been described by company chairman George Weissman: "By hanging some avant-garde or contemporary art, we are saying we are not... hidebound by tradition, but we are open to new ideas."

"It seems likely," comments art critic John Russell, "that many people may get into the habit of dropping into this space and getting to know something about new art without feeling hectored... (It) could become a sanctuary of high enjoyment."

HIRSHHORN MUSEUM SCULPTURE GARDEN

Situated between the U.S. Capitol and the Washington Monument, the **Hirshhorn Museum Sculpture Garden** complements and contrasts with more traditional structures lining the capital city's Mall.

The controversial garden was originally designed to provide a stark Bauhaus background for such pieces as Rodin's "Burghers of Calais," Matisse's "Backs," and Marini's "Horse and Rider."

Though recent landscaping has softened this effect, the garden retains its unique "sunken" design. Two viewing levels, the lowest 14 feet below the Mall's surface, form a long rectangular court holding some of the 20th century's finest sculptures. These include "Spatial Concept-Nature," Lucio Fontana's series of five large spheres, each marked with a jagged fissure or hole, which lie along one side of the lower court. Across from them is a small rectangular reflecting pool surrounded by other pieces, such as "The Traveler's Column," one of Pomodoro's gleaming bronze pillars.

The lower court is guarded at one end by Jean Ipoustéguy's whimsical "Man Pushing the Door," and at the other by Aristide Maillol's "Nymph." Beyond her, a ramp leads to the second level, where one is greeted by Giacomo Manzù's "Large Standing Cardinal." Immediately to the left, next to his larger-than-life statue of Balzac, a square platform displays Rodin's famous "Burghers," as well as his headless "Walking Man." Larger, newer, more abstract pieces can be found on a spacious concrete plaza under and around the museum. These include Calder's "Two Discs," one of Snelson's towers, and a specially-commissioned Di Suvero that includes cobalt girders and a huge ship's bow. The sculpture, which was donated by the Institute of Scrap Iron and Steel, is called "Isis."

In the early 60's, trustees of the Smithsonian Institution realized that, for the first time since the idea had come up in the 1930's, they had the resources to build a national museum for contemporary art. They approached Joseph Hirshhorn, whose private collection in Greenwich, Connecticut was one of the finest in the country. Hirshhorn signed over his collection in 1966, and in the following year New York architect Gordon Bunshaft, of the firm of Skidmore, Owings and Merrills, unveiled his design for the Washington museum.

Bunshaft's original design called for giving the Mall a major face lift, including its first modern building: a drum-shaped structure elevated on four piers. In addition, a sunken rectangular court would transect the avenue's east-west axis for a length equal to two football fields. This "garden," enhanced by a Taj Mahal-sized reflecting pool, would contain the majority of Hirshhorn's important pieces.

Hirshhorn Museum Sculpture Garden The Nymph *by Aristide Maillol — bronze.*

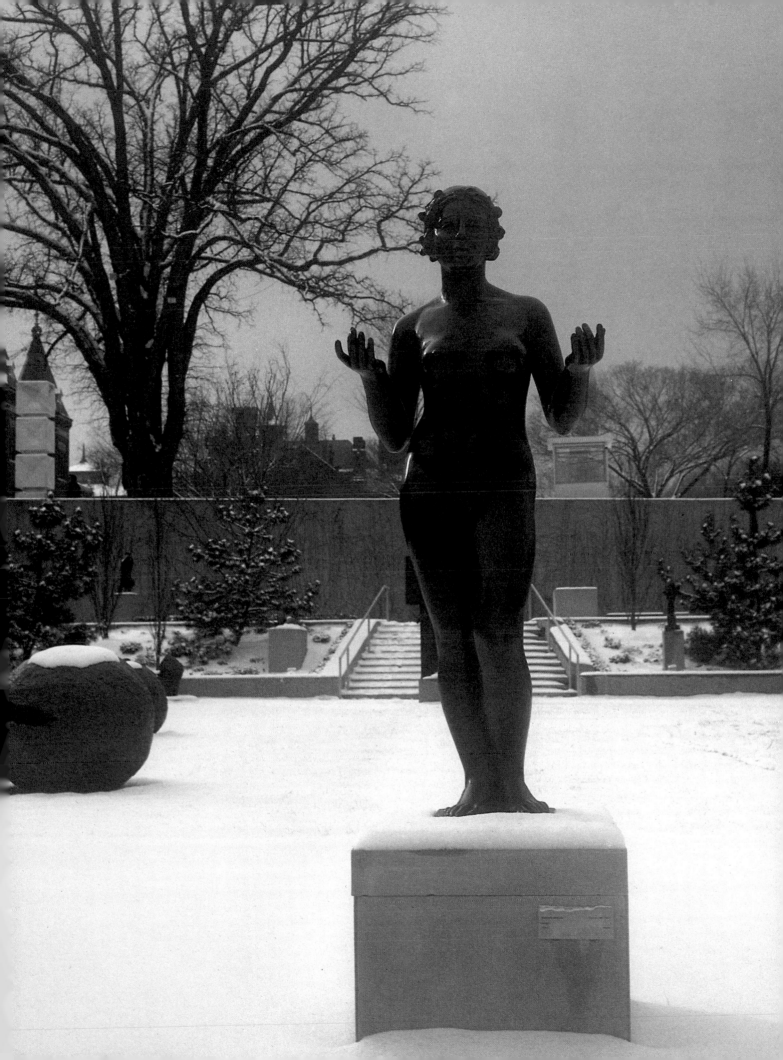

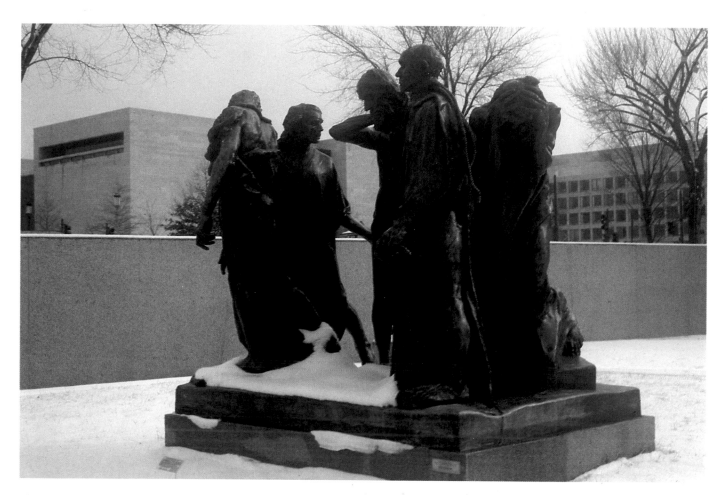

Hirshhorn Museum Sculpture Garden
The Burghers of Calais *by Auguste*
Rodin — bronze.

Hirshhorn Museum Sculpture Garden
Above: Eve *by Laura Ziegler —*
bronze.
Below: Back I, II, III, IV *by Henri*
Matisse — bronze relief.

Groundbreaking ceremonies for this bold addition were held in January of 1969, with Lyndon Johnson in attendance. But difficulties were not long in coming. Many objected to the design of the sculpture court. What only months before had seemed a reasonable, if daring plan for an art space, became, to quote from clippings dating from the time, "an unsightly trench," "an invasion," and "a bowling alley for sculpture." Even senators and congressmen got involved, eventually forcing the Smithsonian to yield and ask Bunshaft to re-think his concept.

In 1971 Washington Star art critic Benjamin Forgey suggested in a column that the garden run parallel to the Mall, rather than cutting into it. This would mean a garden chopped from about eight acres to just under two, but a garden nevertheless. Bunshaft and the Smithsonian agreed to the compromise. Construction proceeded on the revised garden and in 1974, only days before the official opening in October, about 50 pieces were transported (some by helicopter), to the sunken sand-and-gravel floors of the new sculpture court.

For the first several years, the garden followed an early 20th-century tradition of few plantings and un-decorated backgrounds, letting the sparsely placed works stand on their own.

In the late 1970's, when it became necessary to modify parts of the garden for wheelchair access, the museum staff took advantage of the situation and hired landscape architect Lester Collins to plan a major overhaul. Collins, who heads the Innesfree Foundation for the study of Oriental landscape design, essentially turned the court into more of a garden. Plants, trees and areas of grass were introduced, gravel and dark brick surface replaced the floor. "The greening of the Hirshhorn's outdoor gallery," as one critic described it, allowed for the installation of about 25 more sculptures. The new garden opened in the fall of 1981.

Hirshhorn Museum Sculpture Garden
Overall view including:
At left: Ex Cathedra *by Beverly Pepper — stainless steel and isofan color.*
Center: Traveler's Column *by Arnaldo Pomodoro — bronze.*
At right: Five Balls (spacial concept) *by Lucio Fontana — bronze.*

MAEGHT FOUNDATION

The French Riviera is in many ways the spiritual home of modern art, and it is here, in the village of Saint-Paul-de-Vence, overlooking the Mediterranean, that art impresario Aimé Maeght built a showplace for the artists he discovered, befriended and made famous. **The Marguerite and Aimé Maeght Foundation** straddles a hilltop and mimics a village. It is centered on a spectacular terraced construction which offers an effective setting for the works of Alberto Giacometti, Joan Miró, Marc Chagall, Georges Braque, Fernand Léger, Alexander Calder, Raoul Ubac and others.

Few other locations could display pieces so dramatically. The main structure was built on different levels, to conform to the steep slopes it sits on. Its walls incorporate native stone and locally fired brick. Its curved roof resembles a reversed wing, linking earth with the clear blue sky of Provence. The roof also serves to collect rain-water, as the graceful arches beneath serve to collect and diffuse sunshine, bouncing it off walls and through skylights until every courtyard and hallway, every painting and sculpture receives its own quota of natural light.

But it is the landscaping outside these structures that gives the foundation its special distinction. Sculptures, ceramics, and mosaics, many of them specially commissioned, sit amid pools, terraces and courtyards with mountain and sea in the background, or nestle in stone walls curving along the hillside. A grove of pines at the entrance holds a number of works, including a Calder stabile and an Ossip Zadkine bronze. The grove is bounded by a stone wall holding a shimmering mosaic by Pierre Tal Coat. From here a pathway leads to an entrance "moat" and, nearby, another mosaic, this one a fragmented, colorful composition by Marc Chagall. Above, the twin roofs of the central building loom in the sunlight.

Inside, the galleries trailing off to the left display paintings and drawings by Kandinsky, Ellsworth Kelly, Steinberg and Chagall. An interior court contains more sculpture. Through a modest doorway, the court opens onto a spacious square with an eerie group of solitary Giacomettis striding toward the horizon. Another pool lies at the edge of the square, by a gateway to the Miró "Labyrinth," which marks the beginning of the outdoor exhibits.

The Labyrinth — a mixture of rock walls, terraces and pools — features a broad collection of the artist's sculpted creatures, punctured wall pieces and ceramic-tile "paintings," all in primary colors and black. The marble "Oiseau Lunaire" stands here. So does the "Lady with Loose Hair," her shining form sharing a pool with a multi-colored baby's chair. To the west of the building, Miró's "Arc," a huge inverted cast-cement arch, hints at a surrealistic fleshiness. Down a slight grade, in a rocky cul-de-sac, a whimsical Miró "Weathervane," in the shape of a farmer's hayfork, imparts human dimension to a magnificent view.

The happy coincidence of landscape and art are partly the work of José Luis Sert, the head of Harvard University's school of architecture, who

Maeght Foundation
Giacometti's courtyard, *walking men and standing women — bronze.*

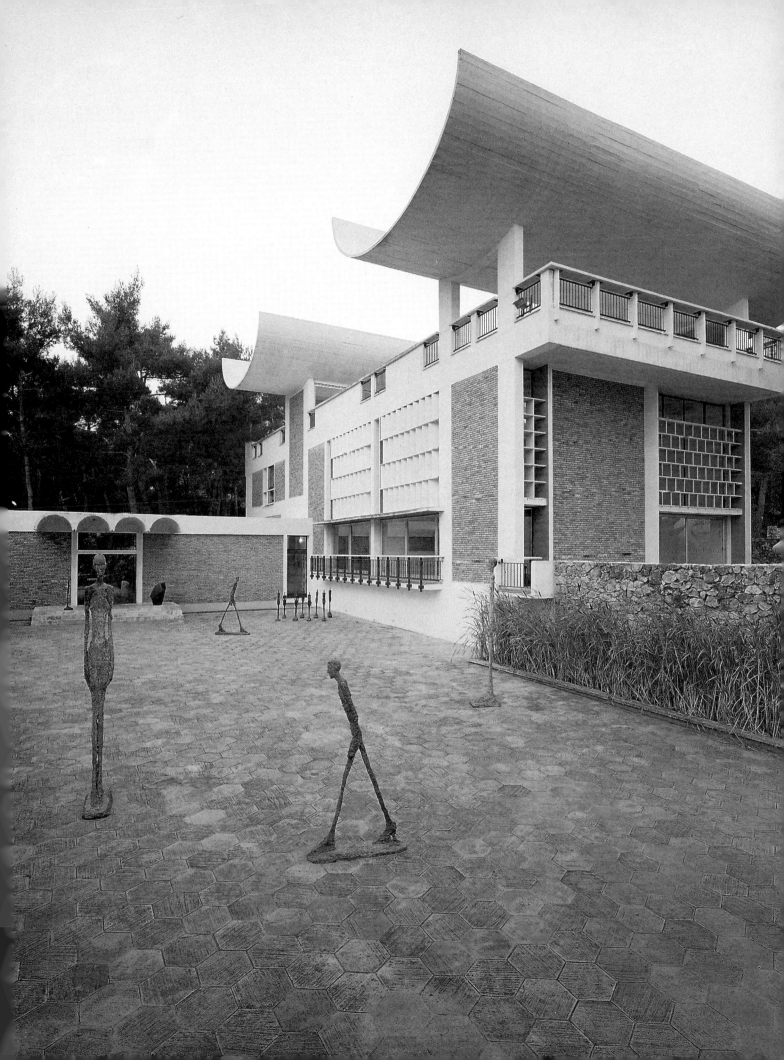

Maeght Foundation
The Fork *by Joan Miró — steel and bronze.*

The Egg *by Joan Miró — ceramic.*

offered his services free of charge to design the foundation. Sert collaborated with Miró, Giacometti, Braque and other artists in bringing the museum into being.

The property at Saint-Paul-de-Vence was purchased in 1950 by Aimé Maeght as a summer house. The foundation itself came into being three years after Maeght's ten-year-old son died of leukemia. Sensing his grief on a visit to the house, Maeght's friend Braque urged him to bury his sadness in a new project: a museum on that very site.

Maeght ran galleries in Paris, New York, Barcelona and Zurich, as well as an active publishing business. It was Maeght who helped to "democratize" art in this century by urging big-name artists to produce prints and multiples at relatively modest prices. The Miró and Chagall prints on view in the galleries and art fairs around the world are the result of this idea.

The foundation came to include a printing studio and apartments for artists in residence. Maeght maintained his residence on top of a nearby hill. A museum itself, the house holds a group of commissioned sculptures and mosaics, as well as a fig orchard and a greenhouse. The "New York Times," in an article about Maeght shortly before his death in 1981, was unrestrained in its praise of his foundation, calling it "one of Europe's most splendid museums... The foundation is a joyous blending of glorious site, sensitive architecture and incomparable natural light that celebrates art and man's creativity in a very special way. It is less a museum than a home for art."

Maeght Foundation
Above: View of Miró's Labyrinth.
Below: Miró's Labyrinth with his
"Oiseau Lunaire" and *"Lady with*
Loose Hair" in marble.

Maeght Foundation
Humptulips by Alexander Calder
— stabile-mobile.

OAKLAND MUSEUM

The Oakland Museum, near San Francisco, is also known as the "Museum of California," due to its strong focus on the history, art and ecology of that state. The museum lies underneath and around a labyrinthine garden with many terraces and indigenous plantings, and is practically invisible from the outside. Camouflaged by redwoods, cypresses, ferns, vines and assorted wildflowers, this "contemporary hanging garden of Babylon" is the work of architect Kevin Roche, who designed and developed it in the late 1960's.

While the garden's primary focuses are botany and recreation, it also holds a small but noteworthy collection of sculpture. Galleries from all three of the museum's departments open onto this collection. Along the vine-bordered, roofless walkway near the museum's entrance, for example, is a clear, molded acrylic work by Bruce Beasley. Half jewel and half instrument, it gleams above a reflecting pool filled with carps, providing a focal point for visitors ascending and descending a nearby stairway.

At the top of these stairs, against the museum's pervasive background of beige, sandblasted concrete, is a dark, burly sculpture by Peter Voulkos. A continuous metal cylinder, the piece alternately piles up and straightens out beneath an overhang of eucalyptus trees.

Other sculptures may be seen in the inner garden's many squared-off terraces, such as a yellow-glazed ceramic cross by John Mason, and the much-photographed "Talking Garden." The work of Doug Hollis and Richard Turner, this structure, which resembles a teahouse, has various ramps and a hypnotic sheet of shining water. Stairs lead down to a series of walkways and terraces lined with greenery, at the end of which is a lawn displaying other works — Richey's swaying "red lines" and a more earthbound ensemble of mounds and slabs by Stephen de Staebler.

Oakland Museum's major showcase for sculpture however lies down the street from its main building. The 22-acre project begins on the edge of Laney College and follows the waterway connecting Lake Merritt with the Oakland estuary. Monumental steel, concrete and bronze sculptures by Serra, de Staebler, Benton and other Californian artists are exhibited on narrow sloping strips of lawn along either side of the long brackish channel. Joined by another hulking Di Suvero, the sculptures range from low and spare abstractions through gesturing life-size figures to 25-foot totemic compositions of steel. Despite the high proportion of local artists represented here, the most Californian feature

Oakland Museum
Tragamon *by Bruce Beasley — lucite.*

110

Oakland Museum
M *by Fletcher Benton — aluminium and plexiglass.*

Oakland Museum
Seated Man and Seated Woman
Group *by Stephen De Staebler —*
bronze.

of the project may be the fact that it is slashed by a busy freeway. The road interrupts the walkway and one has to drive to the end of the channel to see the final pieces. These include the three tiers of Michael Heizer's muscular steel "Platform," Betty Gold's 4,800 pound "Monumental Holistic I," and Gary Dwyer's ephemeral "Seanchai," a sod structure installed in 1982 when the project was officially launched. The idea for the park originated with Oakland's Vice-Mayor John Sutter after a visit to Japan's Hakone Open-Air Museum. Sutter worked with George Neubert, Oakland's art-curator at the time, to convince the city fathers, as well as other parties public and private, of the need for such an outdoor exhibition space in Oakland. Neubert had initiated many previous sculpture programs, including the controversial "Public Sculpture/Urban Environment" in Oakland in 1974.

Their labors eventually met with success. The project has raised, in Neubert's words, "the exciting possibility of doing things in a non-traditional atmosphere, in an environment not like that found inside museum walls. It's a way of keeping in touch with artists who are creating work that can't be put within walls, and a lot of artists are thinking that way, making art... that can't be seen in traditional ways."

DALLAS MUSEUM OF ART

In the years since Oakland's main building opened in 1970, numerous new museums have been constructed that also integrate interior and exterior exhibition spaces — the Hirshhorn, Louisiana, and many others of more modest scale. In early 1984 the **Dallas Museum of Art** completed construction of a building that included a major new sculpture garden in its ultra-modern complex on a downtown block of that Texas city. The 1.2 acre garden runs perpendicular to the museum's elegant, 40-foot-high barrel vault — an architectural feature that has become its unofficial "trademark." Inside its walls, waterfalls, runnels and pools set off a small but select collection of late 19th and 20th-century sculpture. Indigenous oaks, patches of grass, gravel, and a brick surface soften the exact geometry of the space.

A major piece in the Dallas collection is Ellsworth Kelly's untitled grey metal sculpture, from his "Rocker" series. This commissioned work, whose two half-circles are joined at the top, forming an "entrance," appears ready to rock back and forth. Scott Burton's "Granite Settee," also specially commissioned, is a polished group of geometric stone blocks on which visitors are encouraged to sit. Sculptures by Richard Serra, Tony Smith and Kenneth Snelson are also on display in the garden, along with important earlier modern sculptures by Rodin, Max Bill, Hepworth, Moore, Manzù and Miró.

Sculptures on view elsewhere at the Dallas Museum include a gigantic post-and-lintel stone piece by Richard Fleischner in the special "Education Garden," adjacent to the museum's educational facility. At the museum's grassy entrance plaza, facing the Dallas skyline, there is an uplifting bright-red steel construction by Mark Di Suvero titled "Ave." The museum plans to fill its outdoor spaces with many more sculptures in the years to come, putting it in the same league as more famous gardens to the east. Paul Goldberger, the New York Times architecture critic, called the complex "urbane... a museum built by people who know about art and who know about respectability... Its sculpture garden, when filled, should bring to mind the garden of the Museum of Modern Art in New York."

Left: Dallas Museum of Art Ave *by Mark Di Suvero — steel construction.*

Right: Untitled *from the* Rocker *series by Ellsworth Kelly — stainless steel.*

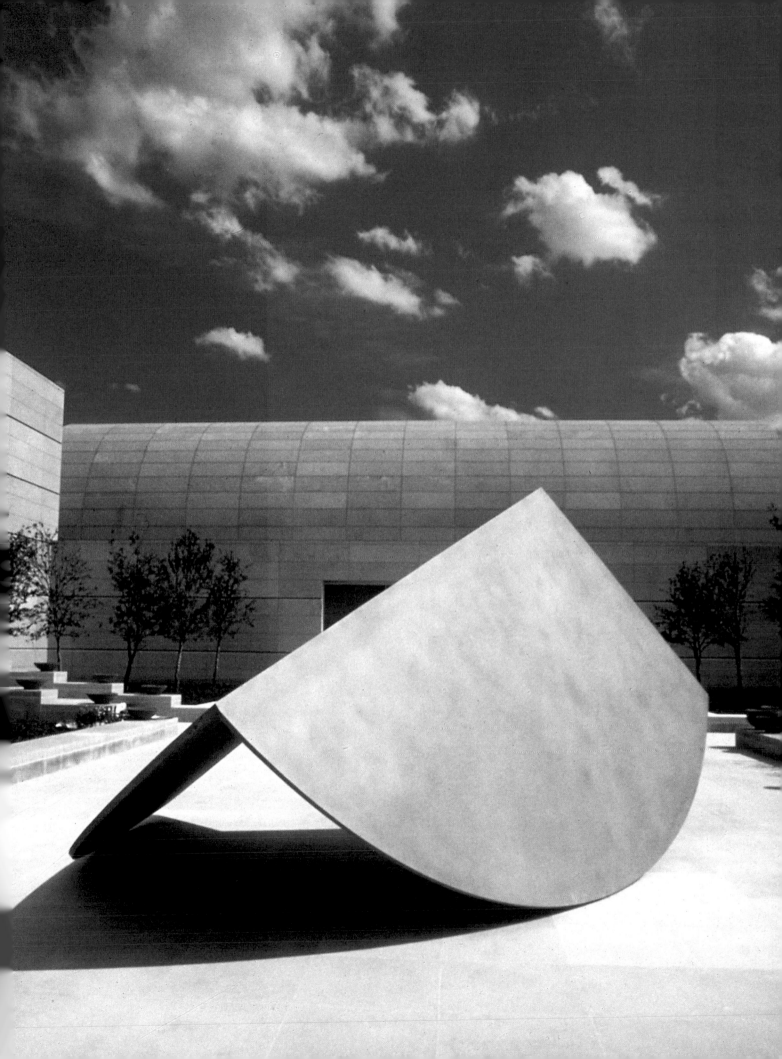

KRÖLLER-MÜLLER MUSEUM

Beyond the geometric patterns of canals and architecture that characterize the city of Amsterdam; beyond the Delft of Vermeer, The Hague of Potter, lies Holland's Gelderland. Here, fields and towns give way to forest and copse encompassed by the Hoge Veluwe National Park. Amid landscapes reminiscent of the earliest of Van Gogh's work, amid pine and scrub, grass and still water, is the **Kröller-Müller Museum** and its sculpture garden. With its array of contemporary sculpture, it is one of the great museum sites in the world today. Where once the Dutch created art from landscapes, now they create landscapes around art.

Kröller-Müller does not leap out at the visitor. The low architecture of the main building appears gradually out of dense greenery. Its outdoor collection, one of the most formidable in the world, is largely invisible behind the trees.

The exception is Mark Di Suvero's large "K-Piece," which slants in brilliant red across the front lawn, and acts as de-facto emblem for the museum. Visitors go into the garden through the museum itself, down a glass enclosed hallway that branches off into indoor galleries. These hold a coherent collection that, although expanded since Helen Kröller-Müller's death in 1939, still keeps to the original theme, namely, that "there is a realistic and an idealistic movement in the sphere of art and that at a point in the future these opposing sides... fuse." Included in the museum's displays are numerous works, both abstract and figurative. Most are 19th and 20th-century pieces, with a heavy emphasis on Van Gogh.

As with Denmark's Louisiana Museum, the many plate-glass windows afford views of woods and sculptures. And at the far end of a T-shaped hallway automatic doors open onto a 26-acre procession of sculpture. In a small pond surrounded by lawn, Marta Pan's swanlike "Floating Sculpture Otterlo," specially commissioned for the site, moves in slow circles across the surface. Around it, Rodin's "Squatting Woman," Lipchitz's "The Couple," Maillol's "Air" and other examples of early modernism contrast with the larger, more daring works in the woods beyond. This section of Kröller-Müller unfolds as a romantic park.

In one clearing, Evert Strobos' "Palissade," a series of 24, two-story-high steel blades, rises in a rusty semi-circle; Tony Smith's "Wandering Rocks" is a series of geometrical steel forms inspired by the stones in a

Kröller-Müller Museum
Jardin d'émail *by Jean Dubuffet — concrete, epoxy paint, polyurethane.*

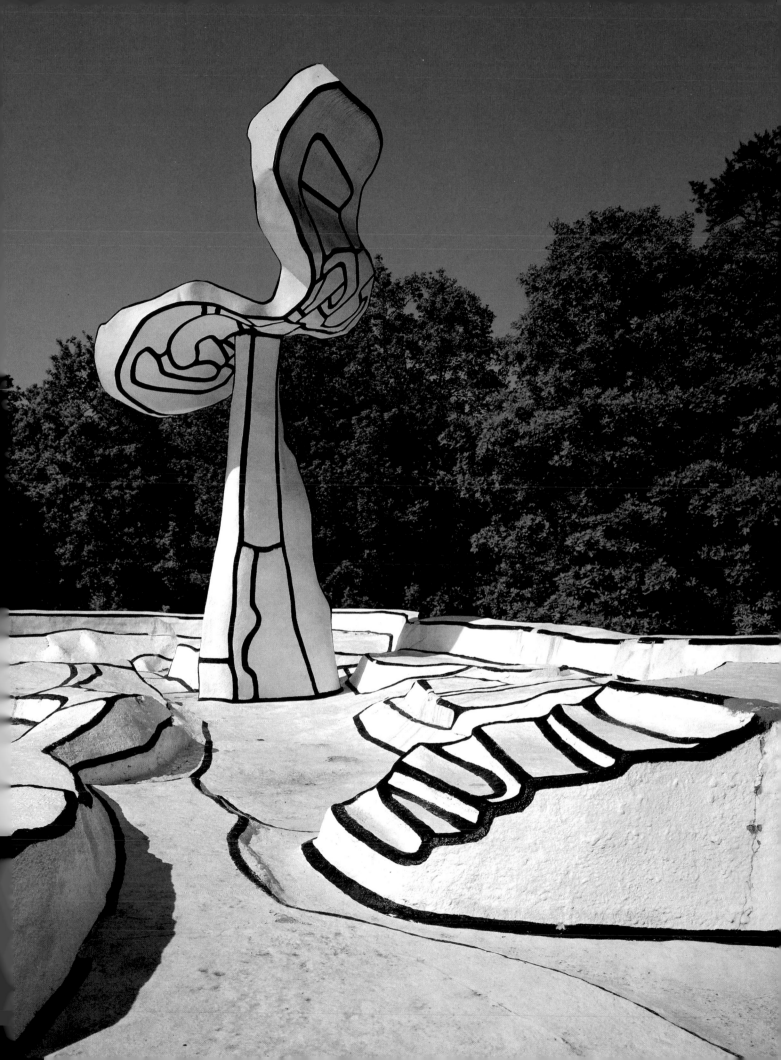

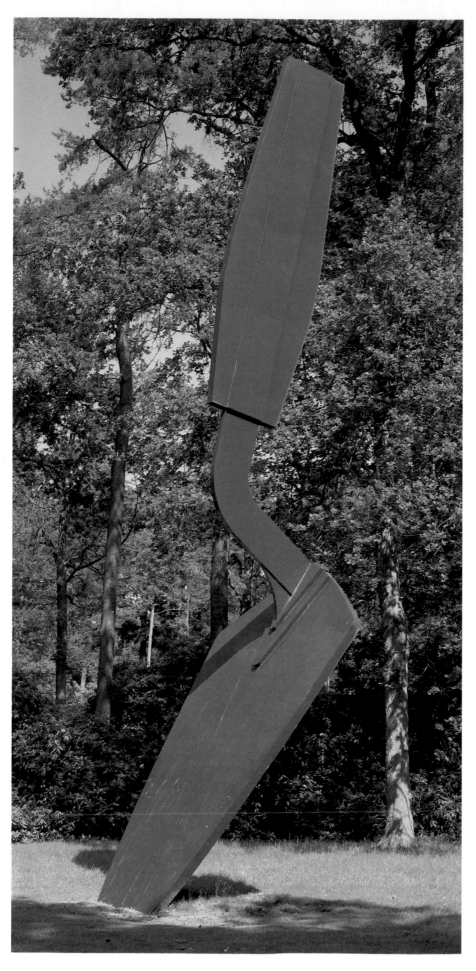

Kröller-Müller Museum
Left: Trowel *by Claes Oldenburg —*
steel sprayed blue.

Right: Kröller-Müller Museum
Palissade *by Evert Strobos —*
Cor-ten steel.

Japanese garden; Kenneth Snelson's "Needle Tower" is a precise series of aluminum tubes suspended by a steel cable. (This example of his patented "tensegrity" system is the tallest of its kind on public display). Elsewhere, Claes Oldenburg's 25-foot sky-blue "Trowel" is of such large scope that it is not immediately recognizable as a garden tool, but appears at first as some grand abstraction.

Jean Dubuffet's "Jardin d'Email," bordered by trees on two sides, is the largest work in the garden, and possibly its biggest attraction. An environment in itself, this walled expanse of black lines over a chalk-white base holds a cement "tree" and can be entered through an interior staircase. According to Dubuffet, the work should be "conceived of as a floating island, looking somewhat like the white of a beaten egg — a pleasure raft swimming on a body of water."

An open-air pavilion in a corner of the garden holds a comprehensive exhibit of Barbara Hepworth sculpture. Hepworth, who cared so much about a sculptor's landscape, would have approved of the site which is somewhat isolated, in a clearing of careful confines. Although unlike the rough-hewn Cornish location of her last studio, the Kröller-Müller site shares the same qualities of sharply defined outdoor space so favorable to the display of sculpture.

There is a cul-de-sac at the end of the circular path, where a "Land-Art" work by Richard Serra divides up space in a recess in the low ridge surrounding the sculpture park. Like many of the contemporary works in the garden, Serra's "Spin Out (for Robert Smithson)" was placed in a setting designed by the artist himself. So was Richey's "Two Vertical and Three Horizontal Lines," whose panels are constantly altered by the wind, and Van de Kop's "Tuam," which completely alters the spatial relationship of a grassy knoll in the garden.

The attractions of Kröller-Müller are architectural as well as sculptural. The re-constructed Rietveld Pavilion is a case in point. Designed in 1955 for a sculpture exhibition at Sonsbeek Park, the pavilion constituted an act of homage to another of Holland's great 20th-century architects, Gerit Rietveld, who with H.P. Berlage and Henry van de Velde, helped reshape Holland's cities. The pavilion's architecture works as a tribute because it successfully fuses with both nature and sculptures, many of which (by Van Elk, Dekkers, Stycken) were made expressly for Kröller-Müller's interior spaces.

The museum's history began early in this century, when Helen Kröller-Müller and her husband decided to move from The Hague to the country.

The Kröller-Müllers commissioned the architect Berlage to design a hunting lodge for a different location in the park. But their early plans for an art museum were halted by the Depression. In order to complete the project, the Kröller-Müllers turned land and collection over to specially-created foundations. The Belgian architect Van de Velde submitted a scaled-down plan for the art museum. The new structure, with its sharp horizontal lines and innovative skylight system opened in 1938. Over the years the museum began to add sculpture to what was essentially a painting collection. In 1953 an indoor sculpture gallery was introduced, but it was not until 1961 that the first outdoor pieces appeared at the museum as a temporary exhibit. In 1965 the garden was expanded, and again in 1970. Dr. Rudolph Oxenaar, director since 1963, has been responsible for bringing to the garden most of its major names and oversize pieces.

In 1979 a new wing was added to the museum, built by the Dutch architect W.G. Quist. The wing provided a new entrance into the contemporary art section, but maintained, through careful proportioning, its harmony with the Van de Velde building.

Following page: Kröller-Müller Museum
Works by Dame Barbara Hepworth in the Rietveld pavilion. All in bronze.
At left: Oval Form, Trezion.
Center: Single Form, Eikon.
At right: Dual Form.

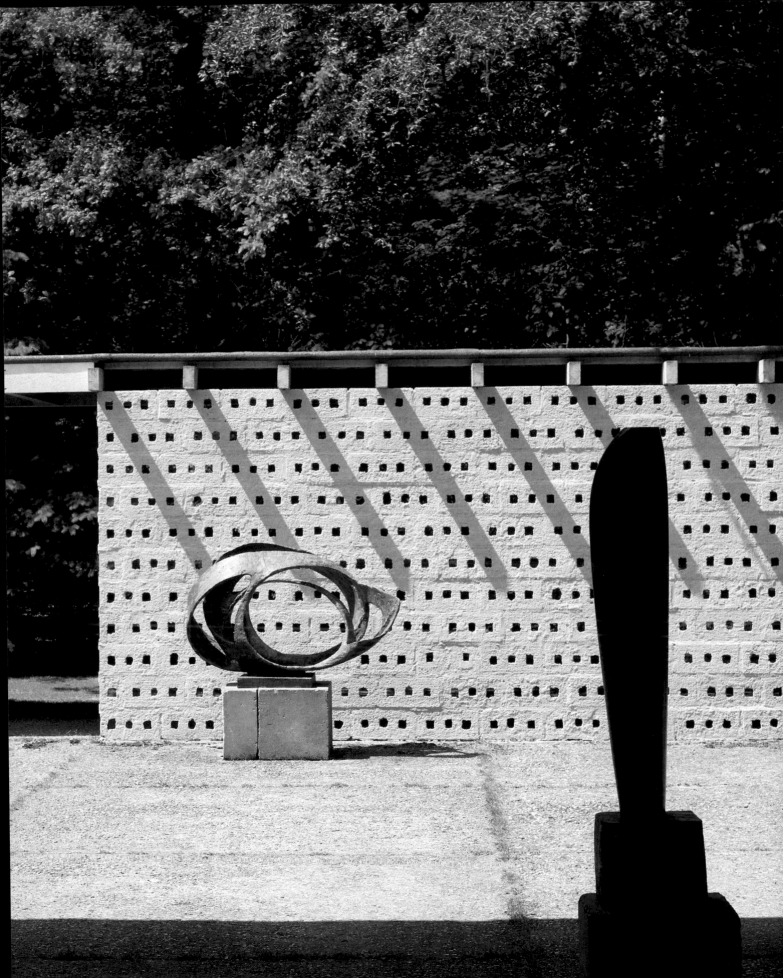

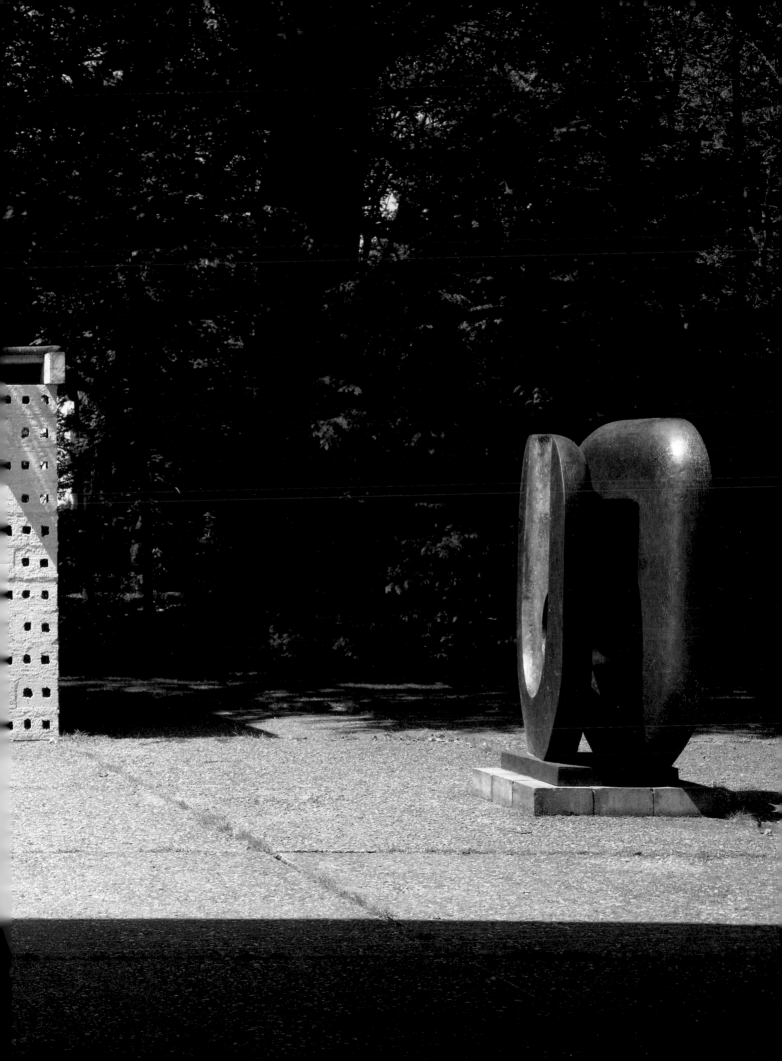

LOUISIANA SCULPTURE GARDEN

The **Louisiana Sculpture Garden** overlooks Öresund Sound in Denmark, opposite the Swedish coast. The garden is both intimate and spectacular, and works as a centerpiece for the Louisiana Museum, a suburban park and villa complex which has become a focus for avant-garde events.

The 19th-century mansion, which serves as a gateway to the museum, reveals little of what is to come. Henry Moore's "Reclining Figure," installed in the courtyard, is the only evidence that beyond this facade lies one of Scandinavia's finest collections of modern sculpture. The mansion itself is flanked by modern museum "wings" where paintings — some of the best Roy Lichtensteins, Lucio Fontanas, Andy Warhols and Frank Stellas of the past 20 years — line crisp, skylit galleries and glass-walled walkways. And there is a light-filled room full of Giacometti sculptures, including the famous "Venetian Women" group.

But outside is where the best of Louisiana's sculpture is to be found, in sweeping vistas against the blue of the Sound or closer in, near the museum buildings, amid a mix of foliage and open lawn. The buildings are designed so that visitors can have a perfect view of the sculpture from indoors. Granite chip pathways wander into the garden, skirting the low-lying galleries and meandering through woods and into clearings, where clusters of sculptures appear unexpectedly, like Max Ernst's "Frog," "Turtle," and "Great Assistant" trio. Sculptures by Jean Arp rise from green turf with more suppleness than they might in a restricted indoor setting.

A forest of stumpy Viking-like stone creatures by the Danish sculptor Henry Heerup occupies one part of this area. Elsewhere, a brick platform holds Nabuo Sakine's multi-media "Faces of Nothingness."

Because Louisiana is located in a park, the larger sculptures are allowed sufficient space as well. The bigger they are, the more dramatic their placement. A trio of exuberant Calders, in primary colors and black, sits high on a terrace adjacent to the museum restaurant. Sizeable works by Moore also benefit from the quantity and quality of Louisiana's grounds. Great pains have been taken to arrange the work of each sculptor in its own locality, and the quality of each area has been strengthened through the choice of the precise placement of the works of art. Each work can be seen from a distance without undue competition from other sculptures.

Louisiana
Spoon-Woman *by Alberto Giacometti — bronze.*

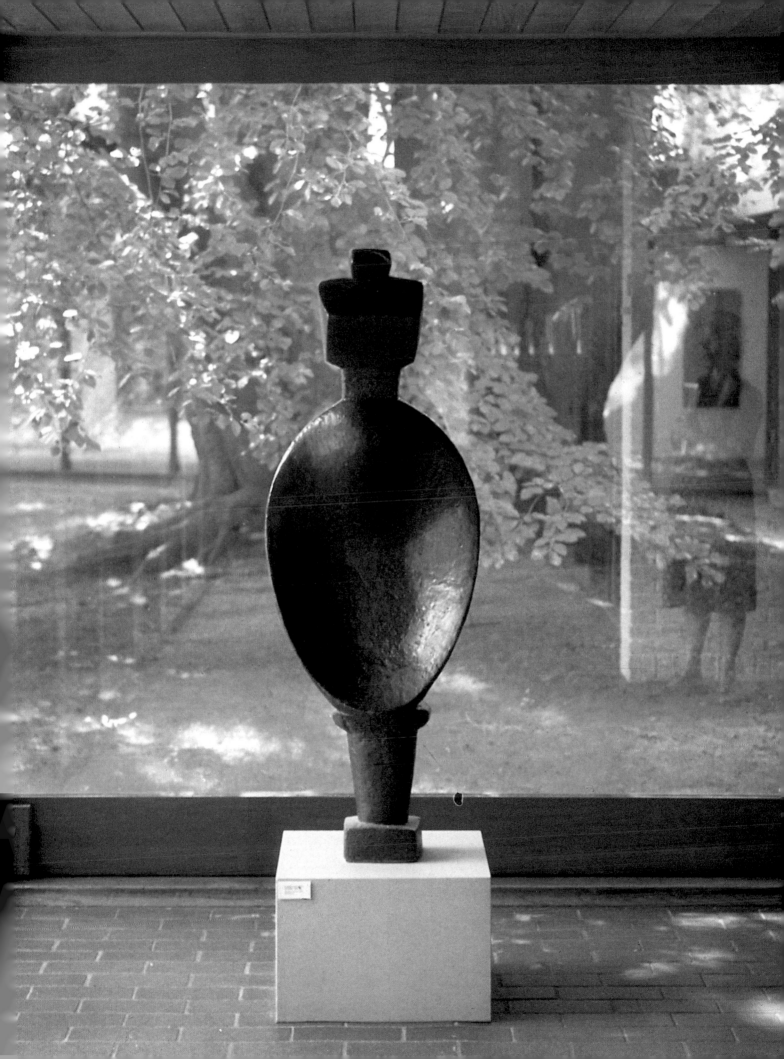

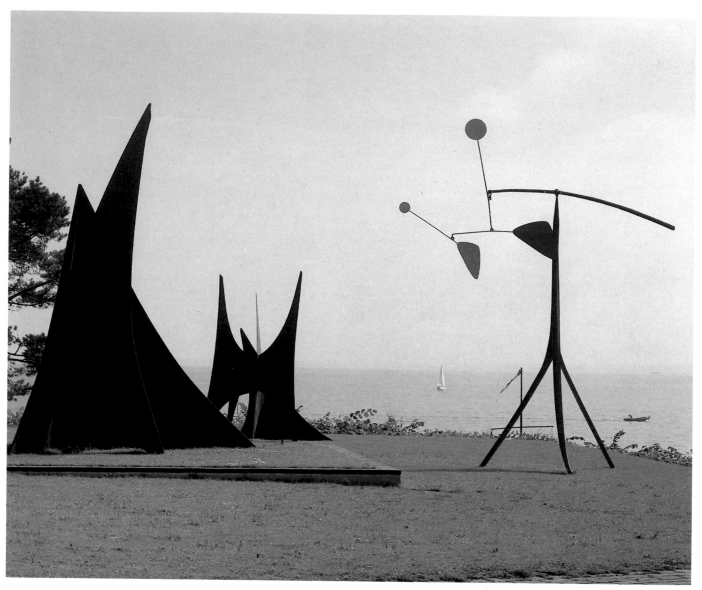

Louisiana
Works by Alexander Calder
At left: Almost Snow Plough —
iron.
Center: Nervures Minces — *iron.*
At right: Little Jane-Waney —
stabile-mobile.

Numerous events, from performance art to children's festivals, take place at Louisiana every year. In the early '60's, Jean Tinguely activated his "Sketch for the End of the World," and there was a near-disaster as rockets and metal parts shot all over the grounds, narrowly missing assembled guests. For "War and Mankind," a performance piece of 1981, several people walked fully clothed into the icy waters of the Sound.

The man responsible for these off-beat events is Knud Jensen, the founder, director and guiding spirit of Louisiana. Jensen became an art collector in the process of decorating his company's offices and warehouses with paintings and sculptures. He then got upward of forty Copenhagen companies involved in collecting art for their employees as well as forming a coalition called "Art in the Workspace."

In 1955 he came upon what was then a dilapidated estate, originally built by Alexander Brunn, master of the royal Danish hunt. The estate was called "Louisiana" because Brunn's three wives all had been named Louise. Jensen, who had grown tired of the stuffy atmosphere of Copenhagen's Royal Museum, bought the property with the idea of establishing an open-air museum for contemporary Danish art. After restoring the grounds, Jensen hired the Danish architects Jorgen Bo and Wilhelm Wohlert to build an exhibition complex that would conform to the natural surroundings.

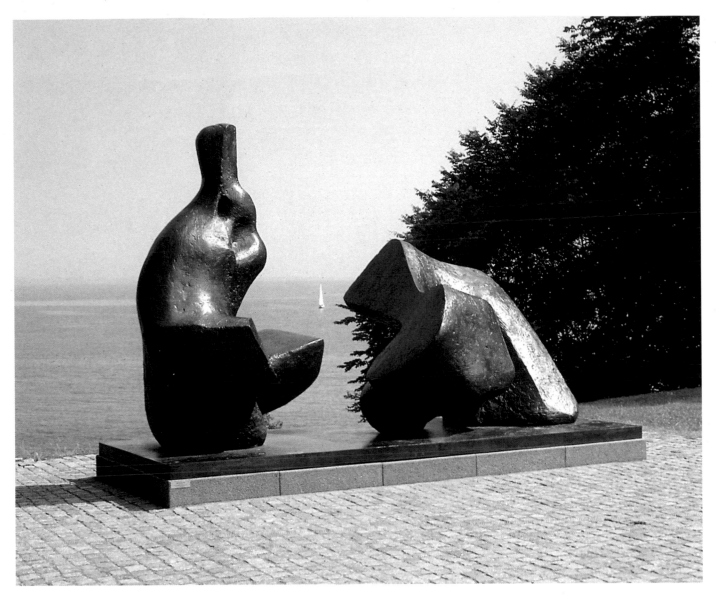

Louisiana
Reclining Figure No. 5 *by Henry Moore — bronze.*

This concern inspired the glass corridors and the three pavilions; in 1966 and 1971 new extensions were added including the concert hall, and in 1982 the south wing for the museum's own collection. The final phase of building will include a corridor connecting the two wings with an underground multi-purpose gallery. Thus, the complex of buildings will form a circle and it will be possible to go all the way round and concentrate on works of art or look out at the park or the Sound. The landscape gardening has been the creation of Ole and Edith Norgaard. Ole designed the sculpture garden and Edith is responsible for the setting around the new buildings.

Louisiana Museum opened in 1958. "At Louisiana," Jensen told the "New Yorker" magazine in 1982, "we've tried to create a refuge, a sanctuary, a sort of Shangri-La... we've tried to preserve the wild and the slightly dangerous element in art."

Louisiana
Left: Groupage in Stone *by Henry
Moore.*

Right: Works by Nabuo Sakine
At left: Nine pieces — *stone.*
At right: Faces of Nothingness —
marble and steel.

MODERNA MUSEET

The Sculpture Garden of Stockholm's **Moderna Museet** boasts a small but spectacular collection. The museum's low buildings stand in the parklike setting of one of Stockholm's numerous islands. Its sculptures surround it, making good use of their environment of thick foliage, open glades, and occasional dramatic views of the sea.

The Moderna Museet has long been one of Europe's better known centers for progressive art, promoting artists like Oldenburg, Tinguely and Bueys, and movements like Pop, "Kinetic" art and "Sound" sculpture before it was "safe" to do so.

Much of this vitality came from former director Pontus Hulten, whose showmanship and curatorial genius in the 60's and early 70's helped build the museum's collection and bring it into the international limelight. Today, in addition to the collection, the museum runs a well-attended art school, as well as a program of cultural events for adults and children.

The museum's lively reputation is appropriately represented at the building's entrance by a buoyant Alexander Calder. "Four Elements" is neither a stabile nor a standing mobile, but a mixture of both that offers different vantage points as visitors pass beneath it.

Lower down, between woods and water, another "ensemble" sculptured by Niki de Saint Phalle and Jean Tinguely violently combines the differing styles of these two artists. Jagged and aggressive metal contraptions by Tinguely threaten as they counterpoint Saint Phalle's sensuous "Nanas" — earth-mother, folk style females of bright Mediterranean colors.

Picasso's evocative "Déjeuner sur l'Herbe" sits in a shady glen next to a handful of wooden houses for art students. Completed in 1966 by Carl Nesjar, the Norwegian artist who executed all of Picasso's monumental sculptures in the year before and just following his death, it is based on the famous Manet painting of the same title. (This in turn was based in part on "La Festa Campestre," a 16th-century painting by Giorgione.) Re-reading Manet's sensuous subject matter — four picnickers, one of them nude — Picasso developed the theme in a series of drawings, eventually arriving at four naked bathers. "Déjeuner sur l'Herbe" was eventually transferred to three dimensions. According to Sally Fairweather, who documented Picasso's concrete sculptures, he "made a series of small cardboard cutouts, then... folded, drew, and painted on most of these."

Moderna Museet
One figure from Déjeuner sur l'herbe *by Pablo Picasso — sandblasted concrete.*

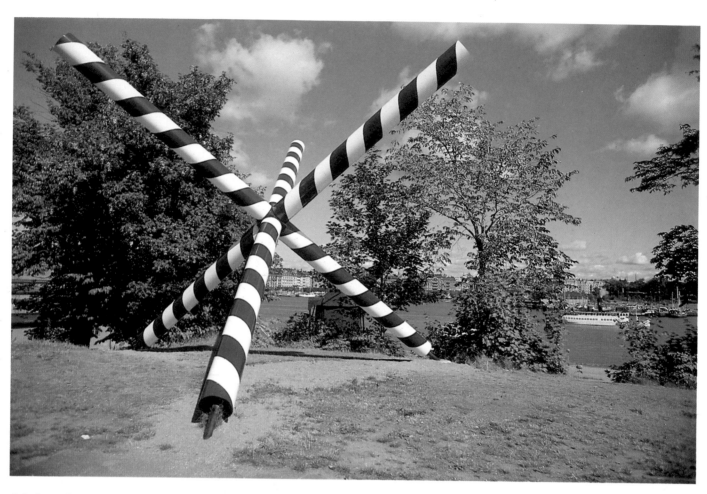

Moderna Museet
Pulsing coordinated-system *by Leif Bolter — painted plastic and motor.*

Four Elements *by Alexander Calder — iron.*

130

In 1964, when Hulten became interested in acquiring a Picasso sculpture for the grounds, the artist "thoughtfully chose four (cut-outs) whose postures related to the figures in Manet's painting," according to Fairweather. "He decided that as a group they would work especially well."

Ranging in height from 10 to 14 feet, the white concrete enlargements of these figures stand outlined in black, in an environment particularly well suited to the lush spirit Manet and Picasso intended.

Sculpturally it is perhaps the high point of this institution which seeks, in the words of current curator Ulf Linde, to give "a picture of this century's creative fever in art, of the divine moments, the elation, the joy."

Moderna Museet
Déjeuner sur l'herbe *by Pablo Picasso — sandblasted concrete.*

ART IN SCHOOL CAMPUSES

Princeton University, whose ancient elms and sun-dappled lawns, make it one of America's most appealing college campuses, also serves as a successful showcase for modern sculpture, with nearly two dozen works scattered among its halls and avenues. **The John B. Putnam, Jr. Memorial Collection** was established in 1968 by an anonymous donor. It adds a special quality to life at Princeton, one perhaps best summarized by sculptor Arnaldo Pomodoro, whose polished bronze "Sphere VI" rests in a glade flanked by dormitories: "I like to see people lean their bicycles on the sculptures, and pigeons come to rest, to see them humanized... (It gives) the sense of being in the midst of life, a part of its movement, and its hope for change."

The first sculpture many visitors to Princeton encounter is Louise Nevelson's 21-foot black steel "Atmosphere and Environment X," an imposing "wall" of abstract shapes facing Nassau Street and the campus entrance. Down a walkway from the Nevelson is Jacques Lipchitz's "Song of the Vowels," an early acquisition evoking a fluid image of harp and harpist, one of the sculptor's favorite motifs. The title comes from an ancient prayer, according to Lipchitz; the image is meant to suggest "the power of man over nature."

Around the other side of the library is one of Princeton's more controversial sculptures, George Segal's "Abraham and Isaac: In Memory of May 4, 1970, Kent State University." The piece was made to commemorate the killing of four young Vietnam War protesters by National Guardsmen, and was rejected by Kent State, only to be accepted and installed by Princeton in 1979. Segal used a Biblical story to illustrate the "violation of...values" inherent in the event. Nearby stands a David Smith "Cubi," a steel Rickey, and Moore's 11-foot-high "Oval with Points," commissioned for Princeton. This sensuously moulded innertube of bronze is constantly leaned upon, touched and used as a resting place by students, giving it a patina, as of great age. By contrast, the Engineering Quadrangle, on the northeast corner of the campus, features sculptures no-one could mistake for old, with a twisting steel "Upstart 2" by Clement Meadmore, a curved work that looks like a gyroscope by the Russian Naum Gabo, and the granite "Stone Riddle" by Masayuki Nagare.

Princeton
Five Disks: One Empty *by Alexander Calder — steel.*

132

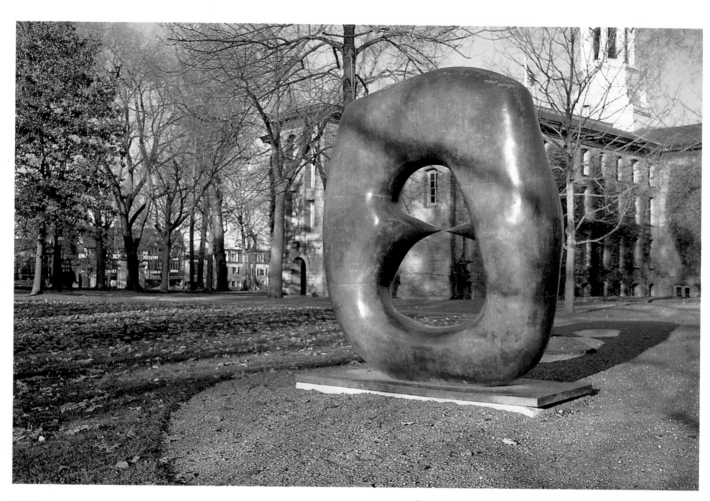

Princeton
Oval with Points *by Henry Moore*
— *bronze.*

The Putnam's many other major sculptures include Tony Smith's "Moses," (a black geometric composition), and Pablo Picasso's concrete 16-foot "Head of a Woman." Carl Nesjar, the Norwegian artist who executed all of Picasso's sandblasted concrete sculptures during the 60's and early 70's, spent five months at Princeton creating this work from the artist's original model in what was one of the most successful and elaborate outdoor seminars ever conducted at the university. Former Princeton Art Museum director Patrick Kelleher writes in "Living with Modern Sculpture": "Like books to which a person becomes attached through constant and informal contact, these sculptures... are exerting a comparable influence on the spirits, minds, and formative experiences of the young, on whom the future of this imperfect world must rely."

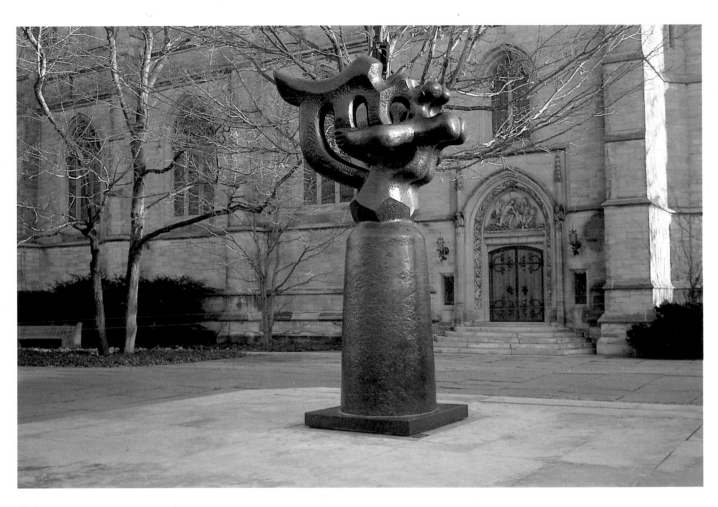

Princeton
Song of the Vowels *by Jacques*
Lipchitz — bronze.

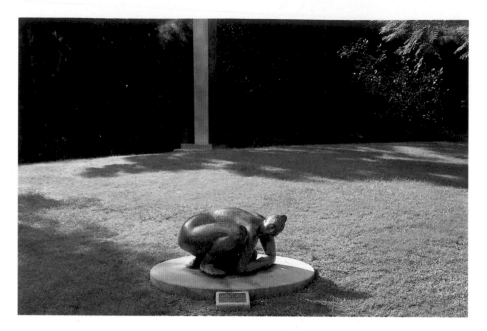

UCLA
Above: Garden Elements *by Isamu Noguchi — bronze set in aggregate concrete.*

Center: Colloquio Duro *by Piero Consagra — bronze relief.*

Below: Desnudo Reclinado *by Francisco Zuniga — bronze.*

Amidst the pedestrian commotion typical of large colleges, the **Franklin D. Murphy Sculpture Garden** at the University of California at Los Angeles offers over 60 outdoor pieces coexisting intimately with the numerous students who pass through it every day. The five-acre plot is inconspicuous at first among the crowds and campus buildings, but once within, the sculptures displayed give UCLA's familiar college atmosphere a unique quality. Classes are frequently taught out here, and students are always present, sitting beneath a Calder stabile, a David Smith "Cubi," or the needles of a 20-foot-high George Rickey. Sculptures cover the entrance to MacGowan Building, including Anna Mahler's stone totem, "Tower of Masks," and Robert Graham's neo-Edwardian figurine ensemble, "Dance Column I and II." This area forms the beginning of the Murphy Garden's second section, an L-shaped, brick-and-aggregate terrace that extends to the Dickson Art Center and its Frederick S. Wight Art Gallery. This architectonic space, with its display walls for relief sculpture, holds a large collection of Modernist masterpieces, such as Rodin's "Walking Man," Matisse's sequential "Backs," and Lachaise's "Standing Woman." Recent works are featured here as well: Claire Falkenstein's "Point as a Set, No. 25," Alberto Burri's black-ceramic jigsaw-like wall relief "Grande Cretto Nero," and, discreetly displayed in one corner, a portrait sculpture of the garden's namesake, Dr. Franklin D. Murphy, UCLA's Chancellor from 1960 to 1968.

The medically-trained administrator was exposed to art from childhood, and the development of a garden at UCLA became one of his chief preoccupations. With UCLA landscape architect Ralph Cornell, then in the process of "redesigning and realigning the mushrooming Westwood campus," Murphy arrived at an appropriate site and design. Something, in Cornell's words, "creative, with diagonal walks and many levels instead of a square flat space... a balance between the creativity of man and the creativity of nature."

The garden obtained its first piece in 1961, the commissioned "Tower of Masks" by Anna Mahler. The garden's first real prestige piece arrived shortly afterwards; Lipchitz's "Song of the Vowels" was acquired in 1963 from a show of the artist's work at the UCLA art gallery, where important exhibitions were continually being brought in by director/painter Frederick Wight.

Acquisitions continued gradually over the next few years, until 1967, when the bequest of David Bright increased the collection dramatically. Bright, highly active in the UCLA Art Council, he left a formidable collection of modern paintings to the University and an equally formidable collection of modern sculpture to his wife Dolly. Murphy knew the family, and suggested a trade, value-for-value, between Mrs. Bright and UCLA. As a result, the garden acquired a museum-quality sculpture collection, including pieces by Arp, Laurens, Moore, David Smith and others, which Murphy and Wight installed over Cornell's grounds.

Murphy left UCLA in 1968, and the garden, now officially named after him, continued to grow. A geometrical steel abstraction by Californian sculptor Fletcher Benton was commissioned, as was a metallic fountain by George Tsutakawa. Other additions included one of the few bronze casts of Joan Miró's "Mere Ubu," "Halfway" by Anthony Caro, and "Garden Elements" by Isamu Noguchi. Like all the pieces in the garden, these came from outside sources: donors included alumni classes, the UCLA Art Council, prominent collectors such as Anna Bing Arnold, the Frederick Weismans, B. Gerald Cantor, Norton Simon, Henry Ford II, and Mr. and Mrs. Sidney Brody.

Yorkshire Sculpture Park
Lower Orders *by David Kemp —*
recycled machinery parts.

The **Yorkshire Sculpture Park** at Bretton Hall College constitutes a unique opportunity for young British artists. Spreading out from the Palladian villa and outbuildings, its 260 acres of formal gardens, woods, lakes, and cultivated parkland in northeast England are devoted to providing a forum for exhibition they might not find elsewhere. Sculptors are invited annually to place their works in the landscape for temporary exhibitions. As at Belgium's Middelheim, a permanent collection is gradually built up from the exhibitions. Works are not bought or given, but offered on extended loan from artists, art councils and, in a few cases, London's Tate Gallery. Throughout the year, as new artists arrive, the park takes on striking new appearances.

Not far from the buildings, Anthony Caro's "Sculpture 7," an abstract framework of steel, sits amid a group of mature trees. Far from seeming out of place, its brown, blue and green beams combine with their background to integrate color, light and shadow.

A more classically sculptural piece is John Maine's "Outrider." This geometric chiseled work rests within the same kind of landscape as the Caro but reaches out in four directions. Close by Michael Lyon's "Heights of David" forms a portal of shining metal which focuses awareness on the rolling lawns that surround it. Austin Wright's "Ring" actually frames these flat vistas, as well as the complex's "Camellia House," an elegant "orangerie" which can also be seen through the work.

The sweep of lawn is similarly refined by Alf Dumm's "Quiet Conversation," a movable sculpture which offers constantly changing focal

Yorkshire Sculpture Park
Bride and Bouquet *by Robert Scriven*
— *wood.*

points at four key areas on the field. Further into the park, near an Edwardian-era formal garden, William Pye's "Deity Enshrined" acts like a giant wind chime in bronze and steel, making gentle metallic sounds and moving in a lazy sway of mass.

Britain's "first permanent sculpture park" opened in 1977, largely through the efforts of Peter Murray, a lecturer at Bretton Hall College. Much public attention that year had focused on a sculpture show in London celebrating the 25th anniversary of the Battersea Park exhibitions, whose early editions had offered sculptors like Henry Moore and Barbara Hepworth their first mass exposure. The "Silver Jubilee" show pointed out the need for a permanent showcase for large-scale sculpture in Britain, one which might be comparable to Middelheim and Kröller-Müller on the Continent and Storm King in the United States. With the backing of Bretton Hall's president, Alyn Davies, Murray enlisted the Yorkshire Arts Association to set up a permanent facility in September of 1977. Yorkshire was a fitting location for Britain's first sculpture park, being the birthplace of both Moore and Hepworth.

In 1978 the Yorkshire Sculpture Park offered its first annual fellowship. Artists and critics gave public lectures and exhibitions followed, featuring works such as Roy Kitchen's 60 foot-long, antennae-laden "Lifting Engine," John Maine's "Pyramid" of 29 interlocking sections of Portland stone; William Pye's polished stainless steel pieces, Andrew Drake's monumental wood "drawings" composed of shaped boughs and branches, placed like anguished snakes along the sloping fields near the house.

Chapter Three
ARISTOCRATIC GARDENS

*The bust of Actaeon from the garden of
Caserta.*

VILLA D'ESTE

Villa d'Este, in Tivoli, a hill town overlooking Rome, is known for its gardens and sculptures. But plant forms and artwork are bound by a third element which unites statues and flowers and provides Villa d'Este with its true focus: water.

Water is both the object and the vehicle of celebration here in the literally thousands of fountains, springs, torrents, basins, ponds, sluices, cascades, and channels that lie in every corner of the sloping gardens. It is the object of celebration because whether in sparkling jets or limpid ponds, in thundering torrents or unexpected and hidden fountains, water in its myriad forms is what gives the sculptured stones and flower-beds at Villa d'Este their originality.

None of this is apparent on entering the villa, a former Benedictine convent that was rebuilt in the late 1500's by Cardinal Ippolito d'Este to include the waterworks and terraced gardens leading down to the southeast slope of Tivoli.

The entrance courtyard is a former cloister, with arches, a chapel, one quite modest fountain in the middle. There is a doorway that leads past a mural depicting the gardens as they were first conceived.

But underneath the courtyard a huge, invisible reservoir is replenished by tunnels, pumps and acqueducts that bring water from nearby springs as well as from the Aniene River. The dynamics of Villa d'Este are concealed in this invisible cistern, for it is the pent-up momentum of this water that is used to bring the stone basins and statues and cascades below to life. A visitor would follow the passageway to a front belvedere that takes up the entire length of the actual villa. From there he could view the tiers of fountains, trees and flowers falling away in horizontal lines to the ancient cypresses and placid pools at the foot of the hill.

The water, however, takes a more direct course. It flows from the courtyard cistern through underground ducts designed and built by the 16th-century hydraulic engineer Orazio Olivieri. The tunnels direct its flow to the fountains of the uppermost level, closest to the villa proper. The most notable of these is the Fountain of the Oval, made of two basins set one on top of the other. Water runs into the first and overflows in a powerful cascade into the second. This cup and saucer arrangement, like many others in the Villa d'Este, is set in a niche cut into the hillside. Between the two basins stands a statue of the Tiburtine Sybil, symbol of Rome's river, flanked by figures representing its lesser companions, the Aniene and the Erculaneo. The statues, again like most of the others in the garden, are thought to be the work of the renowned Renaissance sculptor Ligorio. A balustrade with amphorae, vases and jugs rises above the Sybil's head. Each container adds its own stream to the general crash of water.

Villa d'Este
Oval Fountain. Detail of the Sibyl Albumea.

Villa d'Este
Oval Fountain with Roman inspired
statues in an arcade.

Villa d'Este
View of the Neptune Fountain.

The next level down is a walkway bearing flowers and the "Hundred Fountains," a self-explanatory series of sailing ships, obelisks and eagles (heraldic symbols of the d'Este), all carved in stone, that runs the breadth of the garden. Each symbol spouts its own plume of water, which runs through a number of little cascades into two troughs at the bottom.

The Hundred Fountains lie above the "Fountain of the Dragons," possibly the most aesthetically balanced piece of sculpture and waterworks to be found at Villa d'Este. In the midst of the central basin, a group of angry dragons hiss water in all directions while between them a spout gushes higher than any other in the garden. More water springs from unlikely places around the fountain and gurgles away down a stony ramp of seashells, where two sphinxes, crouched on guard, spray even more liquid from full breasts. The dragon fountain was built in honor of Pope Gregory XIII on the occasion of his 1572 visit.

Still further along lies the water organ, once the centerpiece of the garden, of which the French writer and philosopher Montaigne wrote after a visit in 1581: "The music of the organs, sounding always the same, is achieved by means of the water which falls with much violence into a round vaulted cellar, affecting the air there and forcing it to emerge and reach the organ pipes and furnish them with wind... (and) causing the organ's keyboard to beat in a certain order: one can also hear the sound of false trumpets (and) of birds..." This mechanism, out of order for decades, is currently undergoing restoration.

The water organ is guarded by two statues of musical gods, Orpheus and Apollo. Its large octagonal structure is a mass of carved musical instruments, shells and fish.

Water spilling out of the water organ is led down a long drop through a grotto carved into the hillside and ends much lower in a trio of rectangular pools where huge waterspouts jet high into the air, sprinkling rainbows into the sunshine.

At the bottom of the hillside spent water collects in ponds where the d'Este family kept freshwater fish for their dinner table. Strolling amid the primroses and cypress trees (the tallest of which are as old as the garden), the visitor can look up and see a hillside alive with flowers and shining water, a view not unlike that first conceived by the creator of the garden, Cardinal Ippolito d'Este.

Ippolito d'Este was born in 1509, the son of Lucrezia Borgia and Duke Alfonso of Ferrara. He was appointed archbishop of Milan at the tender age of 10, cardinal at 30, but was frustrated in his subsequent quest for the papacy. In 1550 he received the Villa d'Este and the governorship of Tivoli from Pope Julius III, and immediately set about making the villa and its gardens into an estate worthy of a prince of the church.

After the cardinal died the estate gradually fell into disuse. The painter Fragonard visited the villa and made sketches of its fashionably romantic decay. In the late 1800's the last d'Este duke died and the villa passed through the female line into the Hapsburg family. In 1868 the composer Franz Liszt was given use of apartments in the villa, where he wrote two piano pieces, dedicated respectively to the fountains and cypresses of the Villa d'Este, and gave one of his last recitals. When Italy declared war on the Austro-Hungarian empire in 1915 Villa d'Este was nationalized and restored so that anyone may now view splendors that once were reserved for a privileged few.

SACRO BOSCO, BOMARZO

Most sculpture gardens seek to prove a point, to impose a structure, whether it be on nature or on art. Italy's "sacred wood" of **Bomarzo** does not.

Bomarzo lies in the Italian countryside, in the Cimino hills, near Viterbo and 80-odd miles north-northwest of Rome. The countryside has seen the grandeur of Rome, the glory of popes and city-states, and most of all the Renaissance. It was the Italian Renaissance that first gave men the idea they could ascribe patterns to the universe and use those patterns to control the physical world. This idea was translated everywhere into sculptures, buildings, chapels, bridges, paintings. These humanistic statements, more than anything else, left their gentle mark on the countryside around Bomarzo.

The "sacro bosco" lies at the foot of the old town, an early Renaissance pile of stone houses and Roman tiles, built into a hill and crowned with the desultory but imposing palace/fortress of the Orsini family.

There are paths in the garden today, but the "bosco" follows no rhythm or direction, so you might do as well to wander through the trees and knolls and come upon statues as chance dictates.

Suddenly you find yourself confronting a colossal face staring out of the trees and lichens. It is a monstrous face, pupils vacant, nostrils flared, mouth open, features stretched in a rictus of horror. Stone steps lead to its mouth, which is tall enough for man to walk through. Inside are a table and two benches. On the monster's upper lip are carved the words "ogni pensiero vola" — "all reason takes flight."

Nearby there is a huge stone vase, almost 20 feet tall, half-hidden behind a conifer and an elm tree. A few steps in the other direction reveal a life-sized elephant in full martial regalia trampling a Roman officer to death.

"You who enter here, put your mind to it and tell me if such marvels are the product of art or artifice?" (Inscription at Bomarzo).

More statues reveal themselves, some encircled by neat paths and fences, others hiding in groves or cliffs or meadows, camouflaged with moss. None can be categorized. Few can be ascribed to one recognizable myth, or even family of myths, although many critics have tried. There is, for example, a huge turtle with a tiny woman riding a pedestal on his back: at loss for precedent, students of Bomarzo have suggested that the choice of reptile stemmed from the etymology of the Italian word for turtle, "Tartaruga," with its connotations of Tartarus and the infernal regions of Greek fables. Past some more trees and around a knoll from the turtle you find a life-sized giant trying to rend another limb from limb. This combat of giants suggests several analogies with Graeco-Roman myths.

Bomarzo
Proteus, a sea monster.

148

Bomarzo
Giants in mortal combat.

An elephant devouring a Roman soldier.

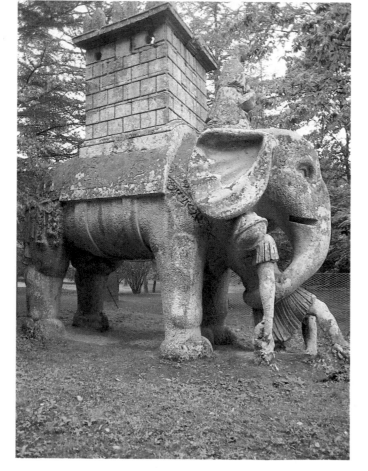

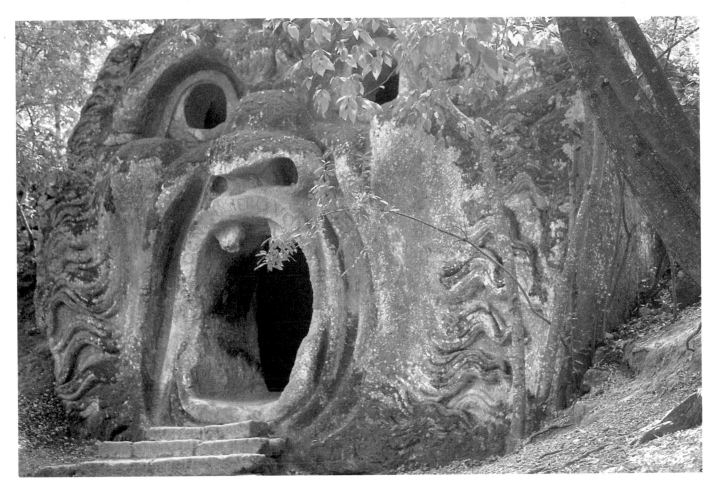

Bomarzo
The "Orco." The inscription on his
upper lip reads: "Ogni pensiero vola."

Most of the horrific statues are on the wood's lower level. On the upper reaches of the glen stand more serene works such as a nymphaeum, a statue of woman (possibly Amphitrite) who carries on her head a vase that is planted with irises. There is also a mermaid whose tail consists of serpents instead of fishtails, a winged Pegasus striking with his hoof at a spring — this last is apparently a direct reference to Pegasus tapping the Hippocrene spring from which poetic inspiration thereafter flowed.

Further along lies a small, square house, tilted to one side, and a tiny chapel. It was built in memory of Giulia Farnese, wife of Bomarzo's creator, Pier Francesco "Vicino" Orsini.

"Step down, Memphis, and all other wonders of the world, in favor of the genius of the sacred wood, which is like only to itself, and to no other." (Inscription at Bomarzo).

The sacred wood is indeed unique. It is also old, having been built in the middle of the 16th century. It was overgrown and its existence forgotten till the early 1900's. Little else is known about it. Those who wish to explain Bomarzo's uniqueness, lacking any other frame of reference, soon find themselves obliged to trace the garden's creation through the life of the man who created it, Vicino Orsini.

Vicino Orsini was born in 1523, the second son of a cardinal, member of a powerful Roman family whose forebears included a pope and who numbered among his blood connections members of the Farnese and Medici families. Vicino Orsini himself appears to have been an example of the quintessential Renaissance man: knight, poet, man of letters, artist, lover, architect, philosopher.

He spent the last part of his life making, and adding to the "bosco," coming up with new ideas, consulting alchemists to find a weather-resistant paint so the statues could be colored and made "more real"

151

than they were before. Often he would ride his favorite horse among the glades of his "bosco," enjoying the change of seasons, watching and watched by the creatures he had brought to life, alone in a private world.

Despite his predilection for food, wine and women, for corresponding with poets and statesmen, for visiting cousins in neighboring palaces, he felt most at home in the sacred wood. "(In the bosco I feel I am) in one of those palaces of Atlantis where the courtiers and maidens were kept dreaming under a spell... I would rather stay in those places than submerged in the illusions and ambitions of the courts, and especially that of Rome," he wrote to a friend.

The correspondence of Vicino Orsini, who died in 1584, provides few other clues as to what the secret of his sacred wood was, or whether there even was a secret.

One of the mysteries concerns the craftsmanship. Who executed the carvings? There is one legend to the effect that they were done by Turkish prisoners from the huge naval battle of Lepanto, in which European men-of-war defeated Muslim galleys to win control of the Mediterranean. Others point to Italian contemporaries such as the artists Raffaele di Montelupo, Del Duca, Ammannati, Ligorio, Vignola. A recent theory holds that the sculptures of Bomarzo represent figures from Ariosto's 16th-century epic "Orlando Furioso," describing the adventures of a hero driven mad by earthly love, who roams naked through various perils until he is finally rescued by the forces of serenity and reason. According to this interpretation, the wrestling giants would represent the mad Orlando attacking woodsmen, the nymphaeum would correspond to the palace of lust where a Circe-type witch held the hero captive. The chapel and adjoining tilted house, would symbolize Platonic love and reason, from whose sober casements the horrors outside all appear skewed or monstrous. Proponents of this theory also point out that many aspects of the sacred wood appear to caricaturize counterparts at Villa d'Este (home of Ariosto's sponsors) such as the Pegasus fountain, the grotto of Venus, the fish-tailed harpies.

But if the "sacro bosco" seems the deliberate antithesis of the pomp and circumstance of Renaissance sculpture gardens like Villa d'Este, it is also typical of the spirit of experimentation, imagination and humor which provided the impetus for that period of enlightenment. Thus its secret may be no more, no less than that which lies at the bottom of every truly creative act.

Bomarzo
The Crooked House. In the foreground
part of the theater.

VILLA BORROMEO

Of all the elaborate flights of fancy built into the varied gardens of Italy, the most magnificent is probably the **Villa Borromeo,** on Isola Bella, on Lago Maggiore in the north of Italy.

Borromeo is a scene from a different world, a soaring fairyland of white sculptures, green trees, grottoes, columns, flowers, terraces and balustrades, jewels of sculpture and horticulture set between the blue lake and the snowy peaks of Italy's Alps.

The main structure of Isola Bella consists of nine terraces, built on massive foundations with stone buttresses that are often identical with the shores of the island itself. The octagonal towers of the palazzo stand to the side, for most of Isola Bella's terraces are given over to fantastic, as opposed to human, environments.

The ground plan consists of flower beds, laid out in intricate arabesque, as well as stands of native pine and cypress, shaped to look like huge bouquets.

Each successive step up the terraces is marked by an elaborate balustrade, often straddled by delicate columns that serve as pedestals for the stone gods, goddesses and "putti" who inhabit the island. The greatest concentration of these statues stands in midair around a mountain of scallopped grottoes, piled one on top the other. More marble gods stand amid the grottoes, flanked by urns full of flowers.

From a distance, the statues disporting themselves on top of columns on top of balustrades on top of terraces give the impression of a great pagan celebration.

Work on Villa Borromeo was begun in 1630 by Count Charles Borromeo, whose wife owned the island and half of neighboring Ticino. Count Charles was the scion of the influential Borromeo family, which included both saints and statesmen in its family tree. The first designs were carried out by Antonio Crivelli, and added to by the architect Pietro Antonio Barca and a bevy of other landscapers and sculptors. The palace itself was designed by Roman architect Carlo Fontana.

The opulence and beauty of Isola Bella attracted many visitors through the years. Montesquieu, Goethe, Richard Wagner and Stendhal came to the island. Napoleon Bonaparte visited Isola Bella as a victorious general of the French Republic in 1797.

In more recent times Isola Bella was the scene of the Conference of Stresa in 1935, at which France, Italy and Britain reaffirmed their commitment to the independence of Austria, three years before it was taken over by the Nazi Reich. At the present time the island and its villa still belong to the Borromeo family.

Isola Bella
South view across Lake Maggiore from the garden.

Isola Bella
View of the Unicorn Terrace.

Isola Bella
Overview of the Lake Terrace.

ITALIAN GARDENS

The sculpture gardens of many Italian villas share common characteristics. Some of these similarities lie along the time spectrum. A good number of the gardens were built during the Italian Renaissance, in particular during the 15th and 16th centuries. At this time, mercantile prosperity as well as a backlash against grim religious philosophies allowed an explosion of villas and gardens that has not been equalled since.

The villa gardens also share characteristics in space. Many were built outside the rich cities of Florence, Rome and Naples, on the steep limestone foothills of the Appennines. This environment naturally led to the building of terraced gardens above or below the villas. Their altitude allowed sweeping views not only of the family property but of the hills and streams, olive groves and vineyards of the surrounding countryside.

The numerous streams and rivers of the area also made possible a profusion of waterworks. The neo-classical philosophies which replaced Scholasticism during the Renaissance re-introduced the ideals of perspective, symmetry and balance. Many Italian villas built during this period provided a welcome relief from the fortification mentality of earlier designers. Their gardens tended to share a sense of proportion; structures built in soft-colored rocks completed the patterns they began: stone and marble figures, well proportioned in and of themselves, were part of balanced groups that line escarpments, surrounded fountains, dotted topiaries, accented flower beds: the central axis was set off by staggered terraces on either side, which blended in turn with a contoured patchwork of agricultural land stretching into the distance.

One of the most typical — and unadulterated — Renaissance gardens is the **Boboli** complex in Florence. Named for the family that once owned land where the gardens now lie, the gardens occupy roughly a square mile behind the massive Pitti Palace. The palace was built by Brunelleschi for the wealthy and influential banker Luca Pitti in the mid-15th century. It then passed into the hands of the powerful Medici family. The gardens were commissioned by Duke Cosimo de' Medici in 1550 and were designed and executed by the architects Buontalenti and Il Tribolo. The Boboli provided inspiration for many gardens designed over the next half century. Triangular in shape, they ascend from a sunken courtyard at the palace's rear, in a succession of terraces and water courses, right up to the ramparts of the city.

Caserta
Partial view of stone statuary group along the watercourse

Directly above Ammannati's Courtyard with its symmetrical flower beds, stands the Fountain of the Artichoke, a broad stone platform decorated with stone infants, or "putti," and topped with a two-tiered basin.

Beyond this terrace lies the Duke's Amphitheatre, the site of festivals and musical performances from the era of the Medici to the present day. The amphitheatre is adorned with a large granite bath and an obelisk dating from 1300 B.C. Behind this, at the summit of the hill, stands a further series of terraces dominated by a bronze statue of Neptune and the stone Goddess of Abundance, modeled on Joanna of Austria, Francesco de' Medici's neglected wife.

One of Boboli's most unusual features is found on the lefthand side of the slope, looking downward. After descending through a broad avenue of cypresses and statuary one comes upon the Isolotto, designed and built by Alfonso Parigi at the end of the 16th century. The Isolotto is a large island of stone, set in the middle of a small "lake" and ringed with a pebble-paved strand. It supports Giambologna's "Ocean Fountain," with figures depicting the rivers Nile, Ganges and Euphrates.

Caserta
Actaeon transformed into a stag is attacked by his hounds. The Fountain of Diana.

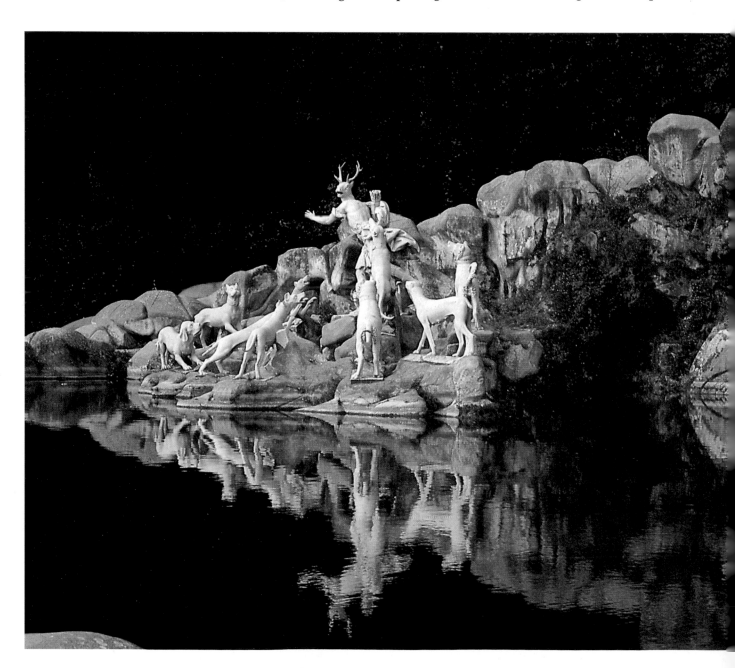

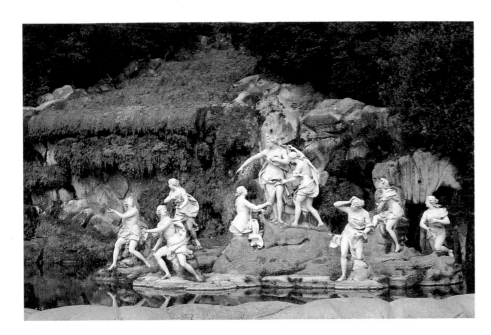

Diana surrounded by maidens, detail from the Fountain of Diana.

A general view of the main watercourse in the magnificent park of the Royal Palace of Caserta designed by Vanvitelli.

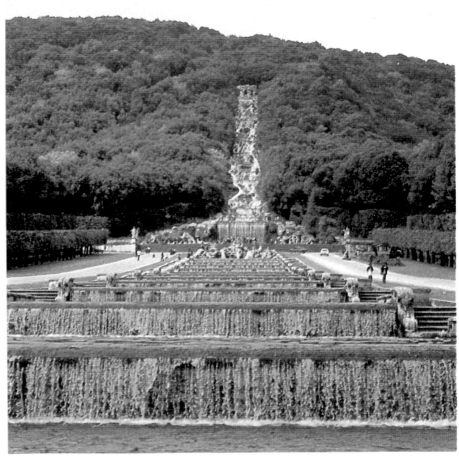

In the water are statues of Perseus and Andromeda, while the lake itself is surrounded by four additional sculpture groups.

The influence of the Boboli reached south to Rome. Constructed within 30 years of this garden, both Villa Lante in Bagnaia and Villa Farnese in Caprarola were partially modeled on Boboli.

The **Villa Lante** was originally the seat of Cardinal Gambera before being taken over by the family for which it is named. It sits in the middle of the village of Bagnaia. Its garden may be the work of Giacomo Vignola, although the attribution is not clear-cut.

The garden begins directly inside the entrance gates to the estate, where formal flower beds rise in stepped terraces to the top of the hill. At this apex stand twin "casinos," or small pavilions set in front of a grotto and flanking formal rose gardens.

But the garden's central feature and main perspective is its watercourse, which splashes down between flowering terraces in a trough standing three feet off the ground. The links of this "waterchain" are fashioned in the shape of shellfish claws. The water ultimately collects in the Pegasus Fountain, a statue of the winged horse dominating flowers, box hedges and topiaries in a park to one side of the pavilions.

The waterchain structure itself ends at the third terrace up the hill, where water flows into a monumental basinful of statues called the "Fountain of the Giants." This statuary, one of the most elaborate to be found in Italian gardens, then directs the water through two more basins and down to the lower levels. (A statue group of similar design and size can be found in the garden of the Villa Farnese.)

Built by Vignola 15 years before the construction of Villa Lante, **Villa Farnese** at Caprarola was the home of Cardinal Alessandro Farnese, grandson of Pope Paul III, and remained in the Farnese family until 1731. While the villa itself is much grander in scale than the pavilions at Lante, similarities in the two gardens' design point to the influence of Vignola in both.

In contrast to the relative simplicity and meditative atmospheres of the gardens of cardinals to the north, the palace and gardens of **Caserta** reflect the grandeur and power of secular royalty — in this instance, the cadet branch of the Spanish Bourbon family, which ruled the Kingdom of Naples from 1738.

The palace — situated on the city's outskirts — was commissioned by Charles III of Spain soon after he conquered southern Italy in order to escape potential bombardment by a British fleet patrolling the coast. The palace and gardens at Caserta were built by Luigi Vanvitelli, with construction beginning in 1751.

The splendor, variety and size of the gardens at Caserta have earned it the epithet of "the Versailles of Naples," but the nickname says more about the image of the French palace than the nature of the Neapolitan. For one thing, the main thematic thread running through Caserta's gardens deals with a subject that belongs only to Versailles' forgotten past: hunting. Charles III's fascination with hunting lies behind much of the gardens' layout; in their proximity to fields and forests, in the views from the long pavilions, in the many statues depicting hunting scenes. For another, the basic structure of Caserta's gardens is borrowed directly from Italian gardens created 200 years before. The fact that Vanvitelli blew up their scale to the proportions of Spanish-Bourbon pride does not obscure their kinship with gardens such as Boboli or Farnese or Villa d'Este. The extent to which Caserta resembles Versailles matches above all the extent to which Versailles' design had roots in Italian gardens of the early Renaissance.

As at Villa d'Este the focal point of Caserta's formal gardens is a watercourse, but this term does little to convey the magnificence of the two-

Villa Lante
View of the parterre.

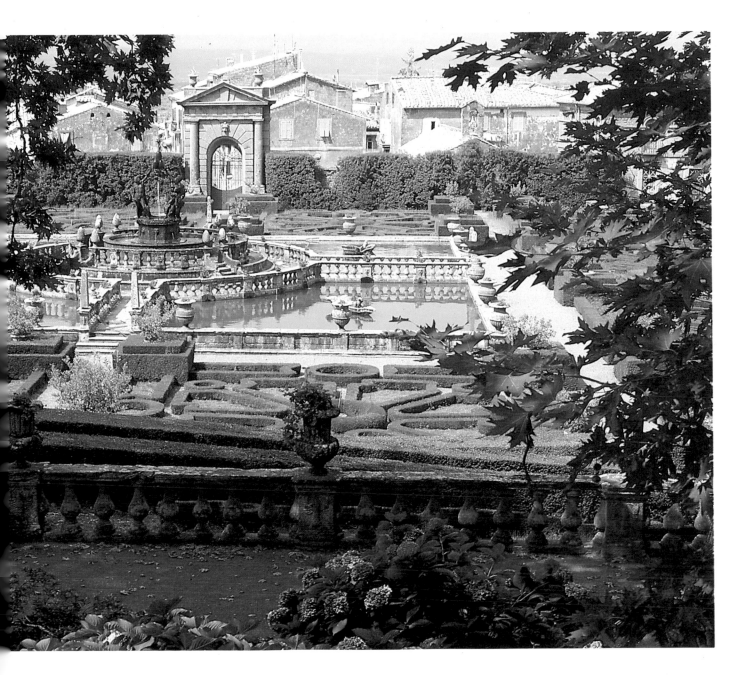

Boboli
The pond of the Isolotto with the figure of Perseus at left.

The Ocean Fountain by Giambologna, with Neptune and figures representing the rivers Nile, Ganges and Euphrates.

Ground-plan of the gardens from the Description *by Soldini (1789).*

mile-long stretch of aqueduct, flower beds, groves of trees, fountains, statues, waterfalls, niches, steps and arches that accompany the water on its run from surrounding hills. The mind tends to filter, select, focus on smaller details, such as the Fountain of the Winds, and the Fountain of Diana, the last of the six main statuary groups along the watercourse. Set within a circular piazzale, bordered by oak trees, the Fountain of the Winds consists of a tall semi-circular stone wall with arches at the bottom and statues above. A broad, shimmering curtain of water falls over the wall, while the garden walk rises above it in a repetitive zig-zag of ramps.

The final statue group of the watercourse concludes, rigorously enough, on the garden's central theme. The Fountain of Diana depicts the myth of the goddess of hunting's encounter with Actaeon. The luckless Actaeon was, like Charles III, a hunting fanatic, but he had the bad luck to stumble upon Diana while she was bathing. To see Diana nude was a mortal offense, so the goddess turned Actaeon into a stag, whereupon his own hounds set on and devoured him.

The grounds at Caserta also boast a landscaped "English" garden,

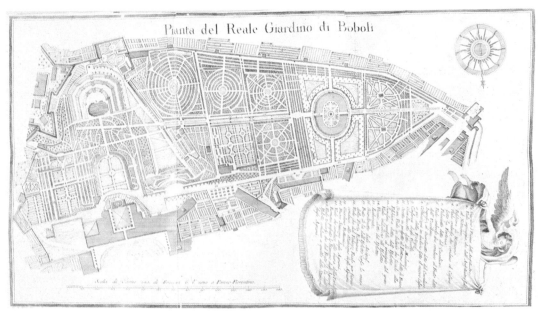

Pianta del Reale Giardino di Boboli

designed for Queen Maria Carolina, and providing a contrast to the sty-
lized formality of the traditional Renaissance settings. Here various
pathways follow the contours of the land through series of exotic
shrubs and trees of the kind fancied by English horticulturists. The
absence of architecture and the minimal use of statuary provide a con-
trast to the crowded statue groups found nearer the watercourse.

A more romantic section of the English garden includes a tranquil pond
with a small island. There a miniature Roman temple serves as a shelter
for swans. A creek leads into a small grotto against which are set
statues from Pompeii as well as a marble bath.

The palace at Caserta was headquarters for Allied forces after the
Anzio and Salerno landings and sustained damage from shelling. It was
at Caserta that the formal surrender of German armies in Italy was
signed on April 29, 1945. Many of the statues that were damaged during
the war have now been replaced or restored.

Caprarola
*Figure from Classical mythology that
graces the staircase.*

*Staircase with ornate channel and
fountain leading to a smaller palace.*

VERSAILLES

PETERHOF

Versailles and Peterhof were created during a period of Western civilization that saw the intellectual advances of the Renaissance stimulate the mercantile stirrings of industrial revolution.

The modern nation-state — a European invention that was to constitute the means of Europe's rise to world domination — was the political expression of that period. Versailles and Peterhof were the aesthetic expression of the nation-state, created by the monarchs who first carved a centralized France, a monolithic Russia out of the raw material of history.

The traditional gardens of Versailles and Peterhof are inextricably linked by their place in the historical spectrum. They are also linked by the similarities in the men who made them. Both Louis XIV of France and Peter the Great of Russia subdued nobles, hammered enemies, tamed clergy, created ministries and navies, conquered territories in pursuit of visions of a European grandeur they would ultimately translate into two palace complexes that have not been rivaled before or since.

There are other similarities, however. Both Versailles and Peterhof were wrested by sheer will, manpower and money from inhospitable marshlands, thus providing another field for contest between stubborn autocrats and their more level-headed fiscal advisers ("it is in difficult matters that our strength and courage are made apparent," the Sun King commented in regard to the Versailles site). The marshy environments of both sites facilitated the creation of spectacular waterworks. Finally, Tsar Peter deliberately copied Versailles' scale and magnificence, and relied on engineers, architects and gardeners who had been laid off when Louis XIV died to erect his counterpart on the Baltic coast.

Of the two palace and garden combinations **Versailles** is the most famous. It was chronologically the first to be built, and even today its reputation for splendor and scale is unsurpassed anywhere in the world. It remains what it was in the Sun King's prime, the benchmark by which all similar gardens are measured.

Its origins were modest. The first royal construction was a hunting lodge built in 1629 by Louis XIII as a refuge from court intrigues. More

Versailles
The Fountain of Latona.

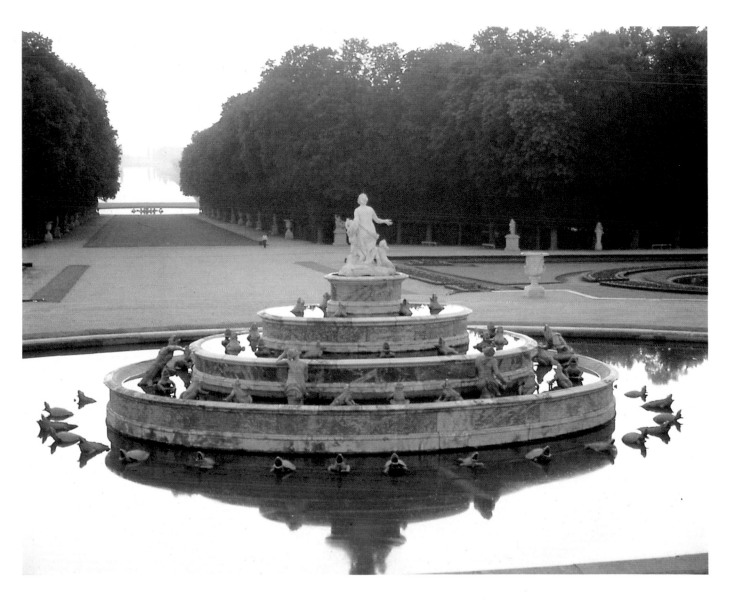

land was acquired and water channeled into the resulting park from Lagny lake. Flower beds were planted. Workmen dug out a small basin called the "Rondeau des Cygnes." By the time Louis XIII died in 1643, leaving as sole heir a child of four, also named Louis, the makings of a formal garden had been laid down.

Versailles was neglected during the regency of Anne of Austria and her chief minister Mazarin. But when Louis XIV effectively took power he began making plans for a palace and gardens on the site, works that would match the role he had in mind for his state. The neighboring townships of Trianon and Choisy-les-Boeux were acquired. Work was begun in 1661 (despite the protestations of Colbert, the new chief minister). The project was to continue for half a century and cost a staggering 66 million livres.

The chief architect of Louis XIV's dream was André Le Nôtre. Under his direction 400 laborers began the task of draining marshes and filling in terraces for the flower beds and waterworks Le Nôtre had conceived. A terrace was called "Pièce des Suisses" in honor of the whole regiment of Swiss guards who shoveled it into place. Louis XIII's modest swan pond, the Rondeau des Cygnes, was enlarged to become the monumental "Bassin d'Apollon." Vast perspectives were laid out to complement the huge palace being built by Le Brun, Mansart and Le Vau. The parterre d'eau — two massive rectangular canals leading perpendicularly from the palace toward the horizon — was completed in 1672 and surrounded by statues. So was the parterre's centerpiece, the "Fontaine de Latona," with its own huge focal points.

By the time Louis XIV died in 1715 the palace and gardens of Versailles were the envy of every foreign court, and the chagrin of most royal advisers. Together with the king's military expenditures, the project almost succeeded in bankrupting the richest treasury in Europe and contributed to the downfall of the French empire in North America. Louis XV continued his father's tradition by neglecting Paris in favor of the royal residence in Versailles. He would have preferred to follow the fashion of his generation and turn the gardens into less formal, English-style plantings, but lacked the necessary funds. Instead he restricted himself to building the small Petit Trianon palace and setting up a lavish botanical garden under the supervision of botanists Claude Richard and Bernard de Jussieu.

A time traveler from Louis XIV's court would have no trouble recogniz-

Versailles
The "Bassin d'Apollon".

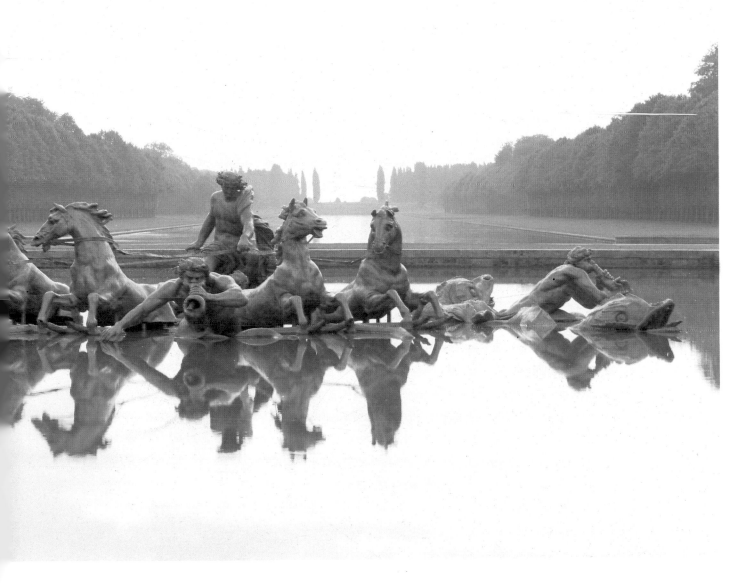

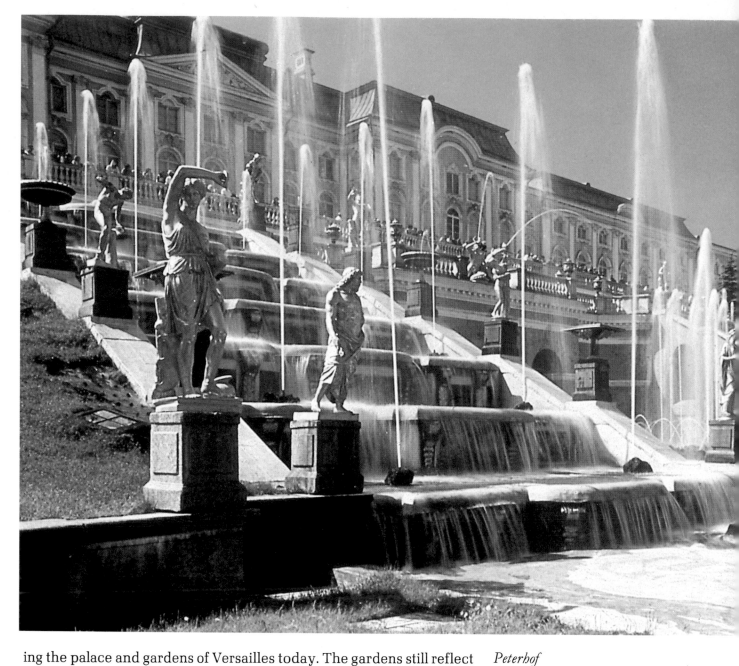

ing the palace and gardens of Versailles today. The gardens still reflect the geometrical precision, the intellectual rigor of the age of Descartes: clipped hedges, box-shaped trees, flowers tamed into square patterns. Le Nôtre adapted his design to suit the terrain, but the terrain eventually became dwarfed by his design. From the palace the eye is drawn irresistibly down the long, limpid parterre d'eau, with the sky reflected in still water. At each corner of the parterre stand ornate classical statues representing the rivers of France. The Saône is a voluptuous woman with cupids by the Italian sculptor Tubi, the Seine is a strong and bearded man made by Le Hongre. Delineated by trees, the twin canals of the parterre seem to measure themselves against the horizon and the clouds of Ile de France.

The appearance is deceptive. The parterre ends on a second terrace overlooking the fountain of Latona, three stacked circles of water flanked by bronze lizards and waterspirits and crowned by a half-nude goddess.

From the Latona fountain, the "tapis vert," or green carpet, continues the parterre's thrust toward infinity, eventually ending at the Bassin d'Apollon and the great canal.

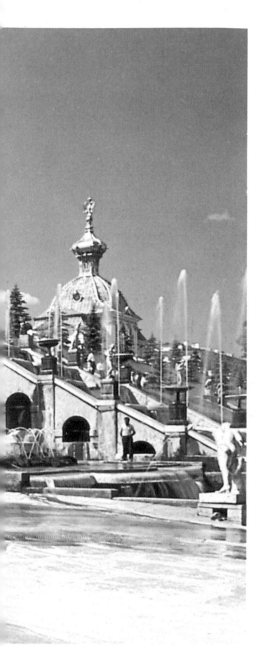

Here the visitor can turn his or her back toward the light blue sky and green cedars reflected in the waterway and, looking back up toward the distant palace, gain an appreciation of Louis XIV's idea of France by the scale of his centerpiece for her.

Peterhof is almost as impressive in scale and similar in design. The estate was to be Peter the Great's summer retreat from his new capital in St. Petersburg (now Leningrad), so he built it down the Neva River, on the coast, where the Tsar could watch his new navy perform. Few others cared for the swampy site, however.

To build this retreat Peter hired a team of French architects headed by Alexandre Le Blond, whom the cessation of work at Versailles had left unemployed. Le Blond was hired personally by Peter on a five year contract and a salary of 5,000 roubles. He designed Peterhof after completing his work in St. Petersburg, where he was responsible for the Nevsky Prospect, among other projects. He died before completing his work at Peterhof and was replaced by the Italians Niccolò Michetti and Bartolomeo Rastrelli.

The extent to which Le Blond and Peter used Versailles as a model is evident from the Russian gardens' layout. Le Blond has replaced the Great Canal perspective with that of the Baltic Sea, looking north toward Finland. As in Versailles, a canal runs at right angles to both water view and main palace, forming a direct visual link between that is interrupted only by monumental statues, fountains and waterworks. The main fountain at Peterhof is a gigantic series of steps made of gilded green marble and set off by statues. The classical figures, which were originally the work of Nicolas Pineau, are made of gilded bronze. Vivid light-green water, channeled in from springs in the Ropsha Hills, splashes down the steps, between the figures and into a grotto. On either side lie two separate cascades. One, known as the "Chessboard," is made entirely of black and white marble squares.

The other, which is called "Golden Mountain," is a series of golden steps. The water collects in a central pool. In the middle of the pool lies a rock on which a great gilded Samson wrestles a golden lion from whose mouth a jet of foam rises to the level of the palace terrace.

Lower down, and on both sides of the main canal, a series of groves are criss-crossed by broad avenues. Many of the trees are descendants of the original planitings of native elms, firs and maples as well as imported beeches and lime trees. Closer to the sea, and again on each side of the main canal, lie two pavilions, designed by Le Blond in the Dutch style to satisfy Peter the Great's fascination with the Netherlands. Their names however are French: "Monplaisir" and "Marly," this last a reminder of the village near Versailles where Louis XIV installed the hydraulic pumps for his fountains. Not far from Marly lies a trick fountain called the "Oak Tree" which showers the unsuspecting with water. There, too, is a small lake where the Tsar of All the Russias would summon his pet carp to dinner by ringing a handbell.

Behind the palace lies a lawn lined with gilded figures from Aesop's fables. The Tsar wanted his statues not only to decorate his grounds but to instruct his subjects as well, so he had summaries of the various fables printed on tin and nailed next to each.

The gardens and palace survived the 19th century and the October Revolution more or less intact, but were severely damaged during World War II by shells and German soldiers who shipped the gilded bronze statues back to the Reich in the belief they were solid gold. The Soviet government subsequently undertook a massive restoration so that the palace gardens, with all their gilded sculptures and fountains still offer an approximation of the grandeur of imperial Russia.

ENGLISH GARDENS

One of the first naturalistic or "English" sculpture gardens was and is the estate of **Stourhead,** in Wiltshire, near the southwest corner of the Salisbury Plain. The estate had originally belonged to the Lords of Stourton. It was bought up by Henry Hoare, of the London merchant banking family, whose son — apparently on his own — decided in the early 1700's to create natural environments for various buildings and stonework.

His first step — a necessary one if he was taking a cue from Poussin or Lorrain — was to dam the river Stour, near the springs which were its source, creating a 20-acre lake in the process. The lake was flanked by a graceful five-arched stone bridge. Around its shores Hoare planted groves of fir and beech. Most of the fir trees were strangers to England at the time and have since died out, but the beeches are now over 200 years old and in their prime.

On one side of the lake, Hoare built a "Temple of Flora," complete with Doric portico and an urn on which were depicted the goddess of flowers and her nymphs. Further along the same shore an artificial grotto was dug into the hillside, around one of the seeps that feed the river. A "nymph of the grotto" and a river god (or possibly a Neptune), both by Rysbrack, hold court there amid big rocks and shafts of light. Large stone shells and moss surrounded an inscription celebrating the nymph. The gurgling of water pervades everything.

The most famous construction at Stourhead is the Pantheon, a scaled-down replica of the Roman original, containing statues of Dionysius and a muse, a Flora and a Hercules, again by Rysbrack. There is also an antique bust from Herculaneum, a facsimile of Meleager and the goddess Diana by Henry Cheere. The Reverend John Wesley, on visiting Stourhead, referred to these works as "mean," adding that he could not admire them "because the gods of the heathens are but devils."

The Pantheon is the most recognizable of Stourhead's monuments: its classical balance, whose original arrogance has been diluted by its miniaturization, sets off a number of different landscape compositions that include rolling woods, ruffled water, beeches and lawns as well as rhododendrons, cherry laurel and azaleas. These flowers were not in the original garden, but are a later addition to Hoare's work. The footpath leads across a second bridge to a replica of the Temple of the Sun at Baalbek in Lebanon. The visitor's itinerary leads him back over the stone bridge to the entrance point where a stone "market cross," which used to signal crossroads in medieval Bristol, stands guard against the east. Built in 1373, the cross is rich with carvings of queens and kings of England.

Stourhead Pantheon, a smaller replica of the Roman monument. Built by Henry Flitcroft in 1745.

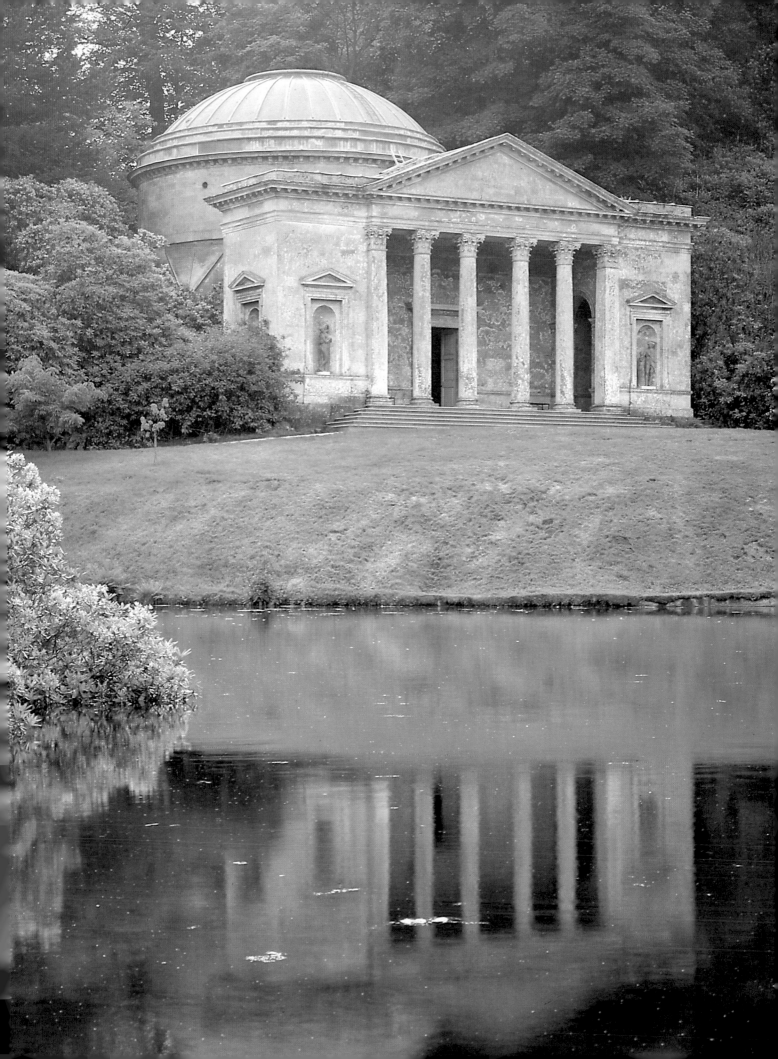

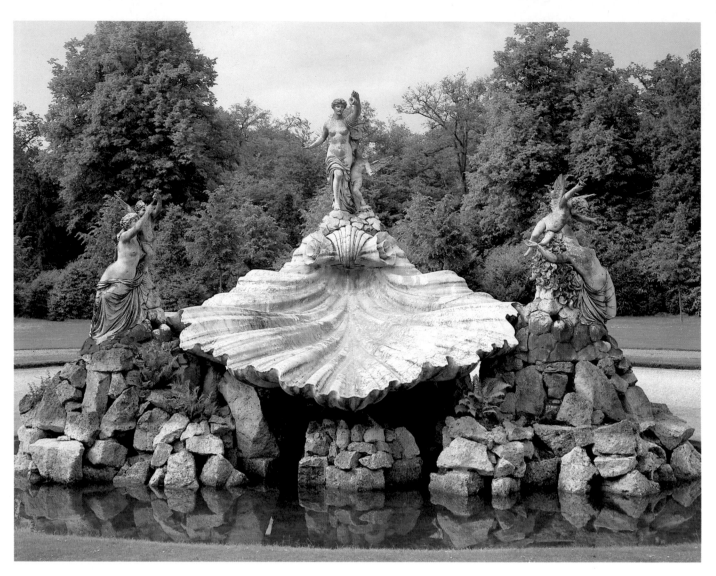

Cliveden Park
The Fountain of Love *by Thomas Waldo Story in the main avenue.*

Among the most famous gardens in an eclectic category are Chatsworth and Cliveden. Of the two **Cliveden** is the most famous, as much for its historical associations as for the elegance and variety of its statues and setting. Situated near the chalk cliffs that line the Thames west of London, on Maidenhead reach, the estate was founded by George Villiers, second Duke of Buckingham, shortly after the Restoration.

A huge arcaded terrace on the south side (designed by William Winde) is a reminder of the Buckingham tenancy, as two garden buildings by Giacomo Leoni are a relic of the tenancy of George Hamilton, Earl of Orkney, who also laid out a series of formal gardens which are the skeleton on which subsequent additions were built. These formal gardens were originally designed by Le Nôtre's nephew, but his Versailles-scale plans proved too costly to realize. Lord Orkney had to content himself with what he called his "Quaker" parterre, with a terraced walk and two rows of elms.

With the help of Bridgeman and the poet and gardener Alexander Pope, Orkney also built yew-lined walks along the western cliffs, as well as a three-tiered grass amphitheatre. Subsequently Frederick, Prince of Wales (a frequent guest at Cliveden), created the Ilex Grove. Fire destroyed the original mansion in 1795 and the estate was neglected until the mid-19th century. In 1850 a new house was designed by Sir Charles Barry for a new owner, the Duke of Sutherland. The parterre

Cliveden Park
Two Venetian figures representing
Marco Polo and a female allegory for
navigation in the Long Garden.

was replanted with 2200 azaleas and rhododendrons and 800 tulips in geometric beds. In 1893 William Waldorf, Lord Astor, scion of the family which founded the Hudson Bay Company (as well as New York's Waldorf Astoria Hotel), bought the property, and set about transforming it according to his own tastes and ideas. Cliveden remained in the Astor family till 1966, when it was turned over to the National Trust to promote understanding between English-speaking peoples. It is now used as a "junior year abroad" campus by Stanford University of Palo Alto, California.

Cliveden's grounds are open to the public but visitors tend to retain only a few samples of the estate's richness. Among these are the Borghese balustrade, a massive piece of stonework carved into basins, pedestals and masks by Giacomo Guiroli and Paolo Massoni in 1618. The first Lord Astor was a great admirer of Renaissance art and had the balustrade shipped from Rome's Borghese palace to adorn his south terrace in 1896, together with a series of hunting nymphs originally sculpted for Louis XIV by Claude Augustin Cayot and Claude Poirier. The northern forecourt of Cliveden House is adorned with a series of Roman sarcophagi representing Dionysius, Theseus and other heroes and deities.

Further along to the north, hidden among trees, lies the rose garden. There a wounded Amazon, sculpted by William Waldorf, guards informal beds of good loam and rare roses. A bit more to the north is the Ilex

177

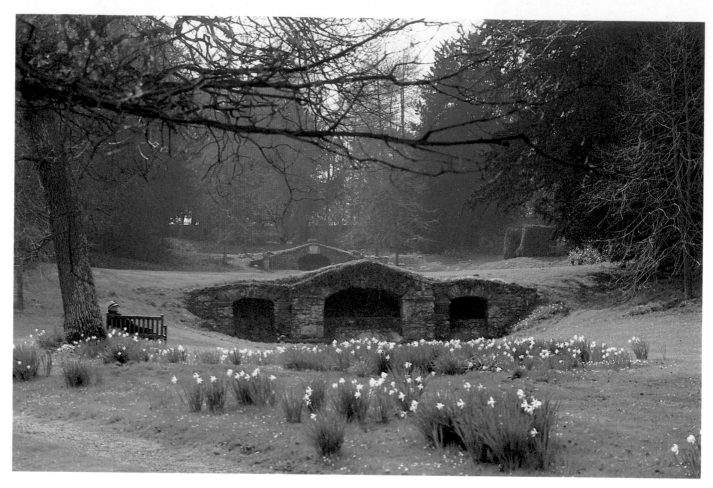

Rousham Park
The lower and upper cascades in
Venus' Vale designed by William
Kent, circa 1738.

Grove, with evergreen oaks and a bronze Prince Albert by William Theed. This may have been a gift from a frequent visitor to Cliveden, Queen Victoria. Nearby stands a bronze Joan of Arc by Princess Marie d'Orléans.

On the very northern bounds of the estate is the Long Garden, which displays a formal arrangement of evergreens and Renaissance statuary, including two solemn figures taken from a Venetian palace, one of which is a female allegory for navigation. The other is Marco Polo in the uniform of commandant of the Venetian fleet. California sweet bay shrubs flank a central circle guarded by four 18th-century Commedia dell'Arte figures. A "Fountain of Love" by the United States sculptor Thomas Waldo Story sits at the end of a main avenue. In the fountain three life-sized female figures and attendant cupids play as the water chuckles. The war-memorial garden lies further down the river bank. Originally slated as a classical arbor with bits of Greek temple strewn around the landscape, it now commemorates victims of the Great War.

Rousham Park, in Oxfordshire, was created between 1720 and 1725 for the Dormer family. General Dormer first employed the well-known landscape architect Bridgeman, but then asked William Kent to rework the park to a different design.

Kent was a famous painter of the time: he had studied in Italy and became the protégé of the third Earl of Burlington, founder of the "philosophy" of Platonic idealism which posited that harmony and balance were the functions of beauty. Trained at the time when Poussin was a dominating influence, Kent set out to design a park which would offer a succession of tableaux like pictures at an exhibition.

The park has survived intact. The vistas are set around a right-angled dogleg in the Cherwell River, defining the property. Green paths lead visitors from one landscape to the next. In each scene Kent placed

sculpted cameos to set off a mix of conifers and deciduous trees around: cameos such as a pyramid, statues of Apollo and a colossus, a pool with cavern known as the "cold bath," a "Praeneste Portico" on a terrace above the Cherwell. On one skyline stands a sham ruin known, aptly enough, as "The Eyecatcher." In "Venus' Vale" Kent constructed a series of pools and waterfalls.

The house at Rousham was built around 1635 for Sir Charles Dormer and remodeled by Kent into "something vaguely resembling an early Tudor palace in free Gothic style," according to the guidebook. The mansion's garden side holds niches with more statues of classical subjects by Henry Cheere — a Venus Pudica and Bacchus, among others. Rousham and Stourhead are similar in that they are both unadulterated examples of the landscape movement which became synonymous with British gardening. Other traditional sculpture gardens in England, however, either pre-dated the landscape movement and were changed and added to subsequently, or were built afterward, incorporating many of the enduring lessons taught by such masters as Capability Brown, William Kent and Joseph Repton.

Another garden in the grand naturalist tradition is the Duke of Marlborough's estate of **Blenheim,** built on land ceded by a grateful nation to the man who won the battle of the same name.

Vanbrugh and Henry Wise were the original designers of the sweeping vistas of meadow, lake, wood and classical sculpture surrounding the palace, of which Alexander Pope once remarked, "tis mighty fine, but where d'ye sleep, and where d'ye dine?"

The Marlboroughs subsequently hired Capability Brown to work on the gardens. These were enhanced in the early 20th century by André Duchêne, who added terraces and fountains.

Rousham Park
The Watery Walk canal flows through the Cold Bath toward the Octagon Pond.

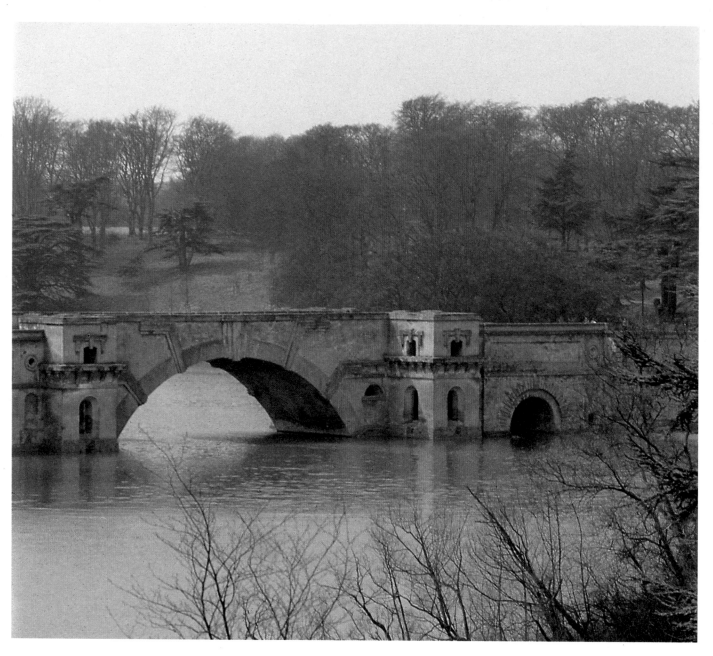

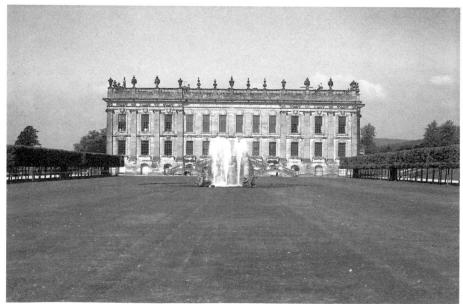

Chatsworth — the Duke of Devonshire's estate in Derbyshire — is a conscious compromise between naturalism and formality. The gardens went through several transformations before arriving at their present incarnation.

The original Elizabethan garden was well-known to Mary Queen of Scots when she was imprisoned at Chatsworth. Only a miniature fortress and moat remain of that stage in the garden's development. Eventually Queen Anne's gardener, George London, was hired to plant a formal garden, replete with terraces and statues by the Danish sculptor Caius Cibber. This garden disappeared as well, leaving behind an ornate "Cascade House" with streaming roof, spewing dolphins, and soaking marble steps. During the Romantic revival, which followed up the landscape movement, the fourth Duke of Devonshire enlisted Capability Brown to change the estate around until, in the words of Horace Walpole, "Chatsworth... is much improved by the...duke, many foolish waterworks being taken away, oaks and rocks taken into the garden, and a magnificent bridge built."

There was a 50-year lull in renovations after the fourth duke died in 1764. But in 1826 the sixth duke hired a young gardener away from his 18-shillings-a-week post at the Royal Horticultural Society in London. The gardener's name was Joseph Paxton, and he and Chatsworth were to make each other famous.

Paxton and the duke planned the compromise which characterizes the estate today, replacing the worn-out Cibber statues with similar works by Francesco Bienaime, planting lawns and rhododendrons, scattering fragments of temple, even dragging in three huge rocks to romanticize the setting. An artificial grotto was built to please the duchess, with walls that glittered with Staffordshire copper ore. There was an arboretum and in later years Paxton designed the world's largest greenhouse, inspiration for his later creation, the Crystal Palace of 1851.

Nothing, unfortunately, remains of this "hothouse," which was heated by underground furnaces fed by a railway of coal carts.

The gardens, however, have been maintained by the present Duke and Duchess of Devonshire, who have even added a maze and other plantings, thus preserving both the history of the older gardens, and the spirit of change and assimilation which makes Chatsworth unique.

Blenheim Park
The Grand Bridge designed by
Vanbrugh across the man-made lake
conceived by Lancelot (Capability)
Brown for the park.

Blenheim
The Water Terrace garden and the
West front

Chatsworth House and Garden.

GERMAN GARDENS

Germany up to the 19th century was politically speaking a collection of duchies, electorates, and minor princedoms whose only link was the language shared by their middle and lower classes. German territories were threatened by the Hapsburgs of Austria on one hand, by France and whatever allies she could secure to the north, on the other.

The various electors, princes, dukes and bishops spent their time courting the French and the Austrians, seeking to play off one dominant power against the other, often with little success.

Only Prussia held its own in the continental struggles. German aristocrats disdained their own native culture, sharing Charles V's cultural as well as social priorities when he commented "I speak Spanish to God, French to men, Italian to women and German to my horse." The ascendancy of the middle classes and the accompanying upsurge in German nationalism were still to come — and would not come before the mid-1800's.

The gardens of Germany naturally mirrored the predilections of the men who commissioned them. Many of the famous traditional sculpture gardens still existing in Germany were created in the late 17th and early 18th centuries. Most of these are exceptional examples of foreign styles: formal (from France), naturalist (from England), baroque and rococo (from Italy via France). What latitude German designers and sculptors were afforded lay in elaborating, refining and sometimes combining the various foreign influences they were paid to imitate.

The gardens of the Elector Palatine in **Schwetzingen,** near Mannheim, are a good example of the welding of foreign influences into a balanced whole. They were created by Elector Carl Theodor in the middle of the 18th century before the fortunes of war caused him to shift his capital to Munich.

The first gardens at Schwetzingen were designed by the Frenchman Nicolas de Pigage. European gardens at the time were still dominated by the influence of Louis XIV's palace at Versailles, and de Pigage laid out Schwetzingen along the same general lines, with a central canal and "parterres" leading through a green perspective of lawn to the horizon. Hedges, avenues and groves of trees ("bosquets," or "Lustwäldchen") were set out in patterns as rigorous as an Euclidian axiom. The resulting atmosphere of lilacs, peacocks, and bowers, where noblemen could flirt and intrigue, survives to this day.

The elector had Louis XV-style follies scattered in strategic locations

Schwetzingen
A water god bordering a pond in the garden.

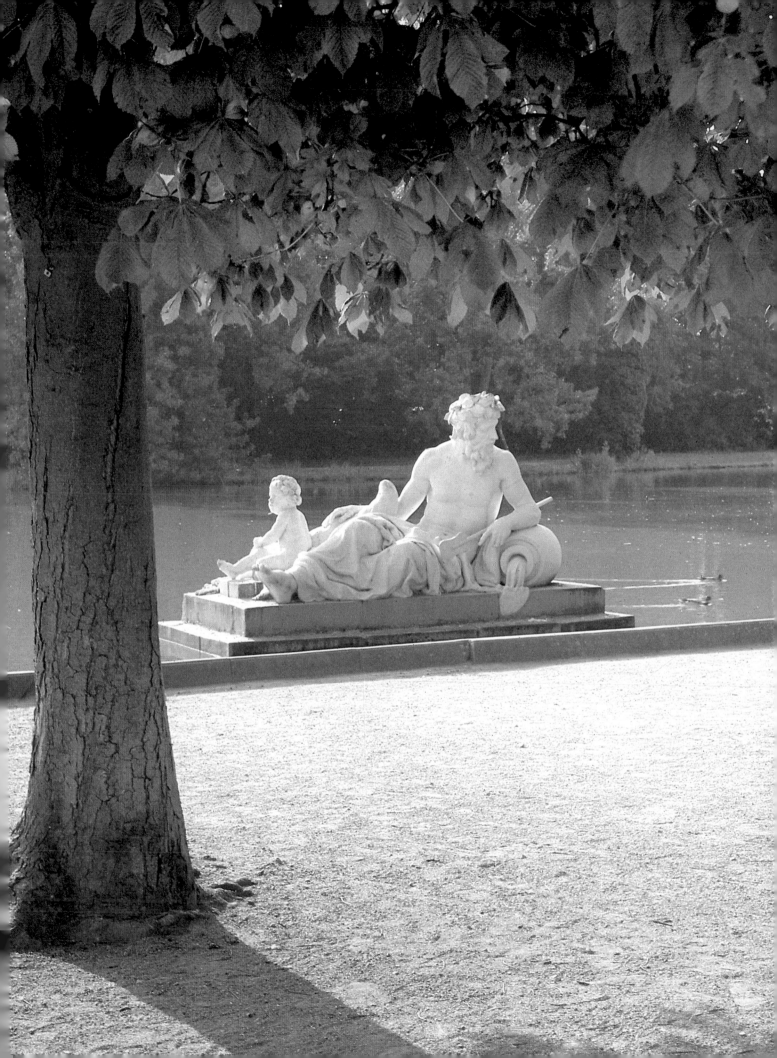

*Schwetzingen
Simon Lamine's statue of Pan in a
wooded grotto.*

around the park. The bathhouse, for example, afforded two perspectives. One led north to a temple of Apollo (ringed by classical statues), the other south to a bronze "bird fountain" where a metallic owl stood in a perpetual spittle of water issuing from the beaks of his revengeful fellows.

Classical statues such as a Pan piping on a rock and a pair of magnificent white stags by Verschaffelt (now symbols of Schwetzingen) were added to alleviate the neatness of topiary.

Later in his stay at Mannheim, however, Carl Theodor learned about the new "English" school of landscaping which was becoming fashionable in cities like Paris, where fashions were made. He allegedly decided to raze de Pigage's work and remodel Schwetzingen in a "natural" style, but was dissuaded in this by the German garden designer Ludwig von Sckell. Von Sckell, who had seen the English gardens in a 1776 visit to London, opted to leave most of de Pigage's work alone, in favor of building an English garden beside the French one. But first he modified the central canal to make it look more like the natural bodies of water which formed a centerpiece for such gardens as Stourhead and Rousham. A "mosque" and fake ruins complemented the whole.

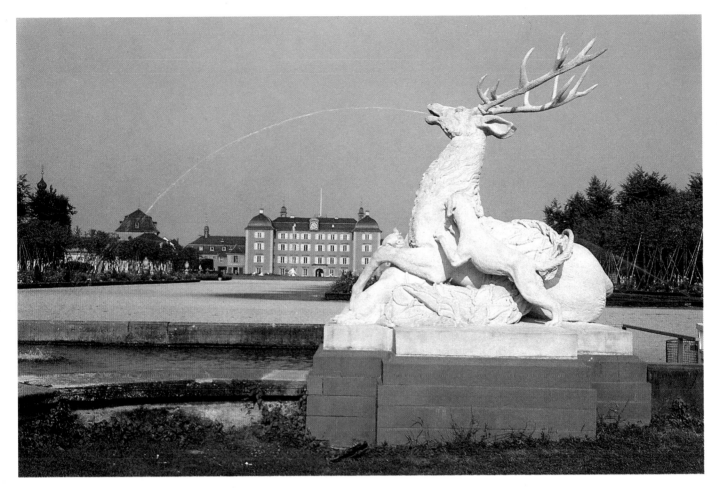

Schwetzingen
A white stag, symbol of Schwetzingen,
by Peter von Verschaffelt. In the
background the 17th-century Castle.

Statues were added so that each section of the park could now be said to have a theme: mythology around the parterres, nature in the English garden, ethics and philosophy around the mosque. The ruins, for their part, symbolized the passing of time with their "Ozymandias" - type message.

Another German garden which is a masterpiece of foreign style is that of **Nymphenburg,** near Munich.

Unlike Schwetzingen, the influence of French landscaping and architecture was never contested here. The scale of the elector of Bavaria's "country palace" is itself reminiscent of the Bourbon court. An endless canal leads up to the endless facade of the Schloss. There it splits, passes under the palace wings and reappears on the other side to embrace an arrangement of ponds, fountains and, cascades. The canal constitutes the main visual axis, in the French style, and, as at Versailles, the overall effect is one of regimented grandeur where walking on the lawns is forbidden.

The gardens are well maintained and still impressive but much of their previous magnificence has unfortunately eroded over the years. Only a few examples remain of the original 19 fountains and 285 water-

spouts, the carved dragons, snakes and tritons, the gilt whales and lions that used to adorn Nymphenburg's lawns and avenues.

Nonetheless the three "pleasure houses" for which Nymphenburg is especially known still exist: Pagodenburg, a "Chinoiserie" built as changing rooms for actors and entertainers; Badenburg, a swimming bath lined with Delft tiles; and Amalienburg, built as a fancy hunting blind for the wife of Elector Karl Albrecht, who used to shoot deer from its roof.

The main buildings of Nymphenburg were also a present to the wife of an elector, in this case Adelaide of Savoy, wife of Ferdinand Maria of Bavaria, on the occasion of the birth of an heir to the Bavarian throne. (Adelaide, with her love of costly festivities, had distracted her serious husband from the task of rebuilding southern Germany after the Thirty Years War.) Their son, Maximilian Emmanuel, was exiled to Paris after a military defeat in the early 1700's, and it was there that he came under the influence he was to translate at Nymphenburg with the help of landscape designer François Girard. (The gardens were subsequently remodeled by von Sckell in the then prevalent "Englische Garten" style.)

Nymphenburg
Two statues from the water cascade.

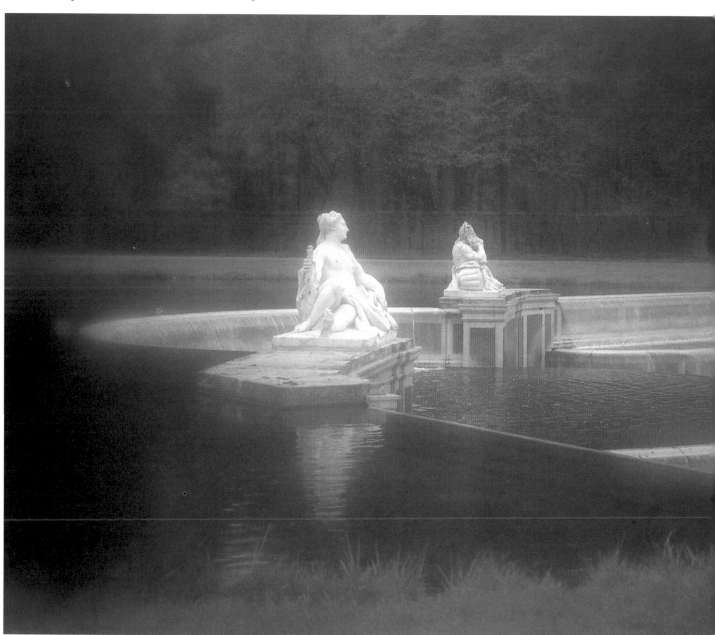

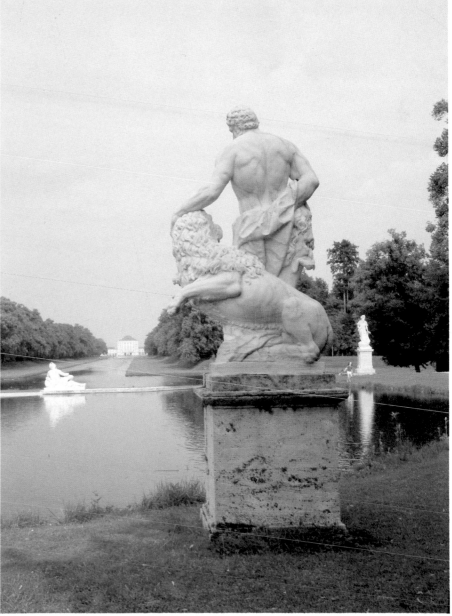

Nymphenburg
Distant view of the house from the great fountain.

Veitshöchsheim
Pegasus adorns an 18th-century
fountain in the gardens.

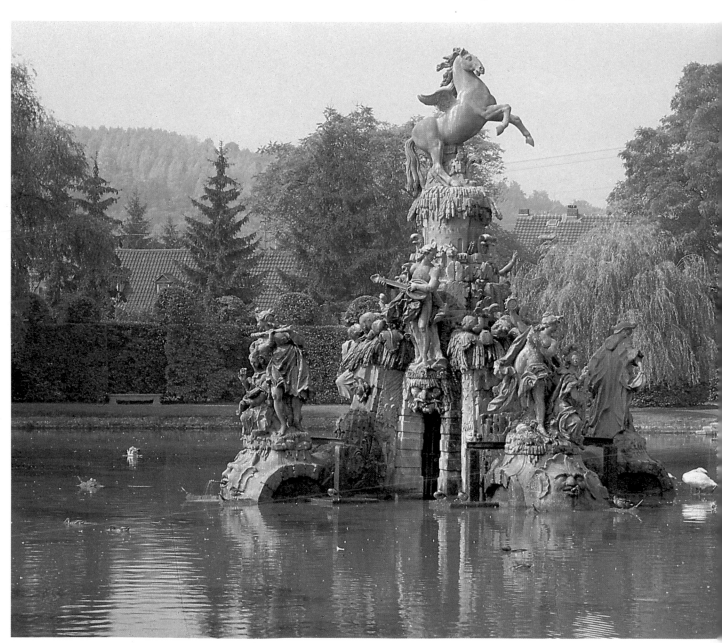

The **Veitshöchsheim Gardens of the Prince-Bishops of Würzburg** were built to emulate a completely different style, that of the rococo period. The ornate fantasy of the bishop's gardens is perhaps more representative of the comic-opera hedonism of the Enlightenment period than such affirmative symbols as Nymphenburg. And while the creators of Nymphenburg never sought to alter the ideals of gardening and sculpture which came to them from abroad, Veitshöchsheim at least took Franco-Italian rococo one step further thanks to the art of the German sculptor Ferdinand Tietz.

The first major construction at Veitshöchsheim — a "summer or pleasure house" — began in 1681 under Bishop Peter Philippe von Dernsbach.

The gardens started out sedately enough, after a modified French design (two central alleys instead of one). Classic statues, of Apollo, Venus, the Muses, were commissioned from sculptor Johannes von der Auvera by Furstbischof von Greiffenklau, who also sponsored Tiepolo.

The sedateness did not last, however. In tandem with previously forbidden ideas that began to flourish during the Enlightenment, small fantasies began sneaking up on Veitshöchsheim's straight avenues and solemn gods.

The hedges became more, not less, stylized, so stylized in fact as to be transformed into mazes and secret tunnels and objects of entertainment. A grotto was built and filled with stone serpents. Masons and stoneworkers were hired to construct temples made of shell and a "Chinese" pavilion with carved pineapples and palm trees. Plans for the garden started to look like plans for a Byzantine labyrinth.

Most importantly, however, the rococo work of Ferdinand Tietz was commissioned to embellish the garden. Tietz's allegories of gods, seasons, and continents included so much exaggeration, fantasy and humor that they stopped only just short of caricature. Tietz represented "America" as a smirking Indian in vaguely Oriental attire. His massive Pegasus is an incredibly elaborate version of the classical theme. The details of a winged horse pawing at a "spring" made of thousands of stylized wavelets are so fanciful as to make a visitor wonder whether Tietz was parodying his theme.

Chapter Four
ANCIENT SCULPTURE SITES

Engraved stone from Tanum, Sweden.

ANCIENT SCULPTURE SITES

If works of art can be said to have a function, it is as a by-product to mankind's search for meaning, as a way of stating what man thinks of general forms — the universe and his place in it.

Sculpture gardens often make these statements more absolute by juxtaposing them with the ciphered forms of the natural world: rocks, mountains, sea, river, forest, sky.

This is especially true of historic sites where early generations of man, open to the stark perils of nature, put their affirmations in the natural context, whether in defiance or entreaty.

These older sites are scattered over the world, on every continent where man has lived. From the huge concentric shapes carved into the earth of southern Peru (visible only from the air) to the Sphinx's smile, from Lascaux to Persepolis, from Easter Island to Stonehenge, they bear mute testimony to the burdens of cognition.

The historic sites described below were not intended to be sculpture gardens in the modern sense of the term. In most cases the surroundings were not landscaped or planted as gardens. In one exception — the garden of Ryoanji, in Japan — the materials used were not carved. But all the sites fulfill the spirit, if not the letter, of a defining rule: they directly connect works of art with the world around them, creating new aesthetic and philosophical patterns in the process.

In many cases, the motivation behind a site was magical or religious. Sometimes the alignment of sculptures had practical applications, like the "solstice clock" of Stonehenge. Sometimes the act of creating and placing was as important as the structures it left behind, as in North American totem poles. But these details do not lessen the relevance of the works to modern visitors, any more than they detract from their impact as sculpture sites. If the old sites cover a broader spectrum of human associations than modern ones, it is because the frontiers between life, art, magic and nature were more indistinct in earlier times than they are now. The world was a harsher and more savage place that did not allow the luxury of such distinctions.

Ancestor worship was probably the basis for the "Moais," the famous stone heads of **Easter Island,** 2,000 miles west of the Chilean coast.

The huge faces, carved from volcanic "tufa" rock, stare in mute awe at the central craters of their Pacific island. Unlike the Haida or Kwagiutl, however, the putative descendants of the Moais' Polynesian creators remember little of their reasons for being. The untranslated petroglyphs that accompany the statues only deepen the mystery.

It is likely that the huge heads constituted monuments to spirits of the

Monoliths on the slopes of the vulcano Rano Raraku. Easter Island, South Pacific.

dead whose home was the summit of Easter Island. The heads were originally placed on top of massive burial vaults, or "ahus." Their well-known features, with pouting lips and hollow sockets, were enhanced by eyes made of coral.

The statues were carved with tools of obsidian out of Rano Raraku quarry. From the mountainside they must have been hauled on rollers by teams of men pulling on ropes of mulberry fiber, and levered on top of slabsided burial lean-tos at their present sites. In the quarry itself, 150 statues, some half-finished, lie scattered in disarray. Around them are tools, dropped from the fingers of men interrupted by a cataclysm that has yet to be explained.

The significance of **Stonehenge,** Wiltshire, England, lies in the patterns made by its stones. Lines of sight drawn between the various megaliths were used in ancient times to predict solstices and equinoxes, the birth, maturity and death of the various seasons.

Those patterns, in turn, implied patterns in the rhythm of things that were the basis for the neolithic cosmology of their creators. The cosmology is largely forgotten, but the visual patterns remain in Stonehenge's huge, linteled doors, open to the sky.

The circle of standing megaliths at Stonehenge, England.

Stonehenge was built in three phases in what was probably at the time a wooded section of Salisbury Plain. Its builders were not druids, or even Celts, as 19th-century scholars would have it. They were probably neolithic and Bronze Age tribesmen, in particular of the so-called Beaker and Wessex cultures, that displaced the earlier paleolithic inhabitants of England in the third millennium B.C.

The newer cultures introduced the circular "henge" to England but more importantly they brought the rudiments of pastoralism and agriculture. With agriculture came a need for future planning to sow and reap at the right times, to predict weather and store crops against dearth to come. This meant timing the seasons according to sun, moon and stars, and the idea of a linear future replaced the cyclical rhythms of hunting, as the male gods of the sky replaced the timeless animal deities and earth goddesses of preceding cultures. The possibility of storing surplus grains enabled priests wise in the ways of sun, moon and planets to accumulate wealth and power enough to build impressive monuments to the new deities.

In this way Stonehenge may represent a cultural solstice in the same way its stones and its very location mark out astronomical watersheds. The people who built the earliest parts of Stonehenge — circular banks, the central "heel" stone, and holes to mark the solstice and other events — were probably making the crucial change from a hunting economy to one reliant on wheat and barley. The more evolved Beaker culture which took their place dragged in large "blue" stones from Wales and set them in two circles around the heel stone. The Beakers were in turn driven off by the Wessex people, who set up the 81 gigantic rocks of the "inner horseshoe." These "sarsens" weighed between 25 and 45 tons apiece, and probably had to be hauled by a thousand men onto successively higher ramps of earth and then tipped into precisely morticed positions, all within a geometry that never varied more than four inches from true. The wealth and hierarchy needed to accomplish these feats are evidence enough of the cultural implications of the shift from nomadic to sedentary existence.

The rock art of **Tanum** is located in the Swedish province of Bohuslan. At some point around 1600 B.C. the Germanic Bronze Age residents of the area began chipping designs on worn surfaces of rocks deposited by glaciers. Altogether some 280 boulders — all flat, or slightly inclined — were decorated in this manner, making up one of the most important collections of Bronze Age art to survive to the present.

The carvings are stylized, one-dimensional. They were apparently carried out over almost two millennia, with most of the work done around 1000 B.C. at about the same time as the Celtic invaders of Spain, Ireland and Brittany were carving their own designs to the south. The images are repetitive; large numbers of men, hunting or dancing, many tall-stemmed ships, male gods of the Germanic pantheon, dozens of axes, daggers, and swords: spirals, sun wheels, cups, helmets, footprints: more axes, more daggers, more swords.

Around the boulders lie only lakes, moraines, and the empty horizon. In common with many other sites, the elemental starkness of Tanum's natural surroundings would seem to have facilitated those communications between man and his elemental gods for which the site was intended.

That Tanum's carvings were religious and magical in purpose is clear. Most of the pictures are symbolic in a direct sense. The god with the spears is Odin, the deity who dethroned the older Tyr, or Thor. (The tallest figure at Tanum is a ten-foot Odin.) Thor is represented with a wheel, goats, a ring and most often an axe, with which (like the gods of Mexico's Olmecs) he struck thunder. The ships are directly related to the goddess Freya.

But the symbols also have deeper resonance. The ship is an ancient symbol of cyclical death, rebirth and fertility. The "sun wheels" — crossed circles — celebrate the sun and the Mesopotamian division of the cosmos into four directions and seasons, a symbol taken up in both the Christian cross and the Hindu swastika. Axes, spears, ships' masts, trees, maypoles, jagged lightning shapes, spirals, are all obvious symbols of fertility whose roots reach to Minoa and Babylon and whose folkloric branches end in local Scandinavian customs that are still extant. The drilled holes and footprints in many of the rocks were probably used to leave offerings for the gods, as they are used today for elf offerings when someone falls ill in Harnaerstedt.

The underlying meanings of the Tanum symbols (like the symbols on more recent Viking graves in the Greby area), were familiar to their creators through the mythology that surrounded them. The mythology turned the drawings into a symbolic language linking the natural forces they represented to man. The language portrayed offerings of animals, food and fire destined to protect the herds and rudimentary crops of the people of Tanum against a world they could otherwise not control.

The ruins of **Abu Simbel** and Namrud Dagi mark a further milestone down the hierarchical road made possible by sedentary agriculture. The original location of Abu Simbel was flooded 13 years ago when the giant Aswan dam shut its first sluice on the Nile, but the statues, obelisks and stelae, salvaged by an international effort, remain on the desert above Lake Nasser to prove the wealth and arrogance of imperial Egypt.

The two temples of Abu Simbel were commissioned in the 12th century B.C. by Setes I and finished by his usurping son, Ramses II, who brought the Egyptian empire to the height of its glory by extending it and protecting it against Hittite invaders. The temples are remarkable for the huge limestone statues of their facade, originally hewed out of sedimentary cliffs near the upper cataracts of the Nile. The smaller temple was dedicated to Nefertary, the wife of Ramses II, but four of its six statues represent gods with Ramses' face. In the larger temple (dedicated to Ramses), all four statues represent Ramses II: as Osiris, god of the underworld, Ramses is seen accepting offerings from Ramses as his earthly self.

The temples of Abu Simbel were, in fact, offerings from the pharaoh to the gods who could guarantee eternal life. It can therefore be seen as

Standing stones of the Viking graves at Greby, Sweden.

Detail of the rock carvings of Tanum, Sweden.

197

Seated figures in the desert at Karnak, Egypt.

one massive, votive offering. But it is also testimony to the wealth of agricultural civilization along the Nile. This was a civilization whose surplus could support men who worked at other things beside tilling the alluvial land. The resulting variety could separate an individual's life from his community to an extent undreamed of in hunting/fishing cultures.

The emphasis on death and the importance of the after-life are not as evident in the massive heads of **Namrud Dagi,** in southern Turkey. But the surplus labor involved in building this type of monument again bears witness to the accumulation of power in the culture that spawned it: the power of pharaohs (waning) and their priesthood (growing) in Ramessid Egypt: the power of the Seleucid kings of Commagene at Namrud Dagi.

Commagene was a small but prosperous kingdom that controlled tall mountains, fertile farmlands and two fords across the Euphrates River. It was a province, first of the Assyrian, then of the Persian empire, finally achieving independence in the 2nd century B.C. under the Syrian descendants of Alexander the Great's general Seleucus. Com-

Obelisk and arch at Karnak, Egypt.

magene expanded by allying itself with Pompey but was finally engulfed by Rome in 18 A.D.

The site consists of a huge tumulus on top of a 7,000-foot mountain that commands a view of bare ranges as well as all of ancient Commagene. Piled on the rubble, cracked by the sun and wind of high altitudes, lie the vestiges of the half Persian, half Greek deities of Antiochus I — stone eagles, lions, altars and especially a number of gigantic carved heads: Greek gods with Persian garlands and headdresses.

The heads all stood between 26 and 32 feet high before falling from their pedestals. The last upright head, the garlanded "Fortune of Commagene," was knocked down by lightning in 1963. In the desolation around them they forcefully bring to mind the poet Shelley's words about another fallen monarch.

Almost 5,000 miles to the southwest another series of giant stone heads marks what was once the Jerusalem of Central America.

La Venta, in the Mexican province of Tabasco, was probably the principal city of the Olmec culture, which held sway in southern Mexico between 2000 B.C. and 900 A.D. The Olmecs started from a small vil-

Carved figure from the Parque de la Venta, Villermosa, Mexico.

lage economy based on the wasteful, "slash-and-burn" cultivation of maize. They transformed it into a flourishing civilization that created complex calendars and an alphabet, pyramids and stelae, and extraordinary works of sculpture. The Olmecs, with all their cultural brilliance and agricultural flaws, were eventually absorbed into the Mayan civilization.

La Venta was built on an island in the middle of mangrove swamps at the apogee of Olmec civilization. It was a city of temples, ziggurats, altars, plazas and colonnaded courts where the priest-chieftains of the Olmecs conducted rituals. Gods and men in Olmec cosmology were related to the animal gods, especially the jaguar, symbol of the powers of earth. Olmec artisans carved cabalistic groups of small, finely sculpted jade celebrants, and huge jaguar masks on the sides of pyramids, to celebrate this bond.

The heads of La Venta, for their part, were a good nine feet high and 15 tons in weight, and were sculpted with the characteristic fleshy lips and full cheeks of the Olmec people. They had to be dragged and floated from quarries 60 miles away before being set up at La Venta. But whatever powers they held or favors they bought could not prevent the collapse of the city, apparently at the hands of invaders, in the 10th century A.D. As in Namrud Dagi, the contrast between the ruins of a forgotten civilization and the natural world which spawned and then buried it carries powerful connotations for visitors.

The time span between the creation of British Columbian totem poles and the collapse of the culture which carved them is not as awe-inspiring as the gap implicit in La Venta. The site where many of the totem poles are collected — **Totem Park** — is not as stark: no jungle here, no eroded mountains or desert cliffs, but the temperate beauty of Vancouver Bay, with snowy peaks dominating the great forests and rich waters of Canada's Pacific coast.

Yet the totems are relics just the same. They lie behind the Museum of Anthropology of the University of British Columbia, tall cedar trunks heavy with the rich motifs of northwest Indian folklore. Killer whales, otters, eagles, wolves, crows, salmon and men stare in painted ferocity or joy. Their features are more pronounced if they were carved by tribes far to the north like the Haida: the relief was toned down to the south, in Tsimshian totems, and Kwagiutl.

The northwest tribes had other things in common beside totem poles:

their economies based on an ability to cure and stock salmon. The resulting surplus was used differently from corn or barley in Europe and Central America. Perhaps because fishing and hunting remained an important feature in their culture, the northwest Indians never got around to supporting topheavy priesthoods or kingdoms like the Egyptians, but used their material wealth to finance mythological "property": songs and dances, masks and totem poles.

The Indians' artwork is, in fact, reminiscent of the symbolism of transitional civilizations of the neolithic and Bronze Age type in Europe. As in Tanum, the myths represented in Totem Park were symbols of links between humans and the natural world. More specifically, they defined the ancestry of a given clan or family all the way back to a primordial state of grace when men and animals were one. Thus the totems served not only to define kinship links, but to connect the Indians with their environment via the spirit world, a type of link common to many hunting and fishing cultures around the planet. A northwest Indian family worked hard, fishing and hunting all summer. When winter came its members would carve totems and other decorations, then have a celebration, during which the hosts would prove how rich

The fallen heads at Namrud Dagi, Turkey.

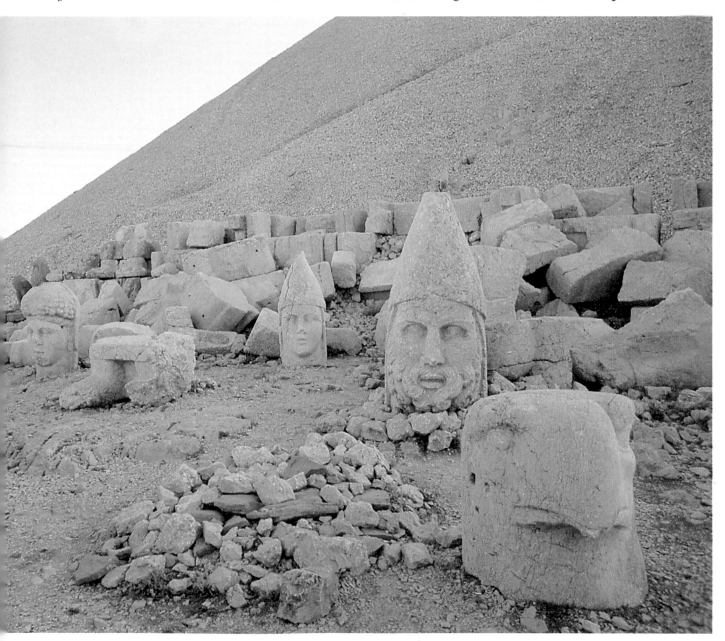

they were in ancestors and family myths by presenting gifts, performing songs and dances, and setting up poles that described how their family had links with raven, or mink, or orca, back when all forms were fluid. The guests would bear witness to the totem pole and thus legitimize the mythological claims of the family which gave the "potlatch." Although the northwest coast Indians made totem poles prior to the arrival of Europeans, most of the existing poles were built during an explosion of trade fortunes made possible by the white man's hunger for pelts furnished by the Indians. Ironically enough, this rich indigenous culture could not survive such an excess of outside wealth: it broke up under the disruptive influences of disease and a monetary economy in the early years of the 20th century. Only a few Indians remain to carve forgotten legends and ancestors onto cedar posts for anthropologists or art collectors.

The cultural foundations of the Zen temple at **Ryoanji** are by contrast still relevant to modern Japanese culture.

The small and abstract space of the rock garden at Ryoanji was built by Zen Buddhists behind the abbot's residence of a Kyoto temple in the 16th century. The garden is a garden by suggestion only: everything in it carries an implication that must be followed through in the viewer's mind. The carefully-raked white pebbles hint at ocean swells. Rocks lie in groups of 5, 2, 3, 2 and 3, suggesting islands and mirroring the outline of the constellation of Cassiopeia.

There is nothing else, but the pattern is no less attractive for all its understatement. The different elements, rocks and stones, are not carved or painted, but they and their relative locations have been so painstakingly chosen that the act of selection has become in and of itself one of creation, and the resulting pattern a sculpture of the highest order.

Ryoanji's rock garden is, naturally enough, part and parcel of the Zen ideal. Philosophically the ideal might be over-simplified by likening it to the search for nothingness, reducing the ego to the point where it dwindles into oblivion, leaving one free to become part of nature.

Artistically, the ideal consists of suggesting (never stating) the harmony of a cosmos. Ryoanji's garden, in this sense, is a direct descendant of other Zen-influenced art forms which came to Japan from China during the Kamakura period, in particular Chinese Sumi-e, or pen and ink painting. In fact the garden was probably designed by a pupil of the ink-painter Soami, who was also a well known 16th-century garden architect and author of a book on the making of hill gardens.

Ryoanji is, however, more distilled than other Zen gardens by Soami and others, and may be closer to the ideal of representing nature in its purest, most universal and most symbolic terms.

It shares this characteristic with other sculpture gardens, which all in one way or another transcend the narrow and specific statements they were built to make. They transcend the specific by suggesting through their own aesthetic harmonies, in tandem with the balance of the surrounding environment, the general harmonies and balances of the natural world, and man who is a part of it. In this sense they are truly an art form.

Detail of a head sculpted on a totem pole. The Museum of Anthropology, University of British Columbia, Canada.

A general view of the Totem Park in Vancouver Bay, British Columbia, Canada.

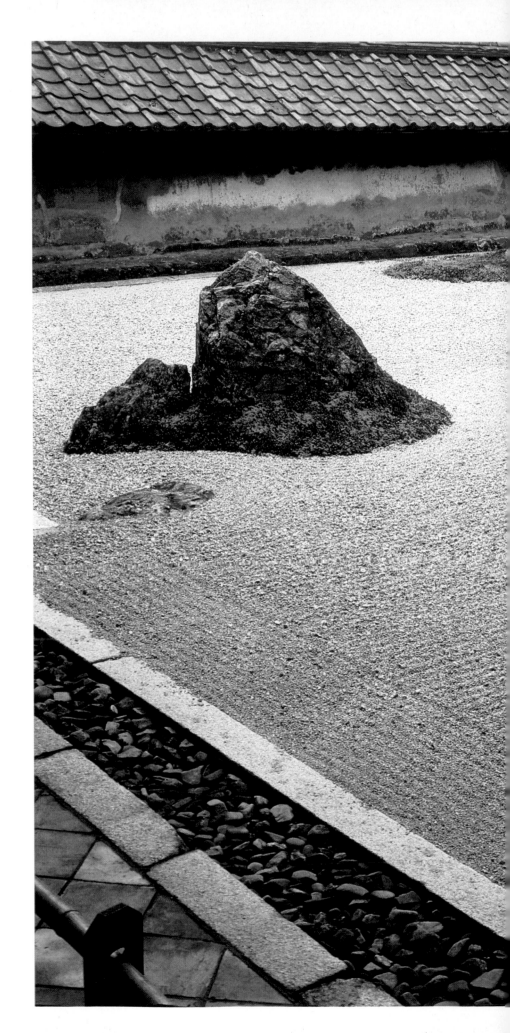

The Ryoanji Temple, Japan: a Zen Garden.

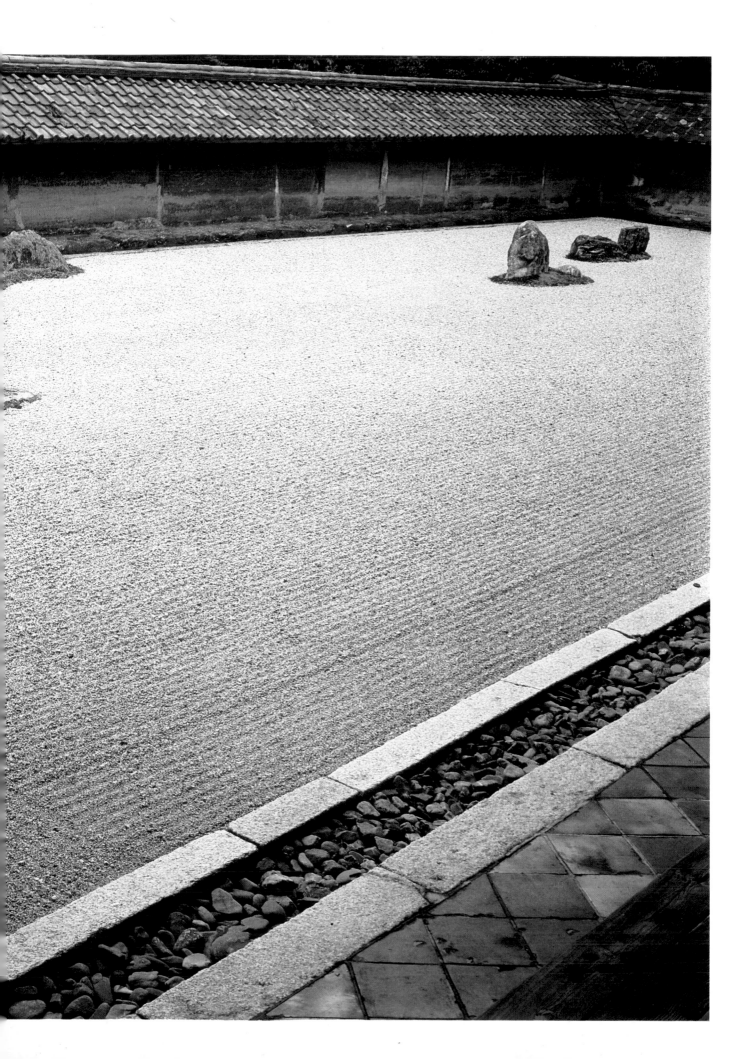

GEOGRAPHICAL INDEX

PHOTOGRAPHIC CREDITS

Front cover by Nicolas Sapieha, back cover by Francesco Venturi.
Page 7 Sekai Bunka Photo; page 9-left Art Resource; page 9-right by Albano Guatti; page 9-bottom, courtesy of Dumbarton Oaks; page 10-top and bottom Alinari; page 11-left and right Scala; page 12-left V-dia/Scala; page 13-right Scala; page 14-top Scala; page 16 Scala; page 17-left Alinari; page 17-right by Nicolas Sapieha; page 18 by Nicolas Sapieha.

CHAPTER 1

All photos by Nicolas Sapieha except: page 43 by Isamu Noguchi; page 44 by Leonardo Bezzola; page 45 by Isamo Noguchi; pages 47 through 51, courtesy of the Hakone Open-Air Museum; page 57 by Aurelio Amendola, courtesy of Mr. Giuliano Gori; page 59 by Francesco Venturi; page 71, courtesy of Sutton Place; pages 76-77 by Anthony Howarth/Susan Griggs Agency; page 83 Giraudon/Art Resource; pages 85-86-87 by Fedor Dzamonja.

CHAPTER 2

All photos by Nicolas Sapieha except: page 92 by Robert M. Damora, courtesy of the Museum of Modern Art; page 93-top by Soichi Sunami, courtesy of the Museum of Modern Art; page 93-bottom by Alexandre Georges, courtesy of the Museum of Modern Art; pages 95-96 by Esto, courtesy of the Whitney Museum of American Art at Philip Morris; pages 99-100 by Peter Tompkins; page 105, courtesy of the Fondation Maeght; page 114 by Robert Schezen, courtesy of the Dallas Museum of Art; pages 115 by Daniel Barsotti, courtesy of the Dallas Museum of Art; pages 133-134-135 by Louis Foy; page 138, courtesy of the Yorkshire Sculpture Park; page 139 by Maurice Elstub, courtesy of the Yorkshire Sculpture Park.

CHAPTER 3

All photos by Nicolas Sapieha except: page 140 by Francesco Venturi; pages 159-161 by Francesco Venturi; page 161-right Scala; page 165 Scala; page 172 Art Resource; pages 178-179-180 by Francesco Venturi; page 181 by Nick Holland/Susan Griggs Agency; page 186 by Manfred Eckebrecht/Bavaria; page 187 by Heinz Schwarz/Bavaria.

CHAPTER 4

All photos by Nicolas Sapieha except: page 193 Art Resource; page 194 by Adam Woolfitt/Susan Griggs Agency; pages 198-199-200-201 by Albano Guatti; page 205 Sekai Bunka Photo